HOLLAND

living with water

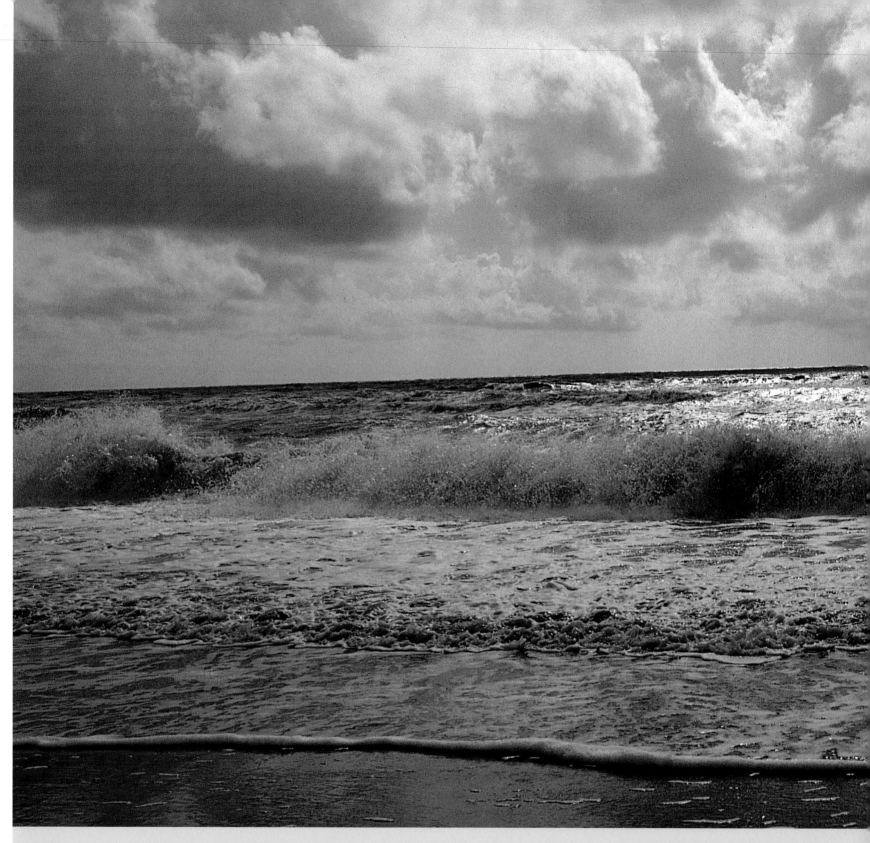

TEXT ART DE VOS **PHOTOGRAPHY** FREEK VAN ARKEL FRITS BAARDA TON BORSBOOM GEORGE BURGGRAAFF WILLIAM HOOGTEYLING MARCO DE NOOD
EPPO NOTENBOOM KAREL TOMEÏ ARNOUD WILNIK **PUBLISHER** SCRIPTUM PUBLISHER

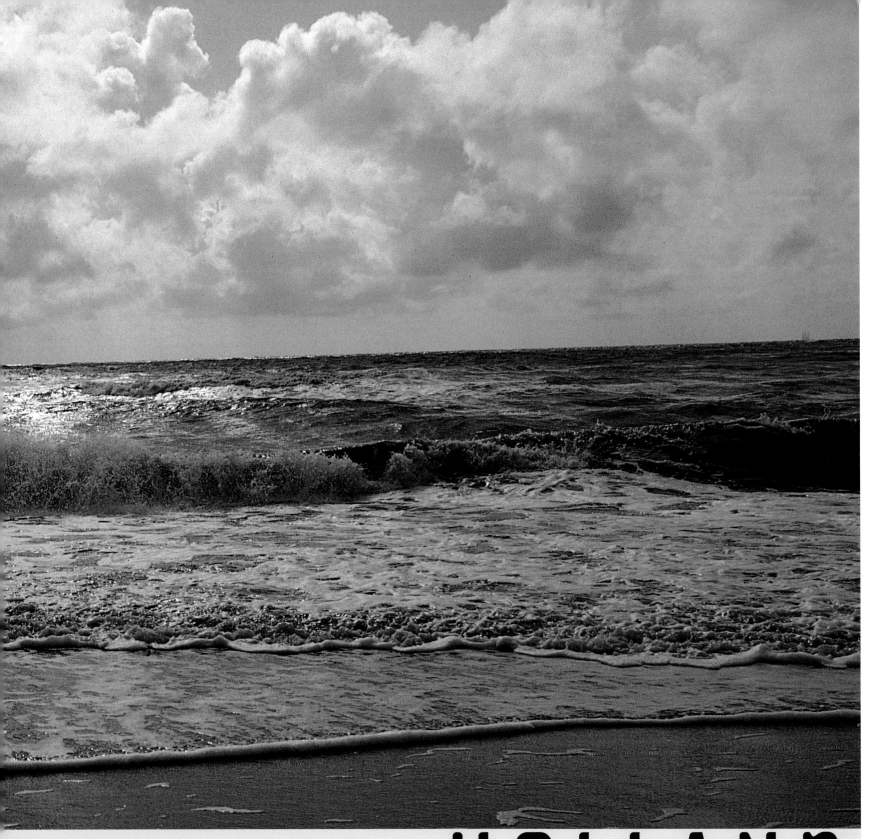

HOLLAND

living with water

THE NETHERLANDS WILL SOON BE FACING A HEATED DISCUSSION ON WATER MANAGEMENT. THE SEA LEVEL IS RISING AND THE RIVERS ARE BECOMING SWOLLEN. YET THIS IS NO NEW THREAT. THE DUTCH HAVE BEEN CONCERNED ABOUT THE WATER FOR CENTURIES BUT, AT THE SAME TIME, THEY HAVE BENEFITED FROM IT.

THIS BOOK IS ABOUT THE RELATIONSHIP BETWEEN THE PEOPLE OF THE NETHERLANDS AND THE WATER THAT SURROUNDS THEM. HOW THE TWO LIVE TOGETHER AND HOW THEY TUSSLE FOR SUPREMACY. THIS LOVE-HATE RELATIONSHIP IS DESCRIBED THROUGH THE EYES OF THE PEOPLE WHO LIVE IN A LAND THAT THE WATER CONTINUALLY TRIES TO RECLAIM.

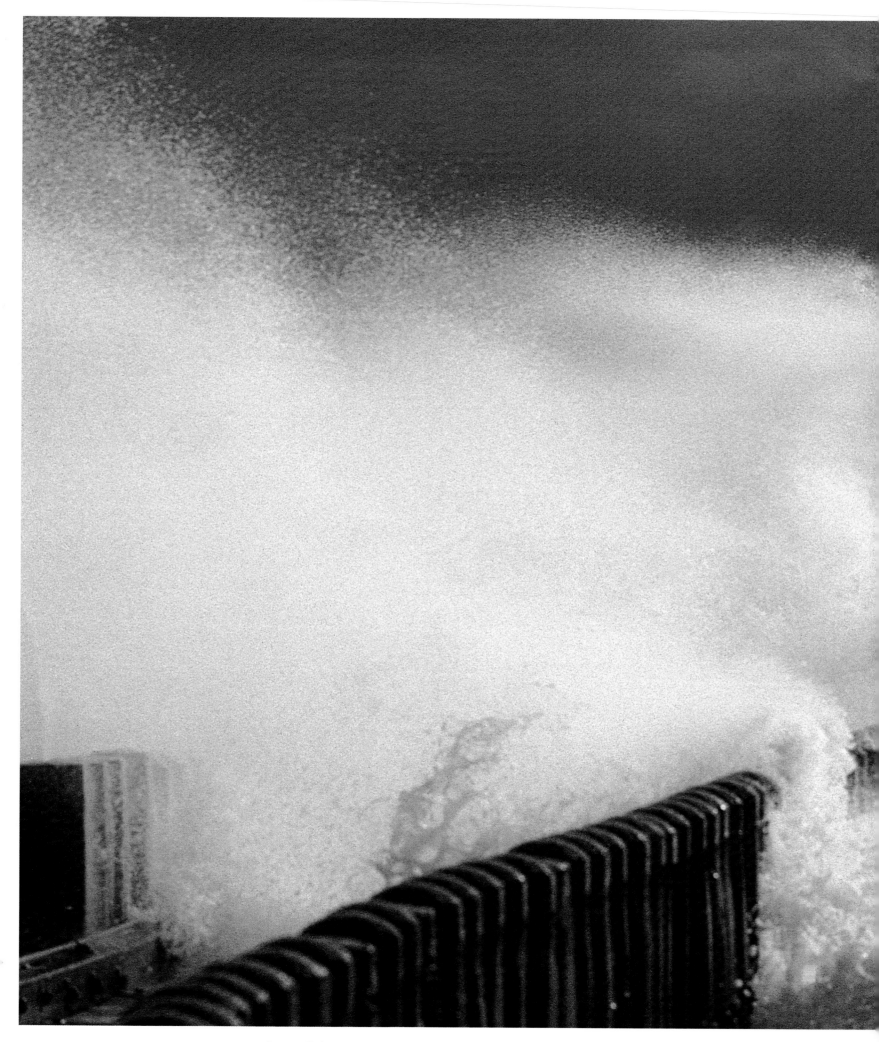

Storm at Vlissingen

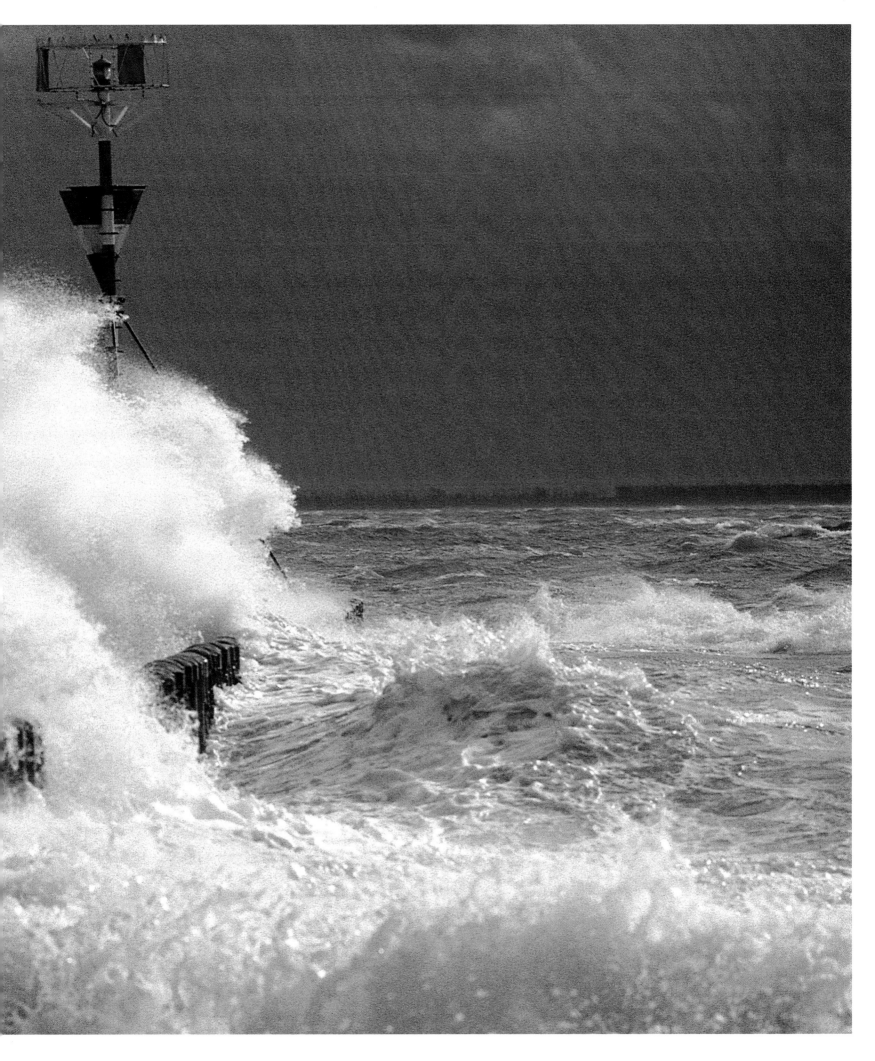

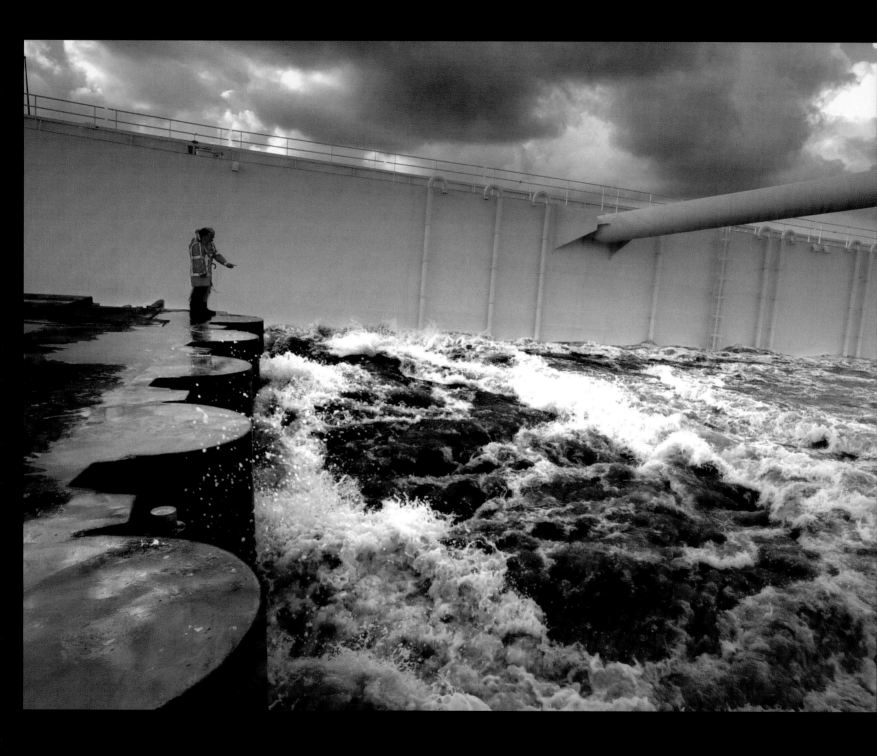

The Maeslantkering [barrage] in the Nieuwe Waterweg protects millions of people from the storm tides

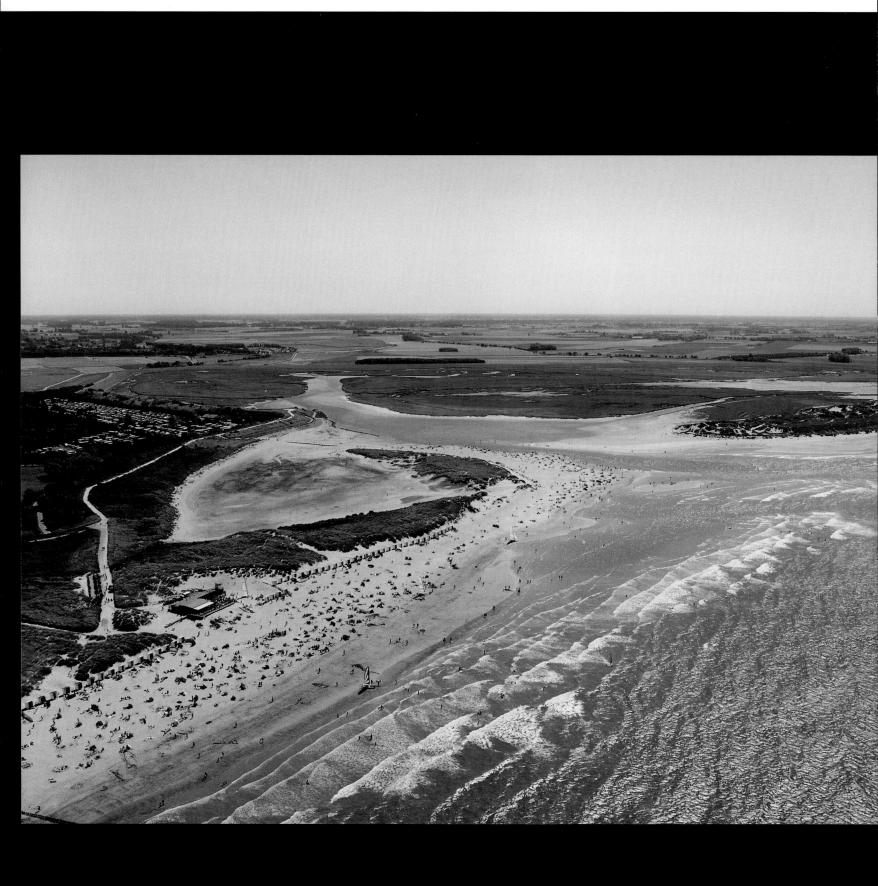

Water is not only a threat, but also a source of pleasure....

...and a source of prosperity

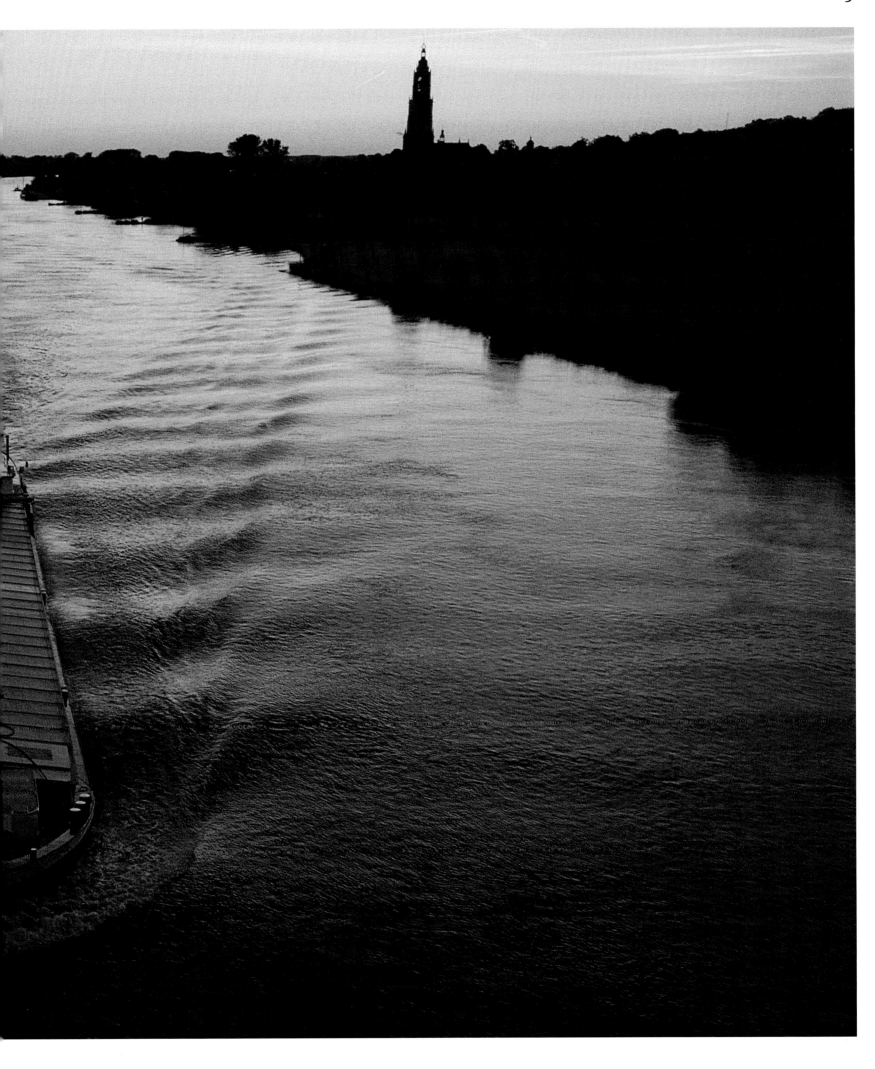

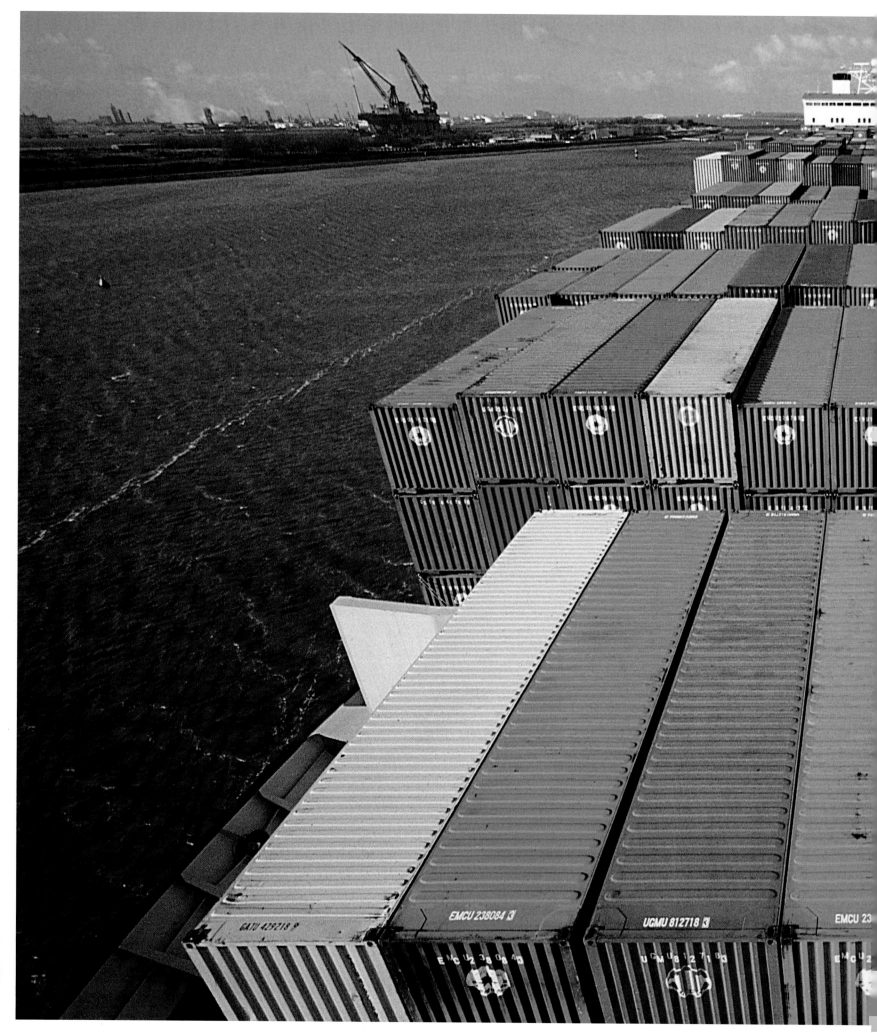

A container ship enters the Nieuwe Waterweg

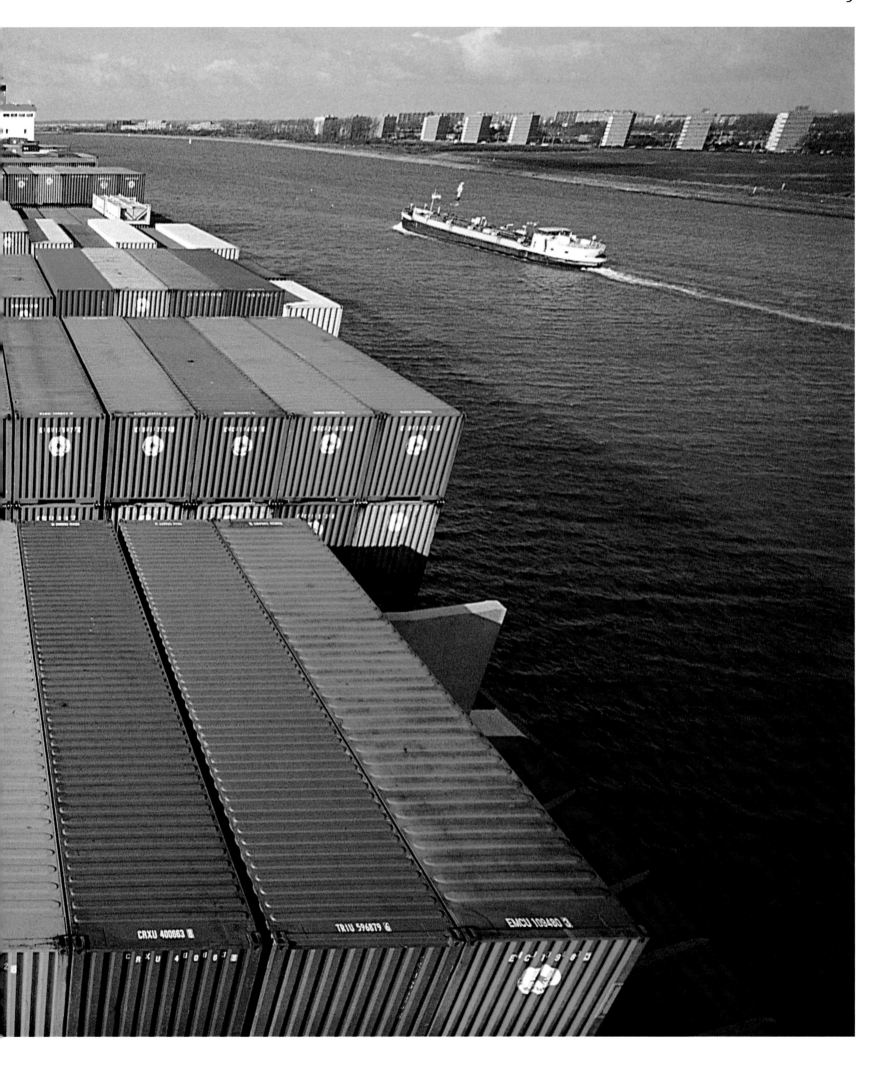

The Nieuwe Maas in Rotterdam

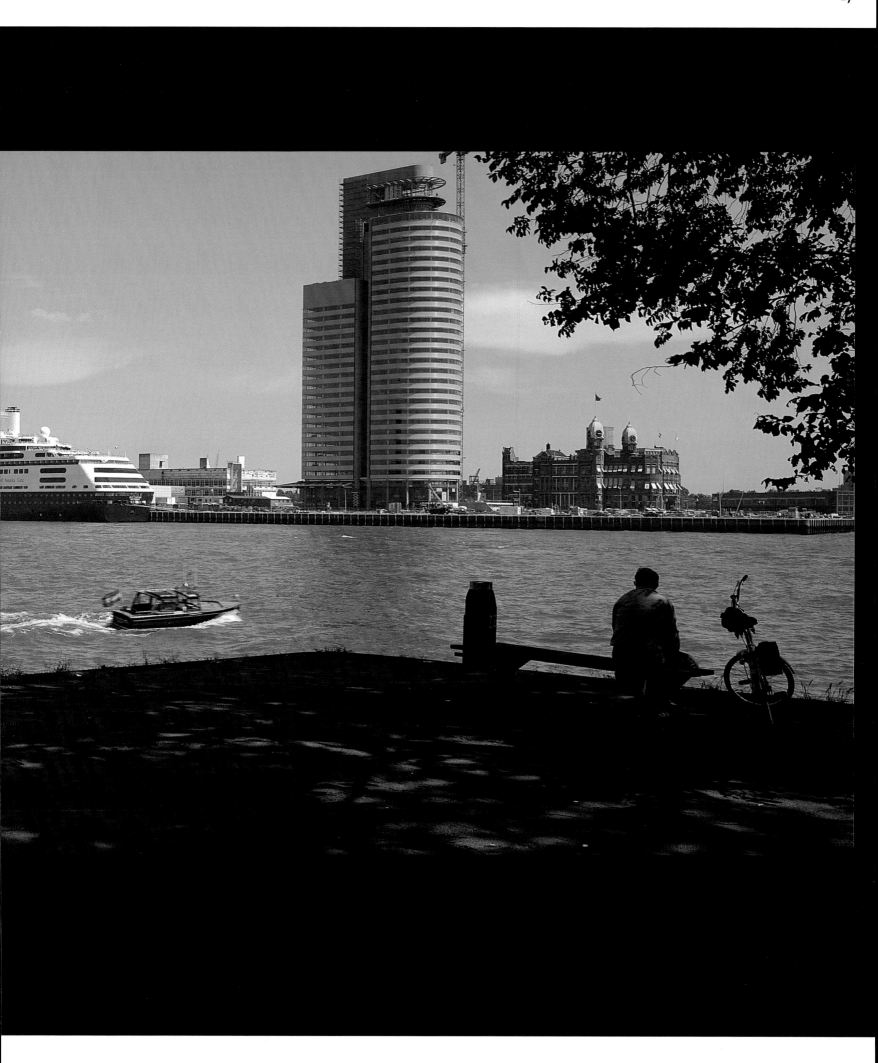

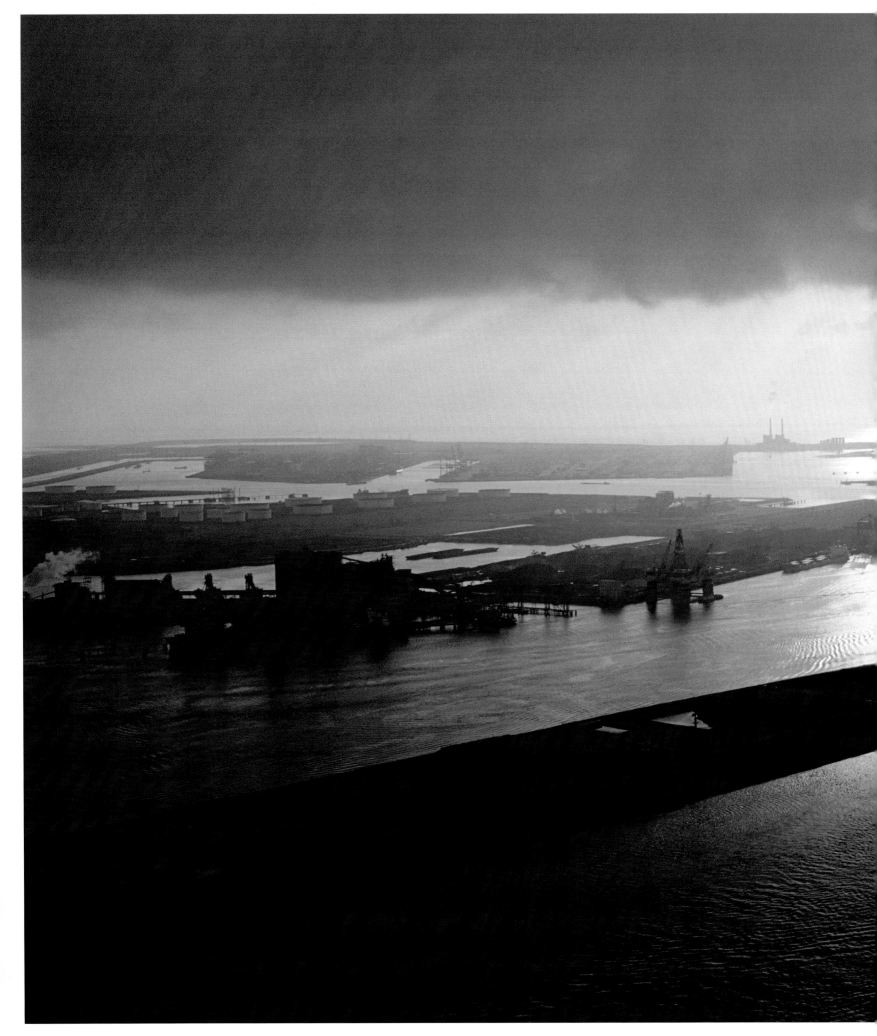

Heavy skies above the Maas estuary

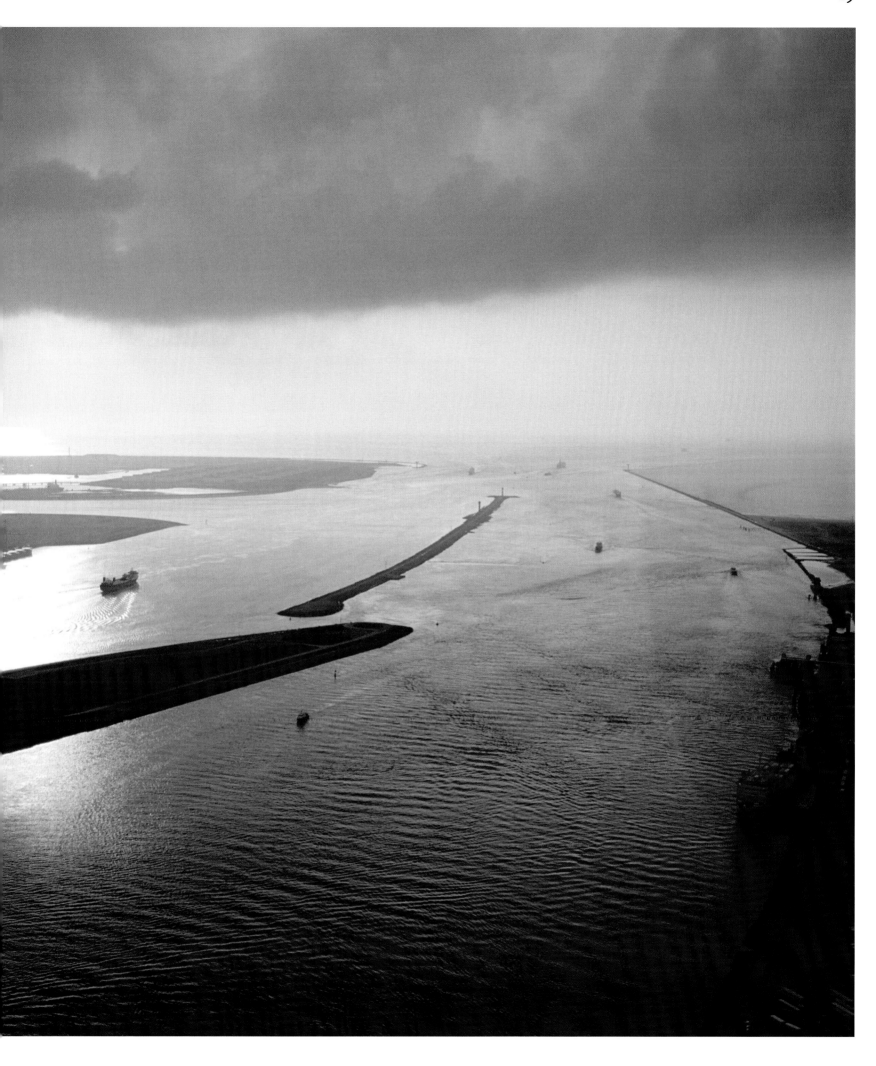

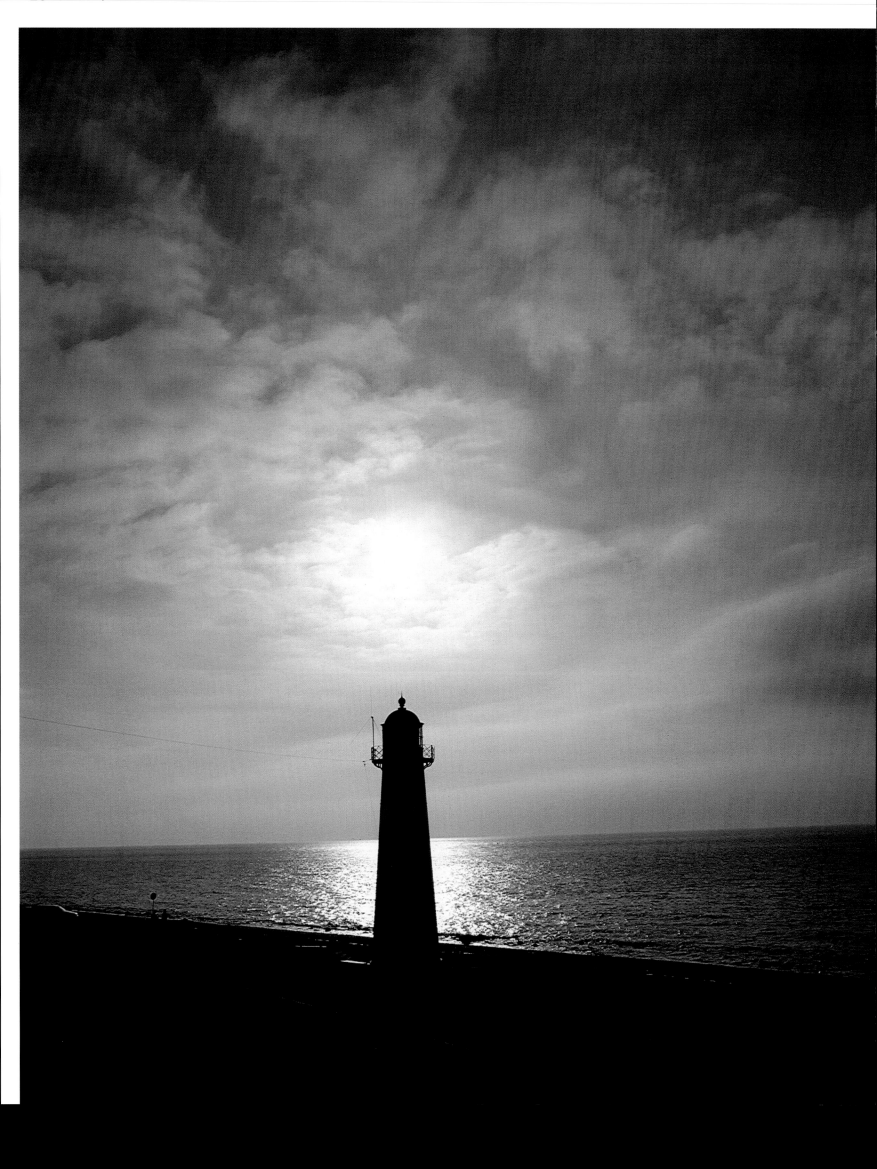

WARNINGS THAT WATER IS ENDANGERING OUR VERY

EXISTENCE SOUND MORE URGENT THAN EVER. FOR

THE FIRST TIME IN HISTORY, WE ARE ASKING OUR-

SELVES WHAT CHANCES OF SURVIVAL WE HAVE, IN

OUR SMALL COUNTRY SURROUNDED

BY WATER.

SUBMERGED IN THE MUD OF THE RIVER DELTA AND ALONG THE COAST LIE THE REMAINS OF SETTLEMENTS THAT HAVE FALLEN PREY TO THE ARCHENEMY: WATER. SOMETIMES, AT LOW TIDE, SMALL TRACES OF THESE VILLAGES AND FARMS CAN STILL BE SEEN. MANY OF THEM DISAPPEARED FOREVER BENEATH THE WAVES, WITH FEW SURVIVORS.

It is an illusion to believe that such tragedies can never happen again. If we are not careful, within a few centuries, only church towers and high-rise buildings will still be visible above the surface of the sea. We thought that we had finally won the centuries-old struggle with the completion of the Delta Project, the ambitious coastal defence programme initiated after the disastrous floods of 1953 which left much of the southwest of the Netherlands under water. But even this unparalleled triumph of hydraulic engineering, which cost billions of guilders, can no longer guarantee us a safe future. On the contrary. As we embark on a new millennium, the threat of rising water levels once again rears its head. Warnings that water is endangering our very existence sound more urgent than ever. For the first time in history, we are asking ourselves what chances of survival we have, in our small country surrounded by water. Filling sandbags will not be enough.

According to the latest thinking in water management, putting our fingers in the hole in the dike is no longer the way to turn the tide. Quite the reverse, in fact – we should let the water in, allow it to become a part of our living environment. Exactly what a government engineer once predicted, in fact: 'One day,' he said, 'we will give this country back to the sea – and we shall do so with a sigh of relief.'

No matter how paradoxical this remark may appear, there is good reason to give it serious consideration. It seems as though nature has intensified her efforts to cover our country with water. Experts have long pointed to a dangerous combination of factors. First of all there is what we have come to call 'climate change', which is resulting in more rainfall and meltwater, and rising sea levels. In 1993 and 1995 large areas of Western Europe were confronted with extreme high water levels in the major rivers. In the Netherlands this led to emergency situations, including the large-scale evacuation of people living in towns and villages along their banks.

In those hectic days, we realised for the first time that we had forced the rivers into an overly tight corset. And that, no matter how high we built the dikes, they would be breached sooner or later. We were afraid that that moment had come – and we took flight. Once the threat had subsided, we discovered that we had been systematically narrowing our rivers by building on their natural beds. Their courses had become so narrow that there was no longer enough room for the water. Heavy rainfall upstream caused immediate problems in our low-lying country on the delta. This pressure will only increase in the coming decades. We must build in an escape valve here and there or the water will seek its own way out. The water needs more room, more elastic in the corset.

A second factor to be considered is that the country is sinking with respect to the sea. The peaty areas in the west are subsiding by a few centimetres every year and the process is irreversible. In addition, the ice caps are gradually melting, as a result of which the pressure on the northern continent is being reduced. This is causing a kind of seesaw movement, whereby Scandinavia is rising and the Netherlands is sinking. The water has brought us both prosperity and misfortune. In the years to come, it will largely be a cause for concern. We are likely to find ourselves embroiled in a heated debate on how to manage the water. We will have to ask ourselves whether there is enough room both for the water – which continues to rise – and for a population which has grown from three to sixteen million in the past two centuries. We *must* solve this problem if we are to continue to live in this region. It is a comforting thought that the Dutch are champions of consultation. We will find a solution, and whatever it may be, it will not be cheap. It will do us no harm to realise that now. History shows that, whenever we have lacked caution or have tried to find cheap solutions, the water has punished us.

This book looks at the relationship between the people of the Netherlands and the water that surrounds them. How the two live together and how they tussle for supremacy.

To investigate the background to this love-hate relationship, the author travelled by plane, car, motorcycle and, of course, by boat through the land of the great rivers. He stood on the dike and listened. He heard how the wind and the water played a fanfare, often cheerful, sometimes dissonant. Scientists, experts and local people listened with him, tuned their instruments and joined in. The score of this pure Dutch water music can be found on the pages that follow.

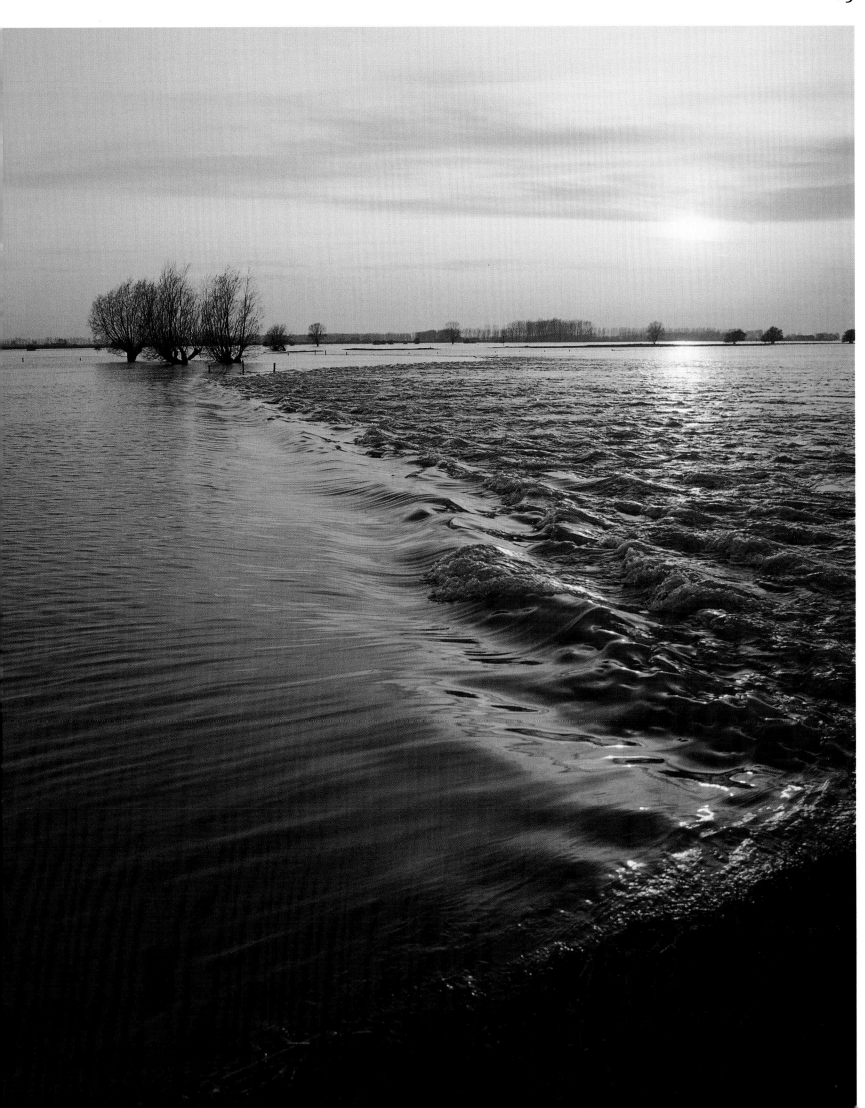

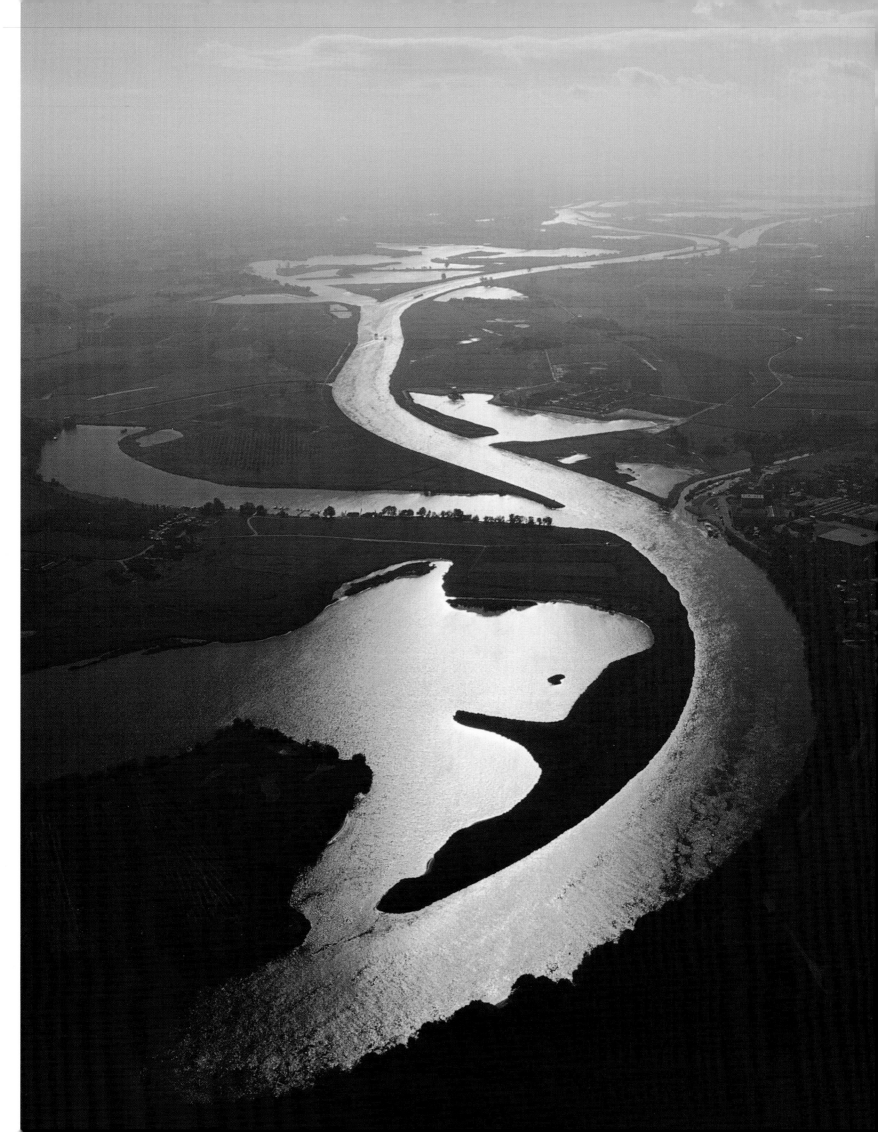

1000

feet above sea level

THE PILOT WALKS AROUND THE AIRCRAFT AND PATS THE THIN, RIVETED SHEET METAL. '1968 CESSNA, THE MOST RECYCLED PLANE IN THE WORLD. IF ONE CRASHES, EVERY-THING THAT IS IN ONE PIECE IS USED AGAIN.' A TRICKLE OF FUEL DRIBBLES ENCOURA-GINGLY ONTO THE RUNWAY FROM ONE WINGTIP. AFTER TAKEOFF, THE CESSNA FLIES IN CIRCLES AROUND THE PANNERDENSCHE KOP, IN THE EAST OF THE COUNTRY, NEAR THE GERMAN BORDER. THE PLANE IS ACTUALLY LITTLE MORE THAN A 2CV WITH WINGS. EVERY-THING RATTLES. BELOW, THE RIVER TWINKLES AT US IN THE SUN. WE CHUG AROUND THE MAIN OUTLET FOR THE RHINE. THE PHOTOGRAPHER OPENS A PERSPEX FLAP WINDOW, STICKS HIS HEAD OUT AND LOOKS THROUGH HIS TELESCOPIC LENS. SUDDENLY THE DOOR SHOOTS OPEN. AFTER A FEW MOMENTS OF PULLING FRANTICALLY AT BOTH DOOR AND PHOTOGRAPHER, THE SITUATION IS ONCE AGAIN UNDER CONTROL.

'Here, below us, the water that enters the Netherlands through the Rhine is distributed,' says Loes de Jong, manager of the *Rijkswaterstaat's Integrale Verkenning Benedenrivieren* (Lower Rivers Integrated Survey) project. The aim of the project is to determine just how much of a threat the river water will pose in 50 years' time – and whether we can deal with it.

The *Rijkswaterstaat* is the government body that is responsible for the Dutch coast and the major rivers. Loes de Jong is primarily concerned with the constant danger of the rivers flooding. She has been studying it all her life, first as a marine biologist and now as a water manager. Originally from Friesland, in the north of the country, she now lives in Middelburg, the main city of the southern province of Zeeland. She pur-posely chose a house above NAP (*Normaal Amsterdams Peil*, the Dutch water level reference) so that, if the dikes breach, it will dry out again at low tide.

The aircraft circles above a landscape that is not threatened by the sea, but which bears the scars of river flooding. According to De Jong, the Pannerdensche Kop, dating from 1775, and the canal are a good example of how we have intervened in the river landscape for many centuries. The canal ensures a balanced distrib-ution of water between the Nederrijn and the Waal, two branches of the Rhine.

'The Dutch have always wanted to control the way the water finds its way to the sea,' she explains. 'Here we ensure that one third of the water coming down the Rhine runs into the Nederrijn, while two thirds runs into the Waal.' Before the canal was dug, the inhabitants of the eastern river region always had the problem

The Waal at Pannerden

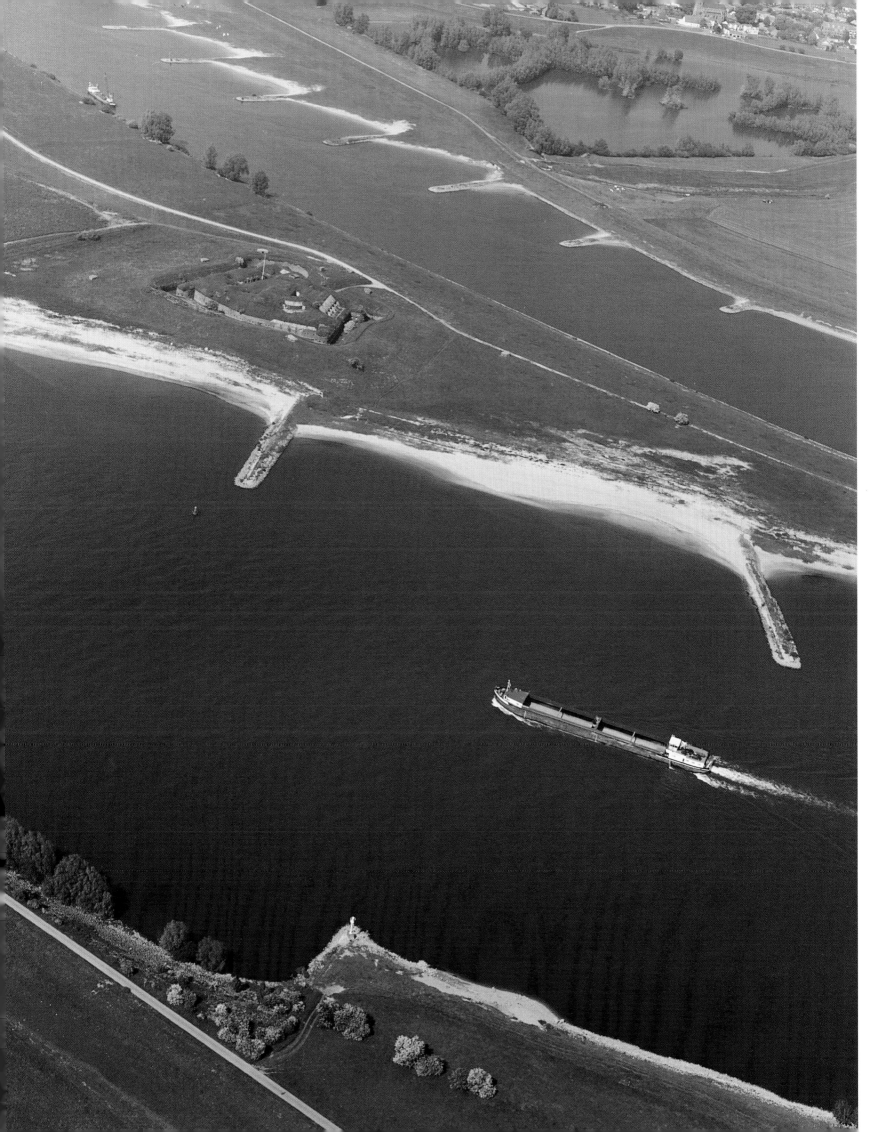

Arnhem [top]

Fort Pannerden [centre]

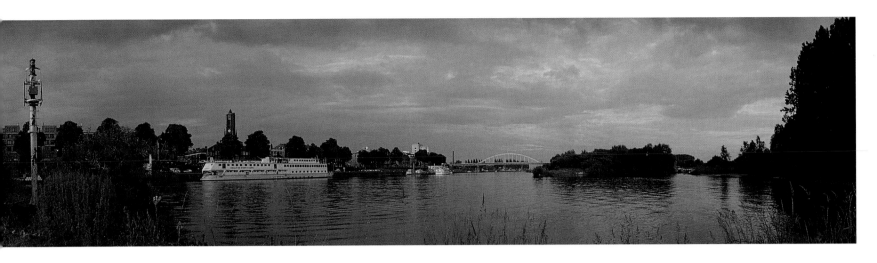

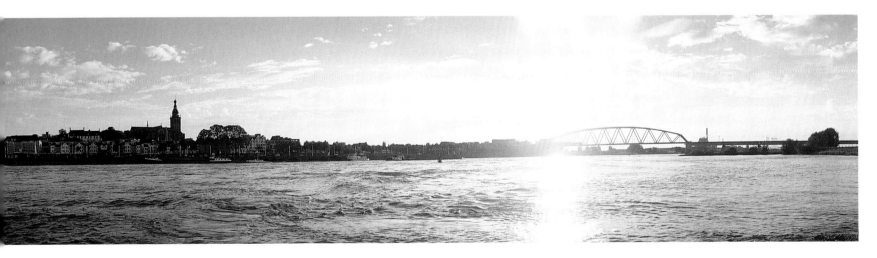

Nijmegen [bottom]

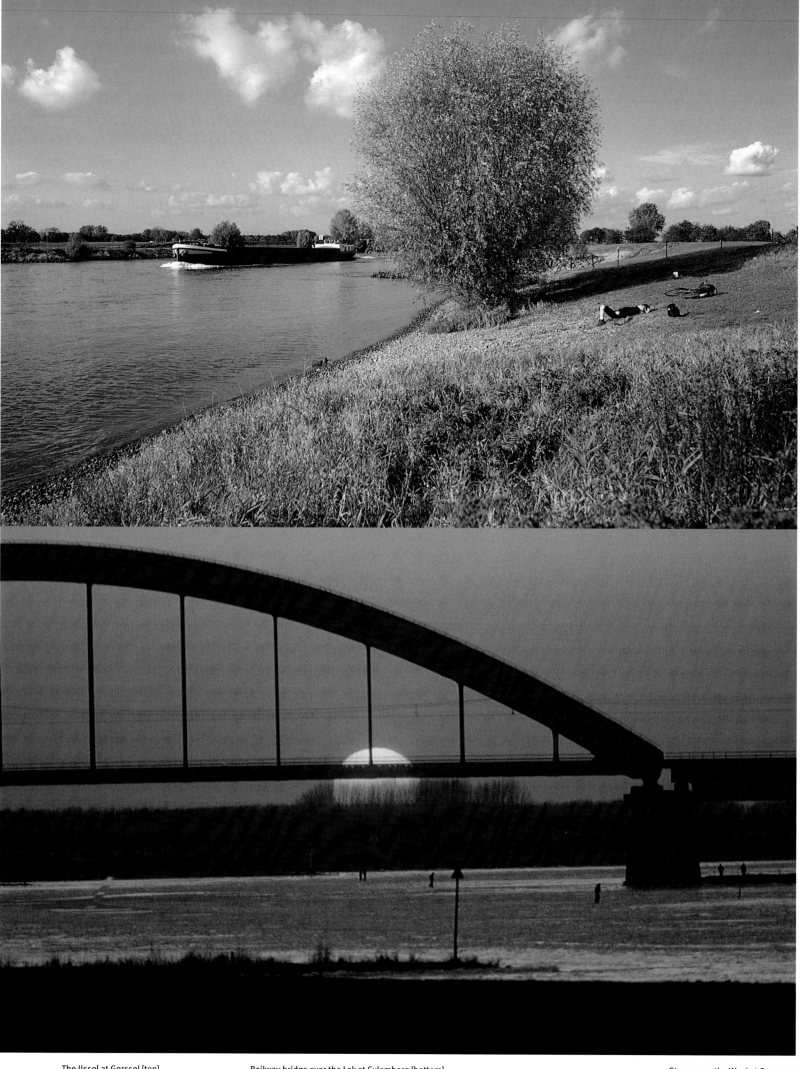

The IJssel at Gorssel [top] Railway bridge over the Lek at Culemborg [bottom] Storm over the Waal at Gameren

of too much or too little water in one branch of the river or the other. What is more, the rivers continually changed their courses. The Roman general Drusus provided the first solution by building a dam at Lobith. His efforts were destroyed by the Batavians, and it took seventeen centuries for the Dutch to stabilise the flow of water again. The Pannerdensche Kop is not only the main outlet for the Rhine. It has also been used for military purposes, serving as a frontline fort in the country's defences. It was intended to prevent enemy boats from entering Holland. It proved useless in 1940, however, when the invasion came not by land or water, but by air.

We make a turn and in the distance we can see the edge of the Reichswald, which marks the German border. Below us, on higher ground, is Nijmegen, with the Waal passing close by. To the right we can see the edge of the Veluwe National Park and Arnhem, the capital of Gelderland. The landscape stretches out like a low, flat valley. The steel bridges over the Waal and Rhine, the scene of heavy fighting during the Second World War, catch the eye.

Just before Arnhem, the Rhine divides again. One branch, the Gelderse IJssel, sets off on its winding course towards the IJsselmeer. The rest continues on its way to the west, along the Nederrijn, the Lek and the Nieuwe Maas to the Hook of Holland, where it flows into the sea. From this higher ground in the east, the Netherlands gradually gets lower towards the west until, just behind the dunes, it drops below sea level.

Here in the east, the landscape is robust. The plane turns another circle above large, multicoloured parcels of land, interspersed with large clusters of dark-green trees. The village of Doornenburg slides way below us. Loes de Jong points out that here the river still has plenty of room to expand in its broad major bed. Further to the west, the bed becomes narrower and the river meadows seem to disappear.

It is difficult to imagine, on this sunny day in May, that during the winter and early spring, large parts of this area are under water. The rivers swell to three or four times their normal size as a result of rain and meltwater. The excess water is captured in the river meadows. The clay deposited by the river water has been put to good use. Here and there we see a deserted brickworks.

The rivers follow a meandering course. But some stretches are straight. The first were dug in about 1650. Later ones were created under the supervision of the *Rijkswaterstaat*, which recently celebrated its 200th anniversary. The *Rijkswaterstaat* is both admired and feared for its large-scale infrastructural works.

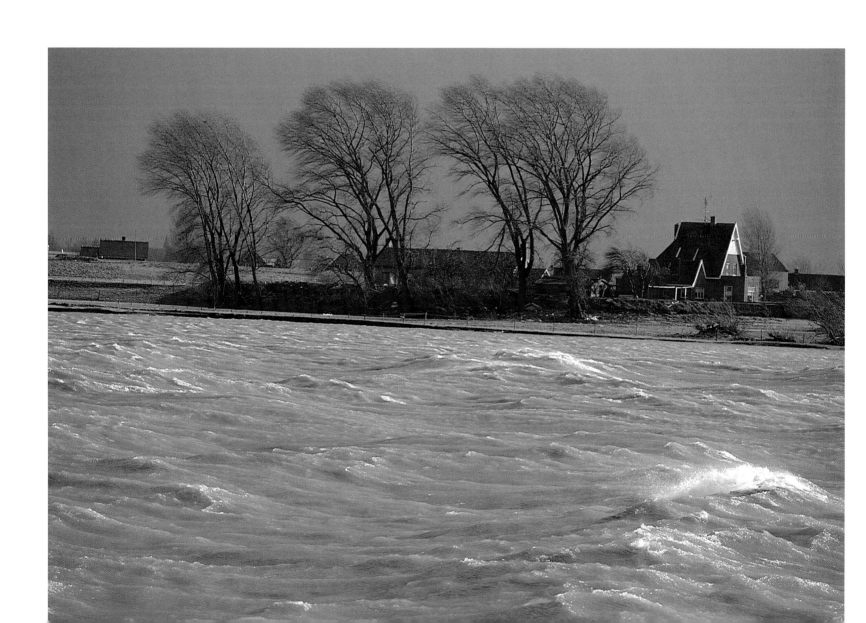

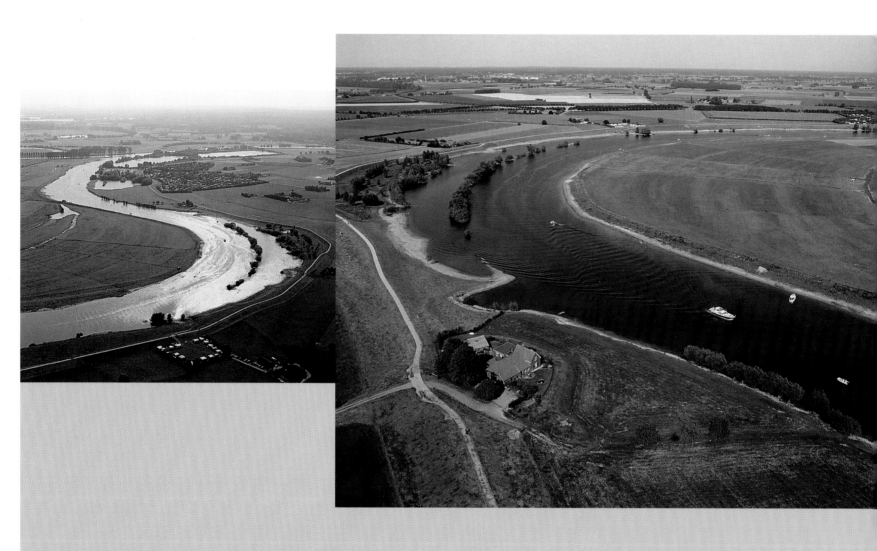

JUST BEFORE ARNHEM, THE RHINE DIVIDES AGAIN. ONE BRANCH, THE GELDERSE IJSSEL, SETS OFF ON ITS WINDING COURSE TOWARDS THE IJSSELMEER.

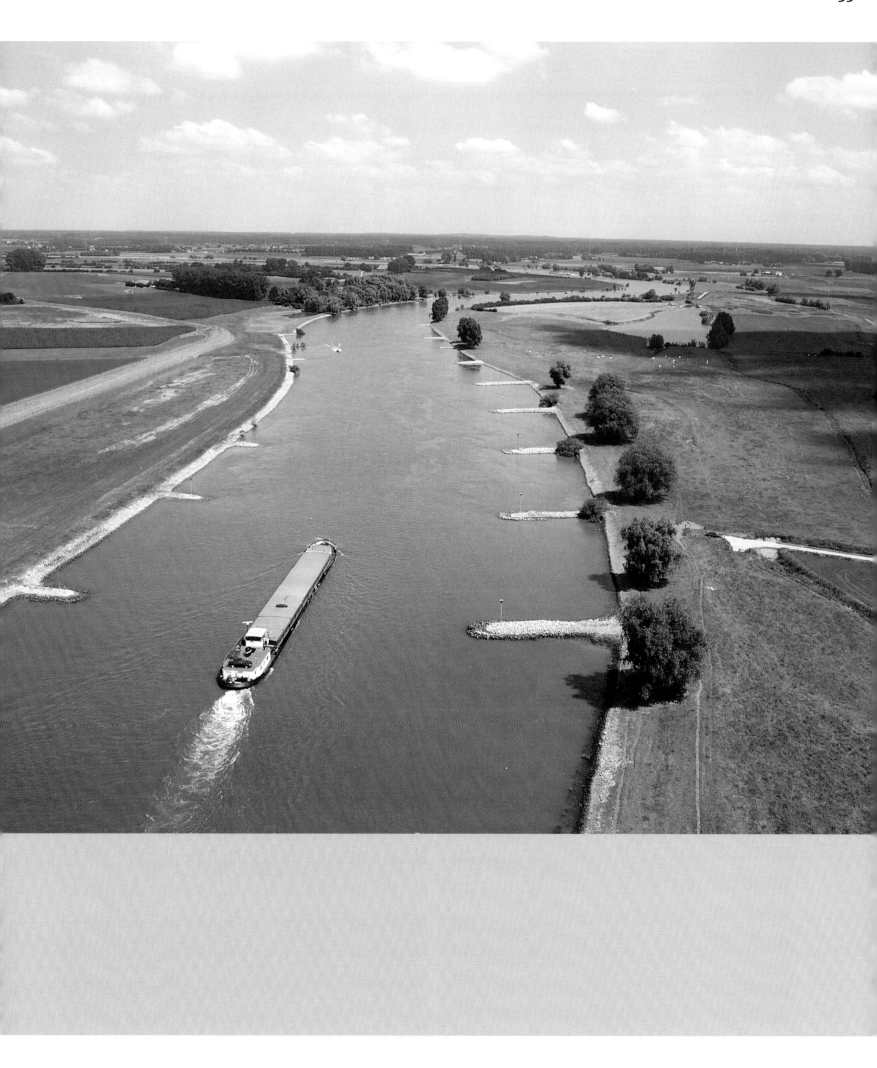

It has sometimes been described as a state within the state, technically excellent, but exceptionally arrogant. Fear of the water and its military importance gave the engineers from the *Rijkswaterstaat* power and status. For 200 years they have been tinkering around with the watercourses. The beds of many rivers that we now take for granted were in fact dug by the *Rijkswaterstaat*. Not only the Nieuwe Merwede, the Nieuwe Waterweg and the Bijlandsch Canal, but also less well-known stretches of water, like the Bergse Maas.

The plane follows the course of the river to the west. The dikes are both countless and endless. From the air they seem insignificant. And indeed, they are. The water could wash them away in a matter of hours. In places where this has happened in the past, there are deep, black pools. Some are more than 20 metres deep. The dikes have been rebuilt around them leaving them as splendid features of the countryside, as well as permanent reminders of the dike breach.
In the distance we can see the flood-control dams at Driel. Dams like these are built to capture the river water, because too little water can sometimes also be a problem. Without these dams, the Nederrijn and IJssel rivers would empty out in dry periods. They are kept closed when there is too little water coming downstream to make sure the river stays deep enough for shipping.

Not everything in this water landscape has been shaped by the hand of man. We can see small strips of water that are closed off at both ends. They are the remains of old river courses. This is a landscape that renewed itself constantly for centuries, as the river continually changed its course. This was, of course, a problem for the people who wanted to use the land. Which is why they set up water and dike authorities as

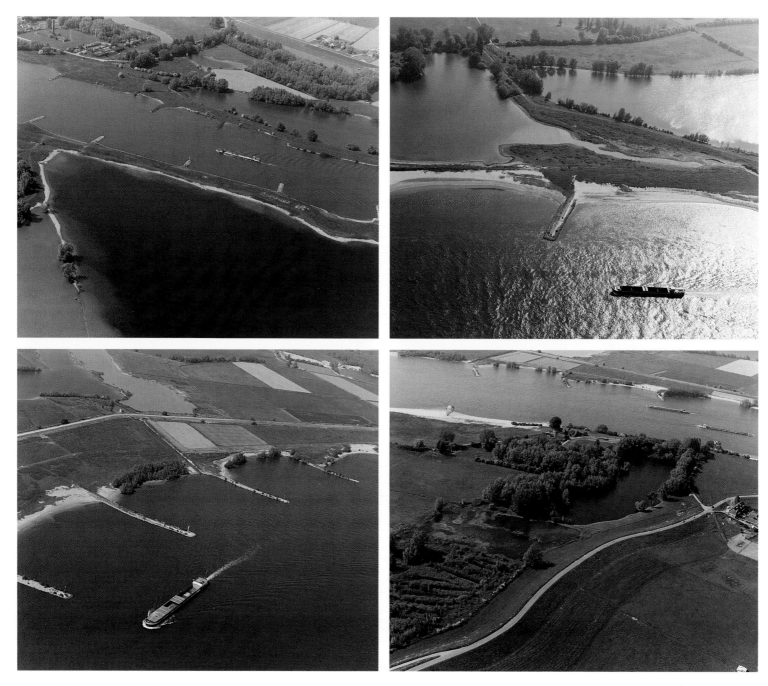

During the winter and early spring, large parts of this area are under water

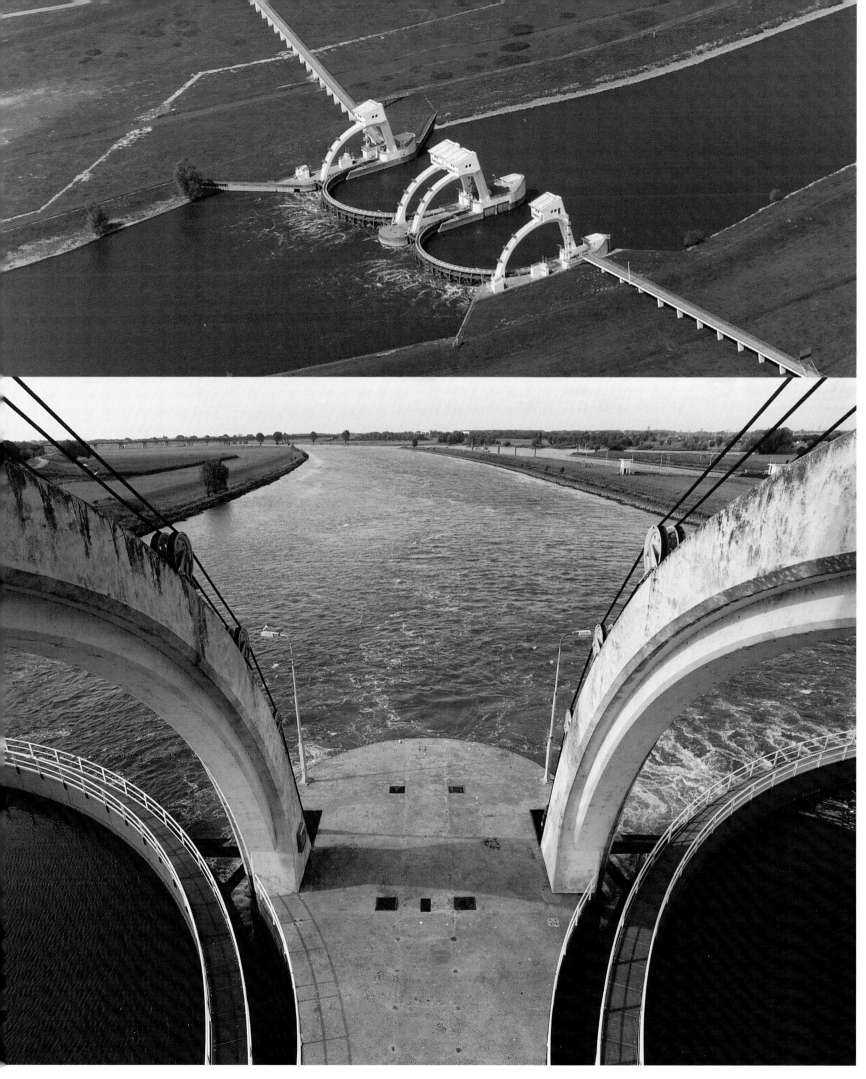

Driel barrage island [top] Hagestein lock [bottom]

early as the Middle Ages and set about imposing order on the chaos. And they still do. We fly over large expanses of sandy land, where yellow dumper trucks drive back and forth. Here the dikes are being reinforced. The plane drones on, following the Rhine for a while. The people that colonised this country 2,000 years ago called it the Betuwe.
The Batavians entered the low countries along the Rhine and settled on the banks and river dunes in the delta. The Roman historians Tacitus and Pliny described the country as it was in their time. Pliny told how the people who lived a little more to the north survived in this inhospitable land:

> 'We saw the tribe of the Chauci…There the ocean pours in a mighty flood over an immeasurable land, twice a day, so that you begin to doubt in this eternal battle between the forces of nature whether the ground belongs to the sea or the earth. Here an abject people live on high hills or on mounds they have built themselves to a level which they know from experience will stay dry at the highest tide. Here they have built their huts. When the water covers the land, they appear as mariners; when it recedes, they are more like castaways…'

This was how the people in large parts of the low countries lived with the water for many centuries. At high water, they just went and sat on the higher ground and waited for it to subside. The later inhabitants of the Netherlands, too, built their dikes to withstand the most recent high water levels. If the water ever exceeded that level, the community would once again be 'castaways', and when it receded again they would build the dikes up a little higher. For many centuries, Insula Batavorum – the Betuwe – had no dikes and the rivers had a free hand. Now this region is protected and is famed for its fruit trees, which flourish in the fertile clay deposited by the water when it could still run unfettered across the land.

We leave the Rhine and head for the Waal. Hundreds of small groynes protrude into the water like long fingers. At the end of each one, there is a swirl of beige sediment in the water. The groynes were built to keep the water moving and to prevent the sediment from settling on the river bed. This ensures that the river stays deep enough for shipping. The river water not only carries sediment and sand downstream. The Netherlands is in fact the drain of Europe, the lowest point where all the dirt and waste collects. Excess water from an enormous area in the European hinterland is discharged into hundreds of minor rivers and canals that in turn lead into the Rhine and the Maas. When a Frenchman has a shave, the water he washes down his basin passes through the Netherlands on its way to the sea. Not to mention all the other waste from previous generations that has come our way and settled in quiet corners of the river courses.

And the Dutch, too, were just as guilty. For a long time, the normal way to get rid of waste was to simply throw it over the dike. These days we are more aware of the need to protect the environment and the water has become noticeably cleaner. But much of the legacy of previous generations still lies on the river beds waiting to be cleaned up by the *Rijkswaterstaat's* 'kitchen helps'.

THE NETHERLANDS IS IN FACT THE DRAIN OF EUROPE, THE LOWEST POINT WHERE ALL THE DIRT AND WASTE COLLECTS. EXCESS WATER FROM AN ENORMOUS AREA IN THE EUROPEAN HINTERLAND IS DISCHARGED INTO HUNDREDS OF MINOR RIVERS AND CANALS THAT IN TURN LEAD INTO THE RHINE AND THE MAAS. WHEN A FRENCHMAN HAS A SHAVE, THE WATER HE WASHES DOWN HIS BASIN PASSES THROUGH THE NETHERLANDS ON ITS WAY TO THE SEA.

Hundreds of small groynes protrude into the water like long fingers

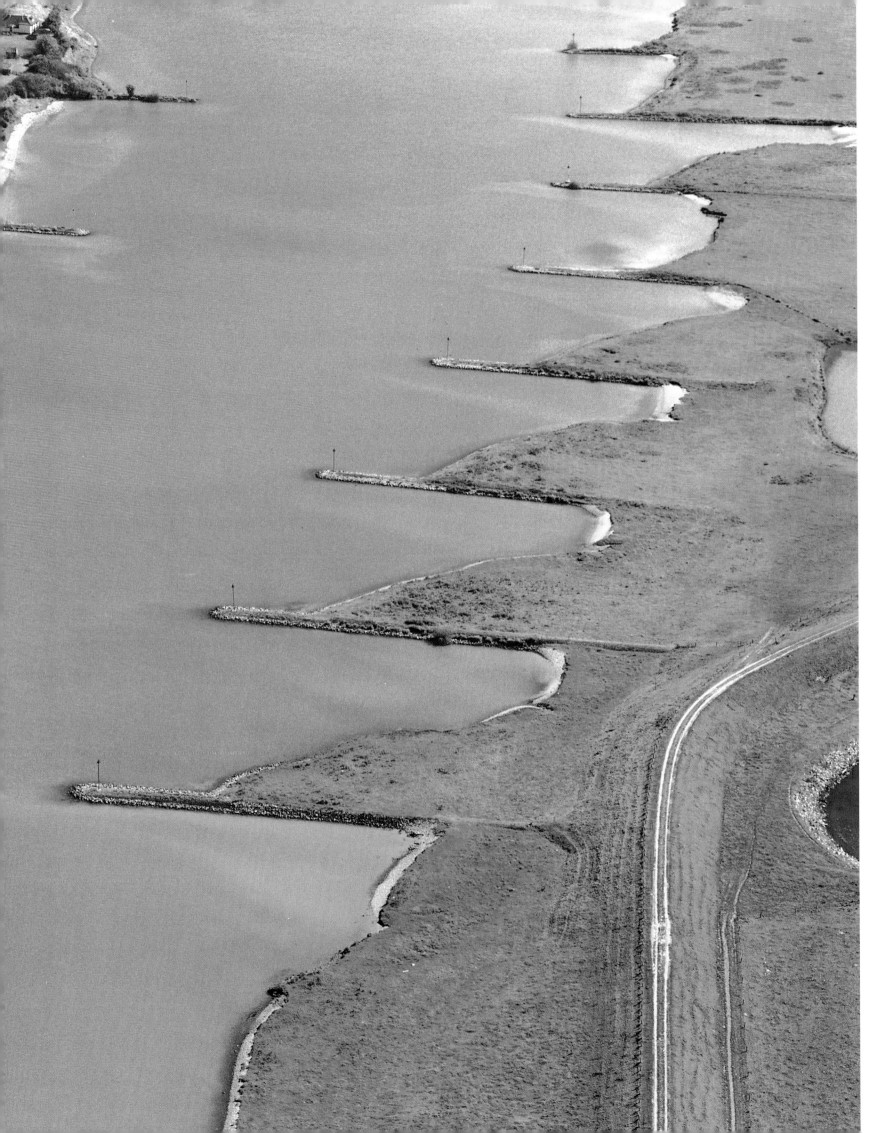

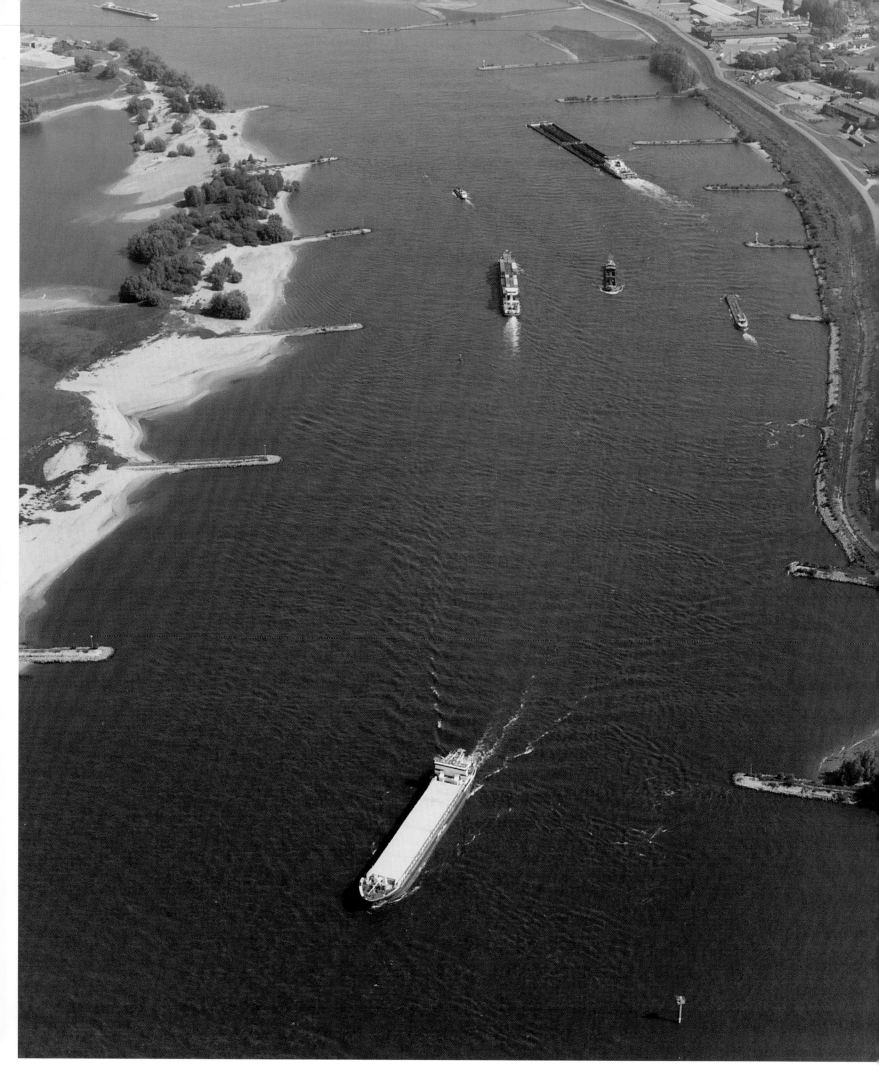

The Waal

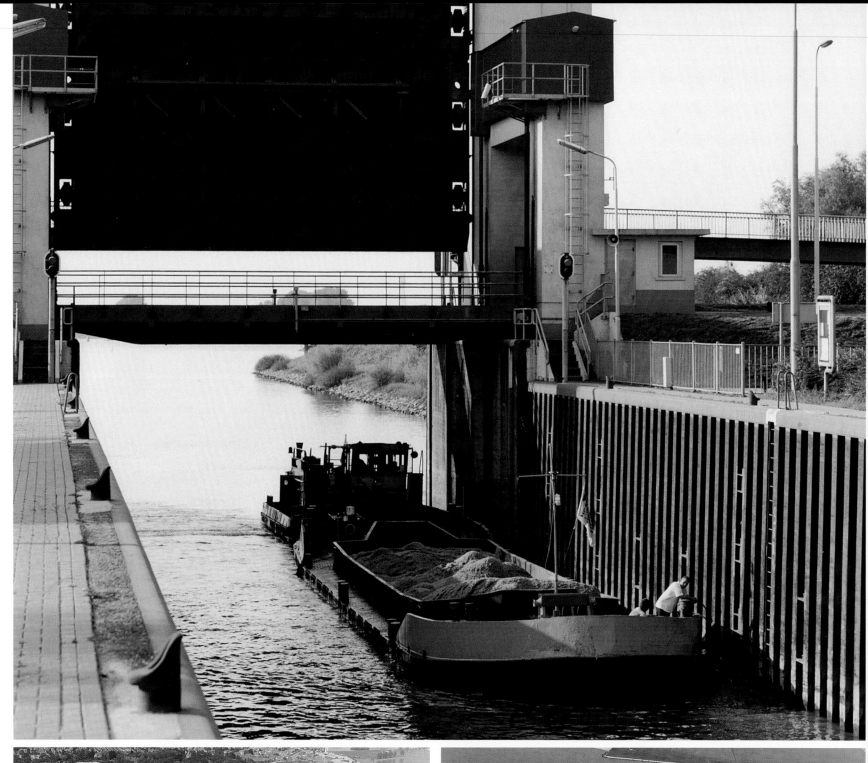

St. Andries lock [top]

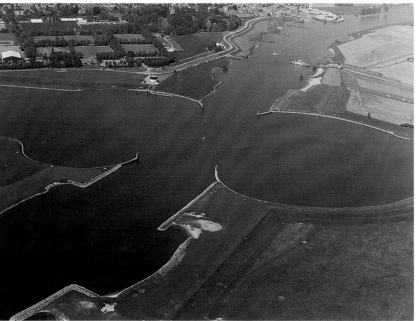

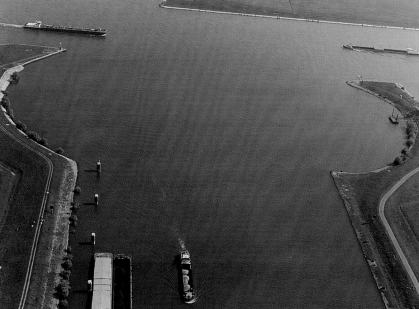

The Amsterdam-Rhine Canal [bottom left] – a crossing of waterways. Here an artificial 'river' crosses a natural one, the Lek, before coming to an end at Tiel [bottom right]

Large sluice gates at Tiel ensure that this stretch of the Amsterdam-Rhine canal is not flooded when the water in the Waal gets too high – a regular occurrence. Further to the north, the canal crosses the Lek. This intersection of a natural and a manmade waterway required an impressive feat of hydraulic engineering. After inspecting this impressive sight from the air we fly on to the Land van Maas en Waal. Here, near the village of St. Andries, the two rivers as good as touch each other. Here, too, a sluice has been built to control the water levels for shipping. 'The rivers used to overflow here,' De Jong explains. 'If there was too much water in the Waal, it could flow into the Maas. That happened quite often and could cause major problems.'

Zaltbommel. The pilot circles the truncated church towers. Here new wharves are being built as protection against the river. The contrast between water and land is clear to see. And then we come to Castle Loevestein. I can barely hear De Jong above the noise of the engine as the Cessna once again flies in circles above this castle on the water. 'The sea's influence reaches this far inland,' she says. 'From here on downstream, the country is under threat from both the rivers and the sea.' Loevestein is an impressive sight. Invincible in the winter, when it is surrounded by water, it now lies peacefully in a sea of greenery. In centuries past, it was a state prison. It was during his detention here in 1609 that jurist Hugo Grotius wrote his standard work on free access to the seas and oceans, *Mare Liberum*. This place clearly has a strong link with the water.

On the other side, near Gorinchem, is a new residential development built at the lowest spot in the polder. 'This used to be a designated flood area for the *Hollandsche Waterlinie* defence system. It was flooded in emergencies to stop enemy armies advancing any further,' says De Jong. But the water also collects here

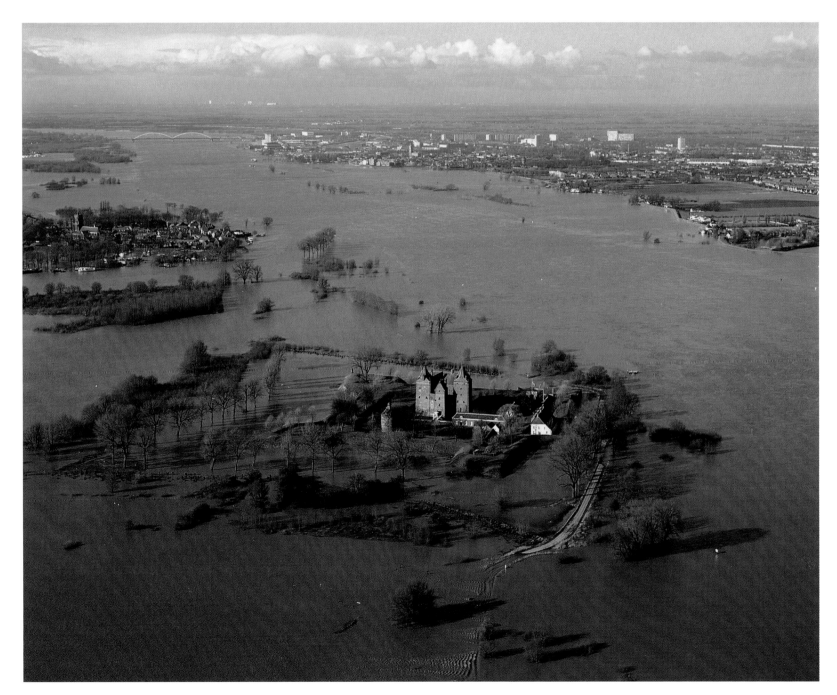

Castle Loevestein: the sea's influence can be felt here, 80 kilometres inland

when a dike breaches upstream, and spillways and sluices are designed to drain it away once the river level falls again. Suddenly, the robust landscape turns into a delicate piece of lacework formed by ditches and small dikes. The parcels of land become long and narrow, separated by innumerable little ditches dug long ago, often with wooden spades. A fragile landscape, which from the air looks like a printed circuit board. It is a green plain traversed by silver lines in a regular but unfathomable pattern. This land-scape must be exceedingly vulnerable. One fatal error and the entire system has to be rebooted.

Below us cars crawl along the dikes. For centuries, dikes have been the main thoroughfares in this country. Soldiers of many nationalities have marched along them in search of a dry field suitable for a battle. Peddlers loaded down with wares travelled the dikes to sell buttons, medicines and eau-de-cologne to farmers' wives. Farmers drove along the dike to church in their gigs.
It grows misty. In the distance, a veil descends over the Biesbosch. 'Ur-Holland', or what is left of it. Is this how our country looked when the first settlers set about making it habitable? No. Appearances are deceptive. This watery botanical garden was once populous and prosperous.
According to tradition the Biesbosch was created in 1421, on the eve of the feast of Saint Elizabeth, when the flood that eventually came to bear her name swept all before it. Large areas of South Holland disappeared under water overnight. People, animals and land drowned in the swirling mass of water. Countless villages now known only by their names lie beneath the sediment.

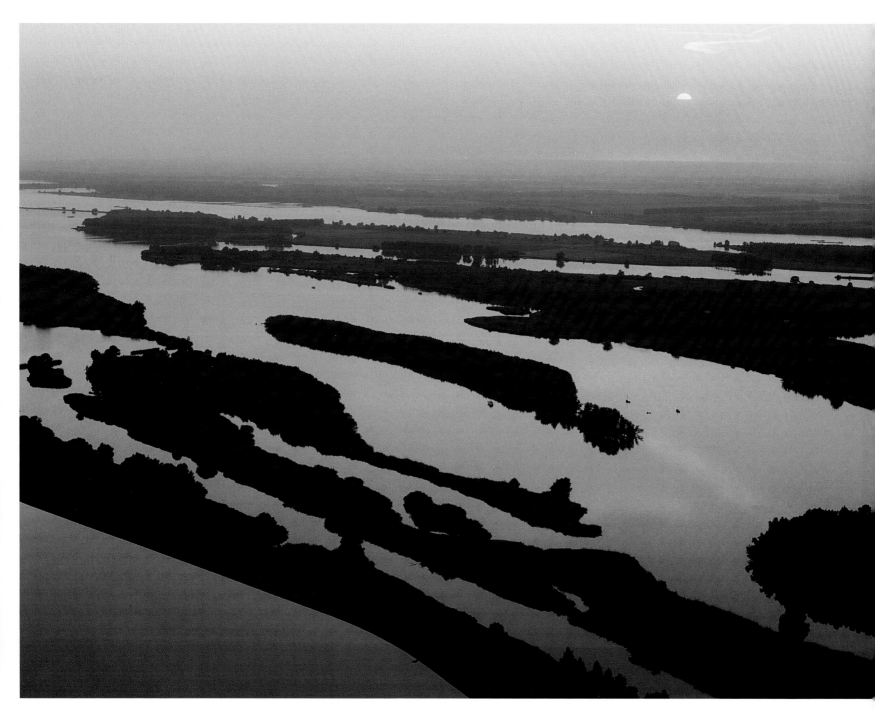

The Biesbosch: large areas of South Holland disappeared under water overnight

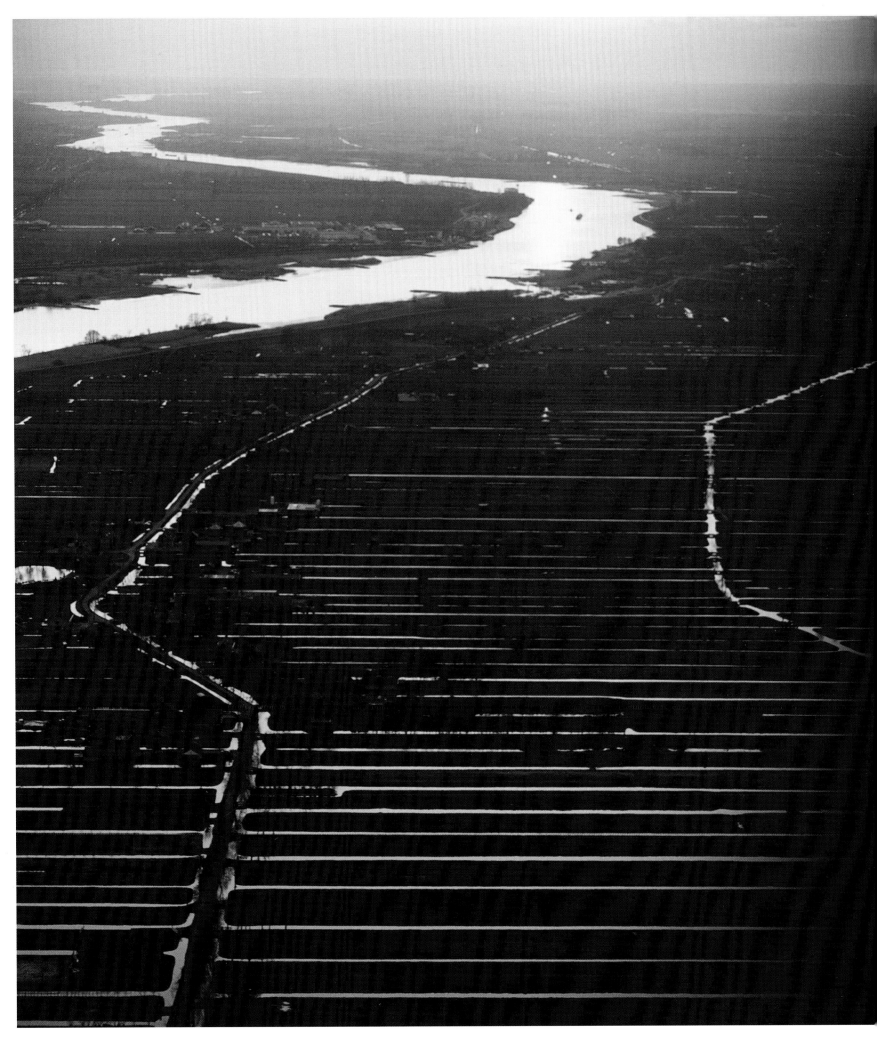

A fragile landscape, which looks like a printed circuit board

The Saint Elizabeth flood appeals to the imagination. It is still the second most famous storm surge in history, after that of 1953. In actual fact there were three storm surges in rapid succession back in the fifteenth century, each of which inundated large areas and destroyed the repairs carried out since the last. Huge tracts of land were lost forever in the Saint Elizabeth floods that occurred between 1421 and 1424. Thirty parishes drowned, along with everyone who lived there. Estimates of the number of dead vary widely. Some believe that twenty thousand perished, while others say it was no more than a few thousand. The Saint Elizabeth storm surge is as legendary as the sinking of the Titanic. There have been worse disasters, but this one is deeply engraved in our collective memory.

After we have flown over the Biesbosch our pilot heads back to Zestienhoven airport. We pass the Hollandsche IJssel river, where there are four watchtowers. This was the first part of the Delta Project to be completed, in 1958. Two giant gates should hang between the towers. They are used to protect the hinterland of the Hollandsche IJssel from the long reach of the sea and the other rivers. One gate is missing. It was badly damaged in October 1998 when a barge collided with it at night in bad weather, creating a hole. The second reserve gate was quickly lowered in to do the job of the damaged gate. A new gate now hangs there ready to protect the six million Dutch people who live behind this defence system.
We fly over the Van Brienenoord bridge. Its sister bridge is shrouded in mist. The grey veil obscures the traffic. The Nieuwe Maas river adorns Rotterdam like the tarnished silver tableware of a shipping baron – elegant but rather worn. A little later the small plane touches down on the runway and taxies to the hangar.

The Hollandsche IJssel: a new gate means that six million Dutch people can keep their feet dry

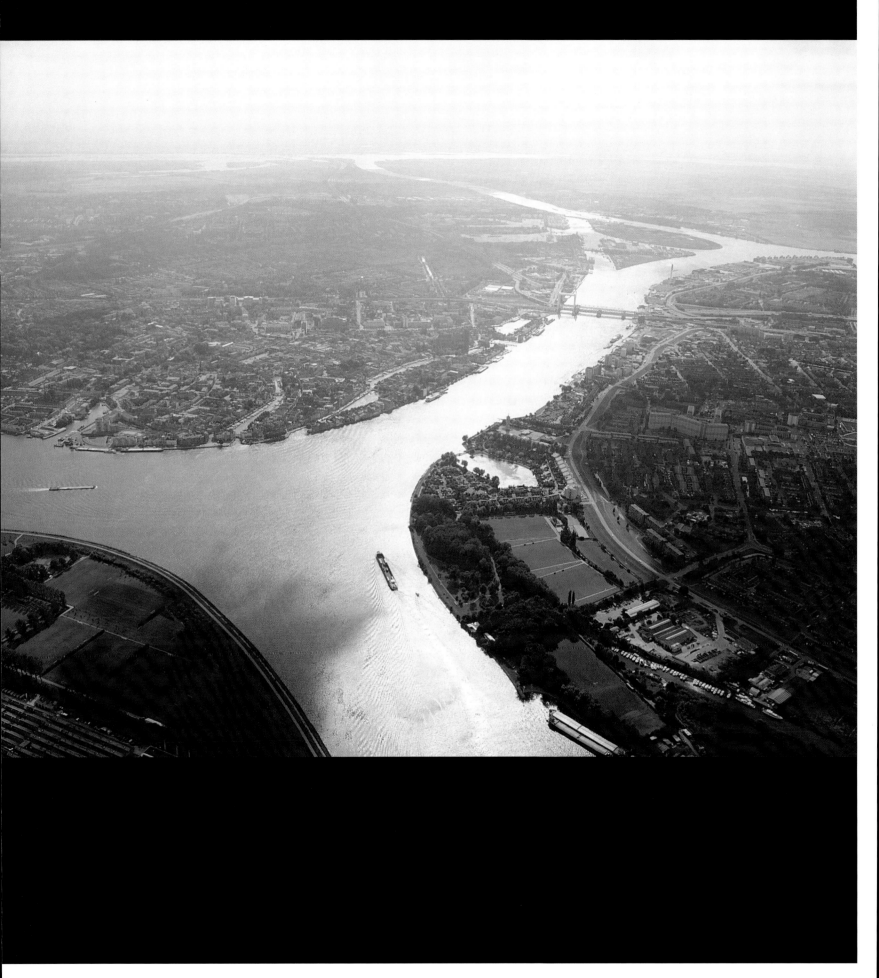

The meeting of three rivers at Dordrecht: the Beneden Merwede (left), Oude Maas (right) and Noord (bottom)

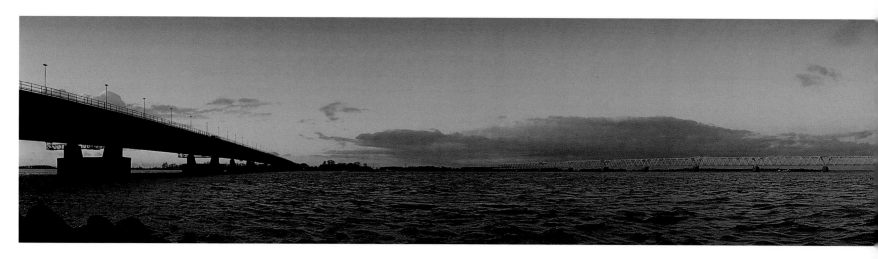

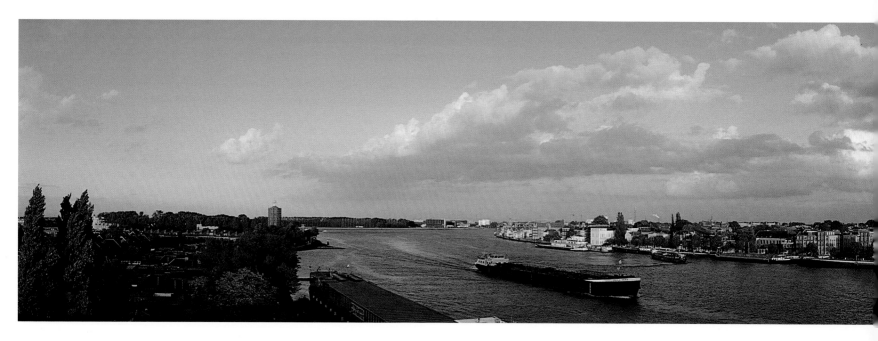

The Moerdijk bridge [top] Dordrecht [centre]

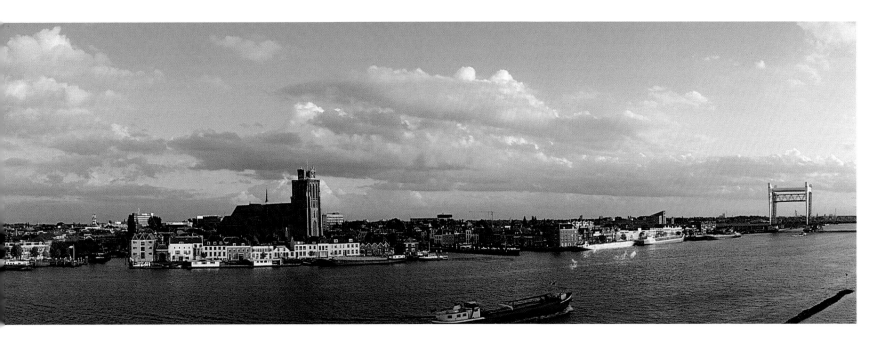

The Maas estuary at the Hook of Holland is the Gateway to Europe [bottom]

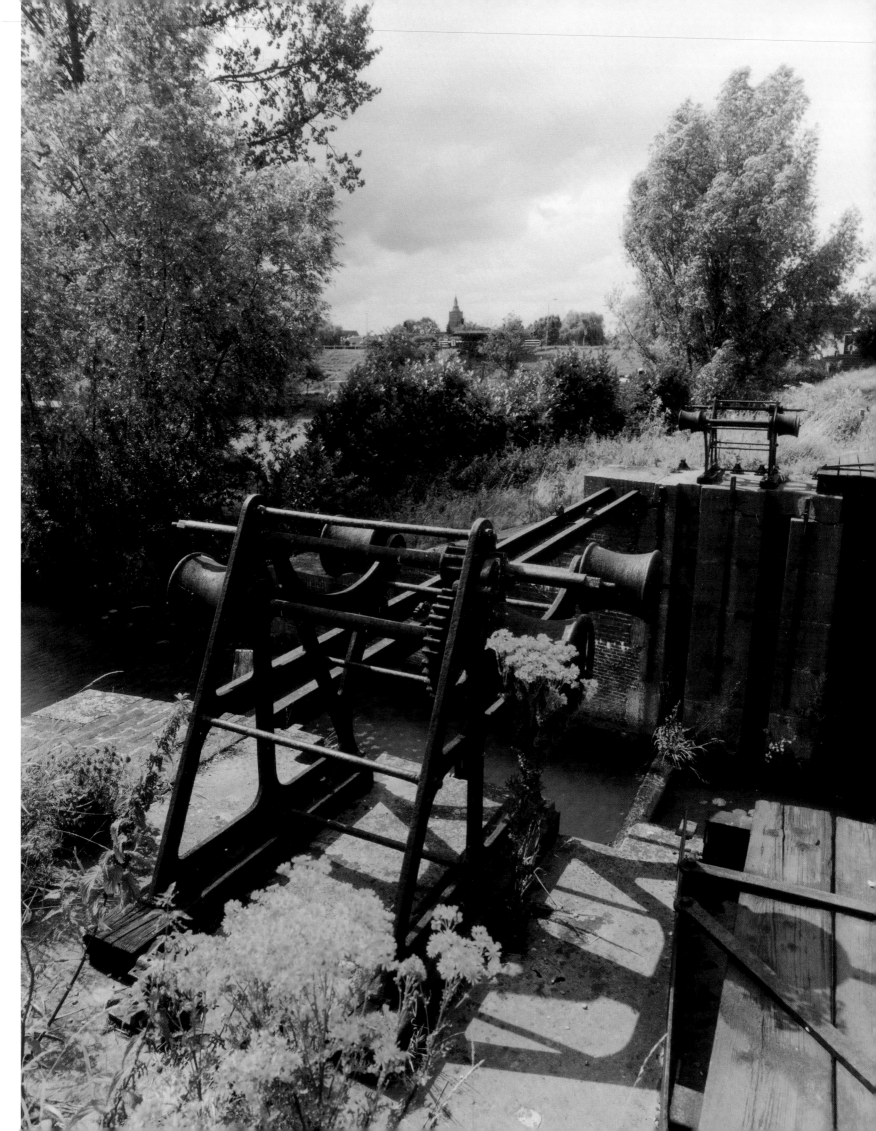

where is the WATER?

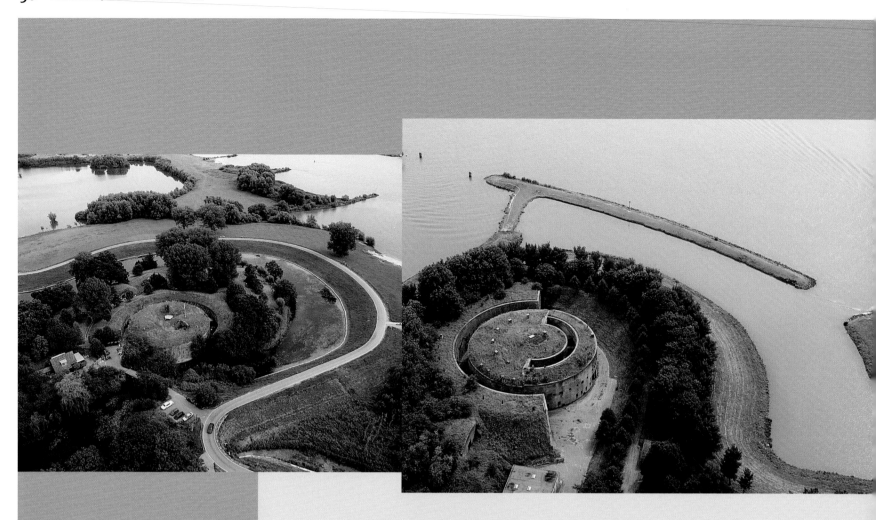

FORT VUREN AND FORT EVERDINGEN ARE PART OF THE HOLLANDSE WATERLINIE DEFENCE SYSTEM. DEFENCE AND WATER ARE CLOSELY LINKED IN THE NETHERLANDS. BOTH HAD A LASTING IMPACT ON THE FORMATION OF THE DUTCH STATE. WATER BROUGHT SECURITY BY PROVIDING NATURAL PROTECTION AGAINST ENEMY ARMIES. FOR CENTURIES, LAND COULD BE FLOODED TO STOP THEIR ADVANCE. BEHIND THE WATERLINIE DEFENCES, 'FORTRESS HOLLAND' COULD FEEL SAFE. UNTIL THE ARRIVAL OF THE AIRPLANE. THE FORTS ARE NOW BUILDINGS OF HISTORICAL INTEREST AND A PART OF OUR CULTURAL HERITAGE.

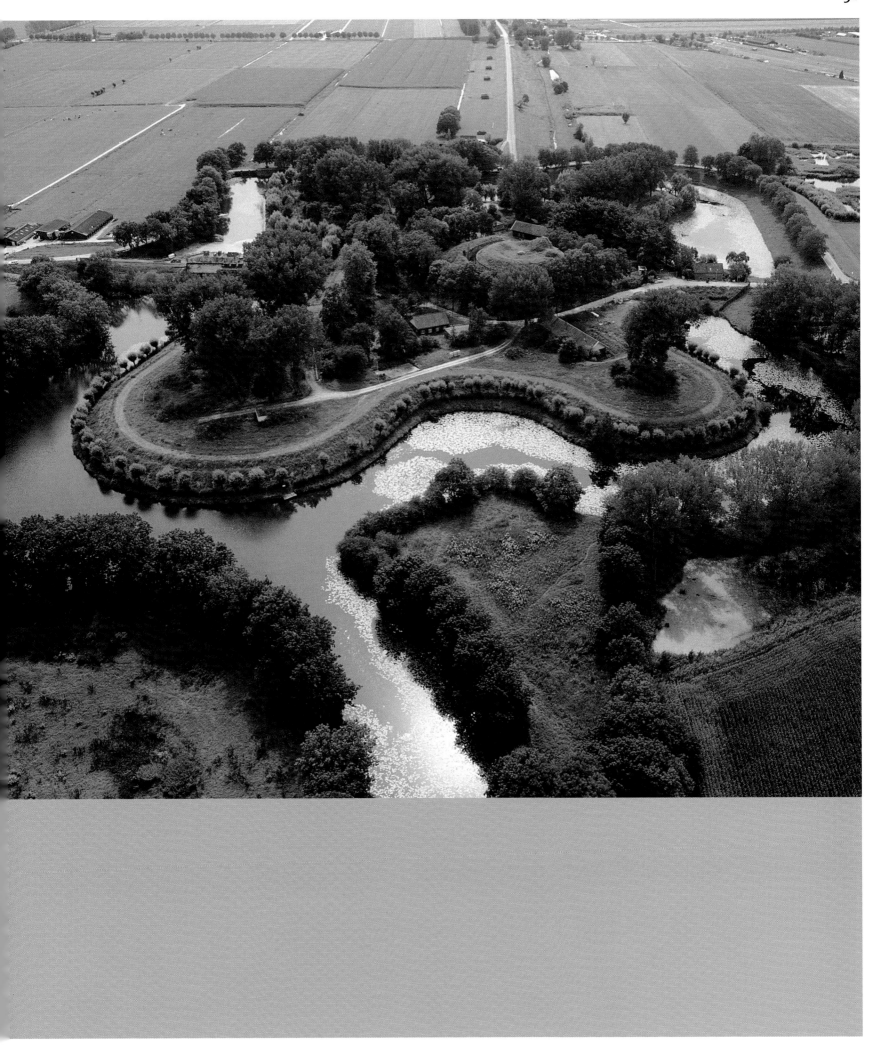

WE NOT ONLY WRESTED OUR COUNTRY ITSELF FROM THE WATER. OUR STATE ALSO EVOLVED FROM THE NEED TO MANAGE THE WATER AND THE PROBLEMS ASSOCIATED WITH THAT. THOSE PROBLEMS COULD ONLY BE TACKLED IN COOPERATION WITH OTHERS. THE MANAGERS OF THE WATER EXCHANGED LETTERS, AGREEMENTS AND OTHER LEGAL PAPERS. TOGETHER THEY DOCUMENT THE FORMATION OF OUR STATE. WHEN WATER LEVELS ROSE AND THERE WAS A RISK OF FLOODING, EVERYONE HAD TO DO THEIR BIT. ARMIES OF DIKE-BUILDERS WERE FORMED. THE BATTLE AGAINST THE WATER BECAME A MILITARY OPERATION. COUNTLESS REAL AND ADMINISTRATIVE DIKE BREACHES SCARRED THE DUTCH LANDSCAPE AND SOUL, BUT ALSO HELP DEVELOP THE STATE OF THE NETHER-LANDS.

Author Herman De Man based his novel *Het Wassende Water* ('The Rising Water') on the conflict of interest between the farmers and the authorities. De Man travelled criss-cross through the Waarden Wetlands by motorcycle, in search of inspiration for his book. I follow his route, beginning on the Diefdijk, one of the oldest and most important stretches of dike in the Netherlands, which also forms the borderline between the historic lands of Gelre and Holland. The Diefdijk is completely landlocked. There is not a river in sight. There are deep pits (known as *Wielen* or *Walen* in Dutch) created by dike breaches. But where did the water come from?

The Wiel van Bassa at Schoonrewoerd is beautiful. It lies amid the flat, peaceful countryside of the Vijfherenlanden. You wouldn't know it, but this area was taunted and chastened by the water, and at the same time it was created entirely by man. Down the centuries, people had feared that homes in the Alblasserwaard would have to be abandoned. On the farmhouses in this area, engraved stones set into the wall remind people of the floods. If there was time, the animals would be taken into the loft. If the water came too fast, they drowned.

I park my motorcycle among the willows by the edge of the water and meet writer and amateur historian Tom de Nijs. In the course of his work at the *Rijkswaterstaat* he carried out historical research and came across many examples of how the districts squabbled and bickered about how the water should be managed. De Nijs vividly describes the fights, both big and small, that occurred in the past. 'This area is very interesting from both a political and a water management point of view,' he explains. 'What happened here certainly contributed to the formation of the state in the Low Countries. People had to negotiate in order to cope with the water. Sometimes things went smoothly, but sometimes they simply couldn't agree. Once there was a fully-fledged Dutch state, central government could coordinate the response.'

But what problems did they have with managing the water? All there is to see today is a tall, steep dike. No water. Sweeping his arm across the horizon, De Nijs describes what happens when a dike breaches to

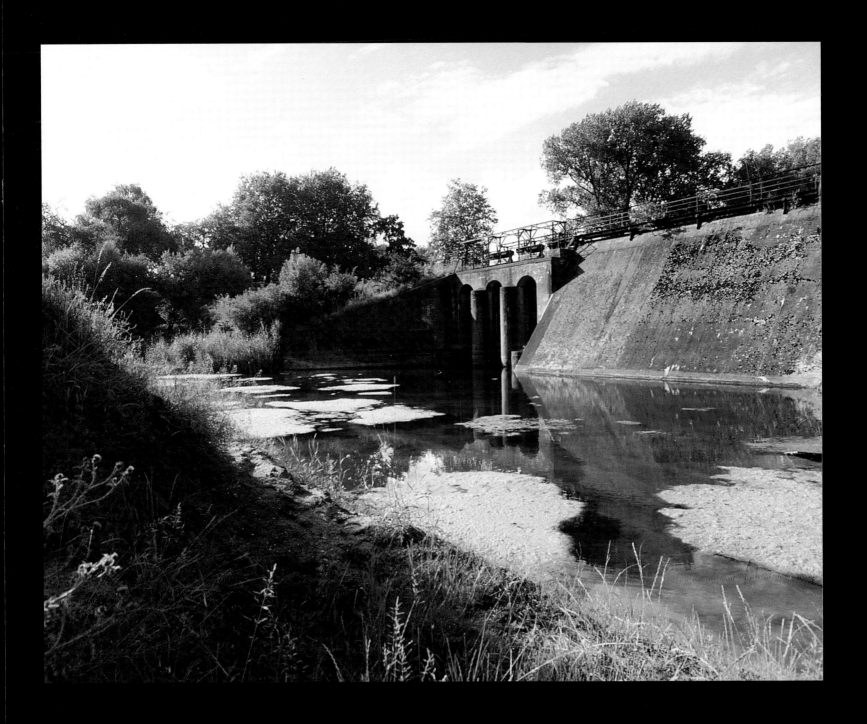

The Wiel van Bassa with the Diefdijk Flood sluice at Diefdijk

IMAGINE THE LAND BETWEEN THE PANNERDENSCHE KOP AND KINDERDIJK AS A HUGE TILTED TUB. THE
WATER RUSHES OVER THE ENTIRE WIDTH OF THE TILTED BASE TOWARDS THE BOTTOM, IN THE WEST,
INUNDATING EVERYTHING IN ITS PATH AS FAR AS KINDERDIJK.

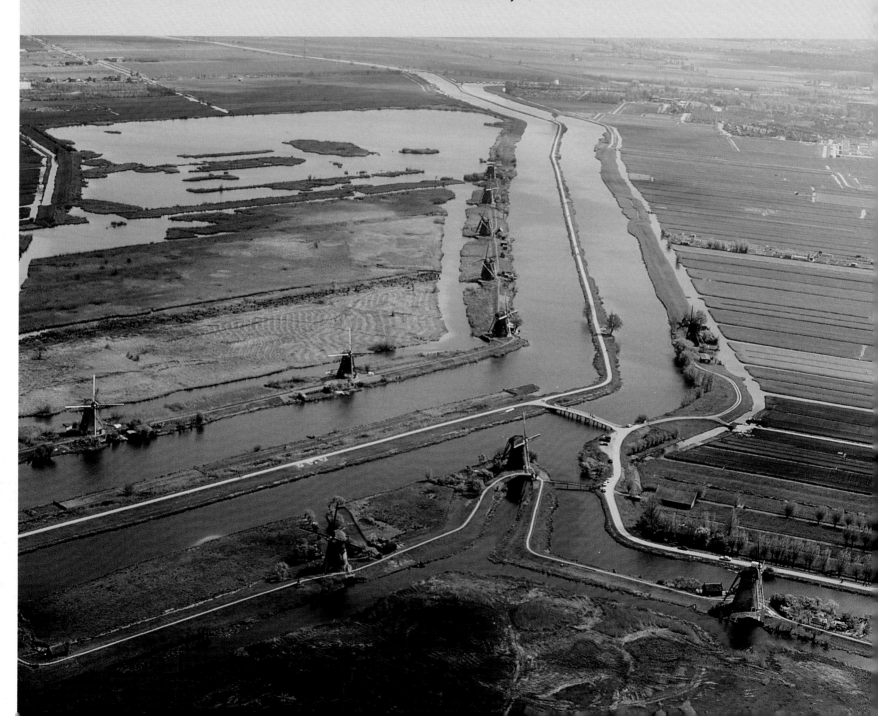

the east, in Bemmel or Huissen. 'Imagine the land between the Pannerdensche Kop and Kinderdijk as a huge tilted tub. The water rushes over the entire width of the tilted base towards the bottom, in the west, inundating everything in its path as far as Kinderdijk.'

To minimise the impact of disasters and control the water the Betuwe has been divided into compartments. Cross dikes are designed to hold the water back. The Diefdijk is a very early example of a cross dike. It has always been an important dike. For centuries it had military significance as part of the *Hollandsche Waterlinie* defence system. Constructing cross dikes like this led to a lot of tension between different districts. They were expensive to build and it was difficult to determine who should bear what proportion of the costs. After all, the more rapidly the water drained away, the better it was for the higher-lying districts in Gelderland. The cross dikes actually dammed up the flow. The water level rose higher and remained so for longer. 'People living to the east of these dikes risked drowning so they sometimes made holes in them,' says De Nijs. Furthermore, a district that built and funded a cross dike also protected lower-lying districts, so they often knocked on their doors for a contribution. Often, the lower-lying districts paid only with great reluctance. So the dike not only provided safety, it also brought discord, disputes over money and sometimes even betrayal. There was always one party who felt they had paid too much and the others had paid too little. This could escalate into serious conflict. It wasn't until the *Rijkswaterstaat* was established that there was an independent body to resolve such problems. Even today, some important links in this dike are still controlled by central government.

We take De Nijs' car and drive along part of the huge body of the dike. The Diefdijk was built in 1284. According to tradition, it was based on an agreement signed in Everdingen by five gentlemen. Hence the name *Vijfherenland* ('vijf heren' meaning 'five gentlemen' in Dutch). This was the time of the first land reclamations and the first organised dike-building projects. Since the thirteenth century the Diefdijk has been repeatedly demolished, restored, moved and raised. Many dike houses from later centuries stand against the dike. Here, representatives of the land protected by the Diefdijk and their dike-builders could take refuge when the water came too close for comfort. This happened several times a year. If the water broke through the dike there it always caused some fatalities and enormous damage. After all, until the 1950s, people in Huissen couldn't simply phone their relatives in Leerdam to warn them to bring in their cattle and put them in the loft.

'Downstream everyone hoped the cross dikes would stop the water,' says De Nijs. 'But the dikes were low, sometime only a metre and a half, so they couldn't hold back much water. And the soil is also a problem, with all the old sandy ridges interspersed by areas of peat.' Although the ridges are strong and can take a hefty dike, the water can penetrate the sand beneath. Peat is a weak base. A dike can simply sink away in it. In short, there was plenty of trouble and strife.
We pull over to the side of the road. Steel wheels rise above a concrete parapet. For the first time we espy a kind of river: cars streaming along the A2 motorway. Steel gates are suspended on cables above the asphalt like guillotines. This solid defence had to be constructed to keep the Diefdijk intact. The motorway cuts right through the dike, as any other route would have cost too much. The gates can be lowered to hold back the water when necessary. 'That means you get this great little scene every year during the annual inspection,' says De Nijs. 'The police stop the traffic, the gates are lowered and raised and a bunch of VIPs stand around smoking cigars.'

According to this amateur historian's theory, the Netherlands has had its day. 'This country's fate was sealed 800 years ago when the first dikes were built. Drainage caused the land to subside, and no new sediments settled. Also, our land is sinking relative to Scandinavia as a result of the ice ages. For centuries, heavy sheets of ice pressed Scandinavia down and raised our land. Now Scandinavia is bouncing back and we're sinking. This is causing peaty areas in the Netherlands to oxidise. The country is sinking into a deep pit. And the rivers are getting higher and higher. We might be able to control them, but the sea is also rising. It has risen two metres since the beginning of recorded time, half of that since we started building dikes. Over the next few centuries it will rise another metre. And all the while the land is sinking. I don't think we'll be living here as we do today in two centuries' time.'
The land has formed, the state is in place, the rivers have been tamed with dikes. As Tom de Nijs says, we have worked on this country for centuries 'with everything we could find. Soil, excrement, dead bodies, bunches of twigs'. We see it as a heroic battle in which we were eventually victorious. But with all our twenty-first century technology, we are still unable to calculate how strong a dike is. So we don't know how safe we are behind it. Computer calculations suggested several dikes should have given way in 1995, but

they didn't. And dikes have also been known to slide away for no apparent reason. But it is impossible to predict when something like that is about to happen. Dikes remain a constant cause for concern.

I say goodbye to Tom de Nijs and continue my journey by motorcycle. The Harley has tilted to one side under the willows. I climb on, start up and take a fantastic ride over the Diefdijk and the Lekdijk, crossing to the northern Lekdijk by ferry. The dike is being reinforced near Schoonhoven. Step by step the dike slope is being dug away, and dark stripy shadows trace the contours of the landscape. Heavy machinery has torn up the road surface, and the holes have been filled with rough gravel. It is Sunday and the machines are resting, sleeping in the sun.

The old army bike occasionally skids on the gravel. I have to be careful. The old-fashioned Dunlop tyres stir up a huge cloud of dust. The exhaust occasionally explodes and belches flames. At the bottom of the dike a group of horses are startled into action as we approach. A little further along an old man waves in greeting as I pass.

The second half of the nineteenth century saw major improvements to the rivers in the Netherlands. The huge numbers of flood victims and the major economic damage caused by flooding gave rise to plans designed to rid the central Netherlands of this scourge forever. The land was not only inundated in the seventeenth and eighteenth centuries. The rivers area was also hit by major flooding in 1809, 1820, 1855 and 1860.

The Netherlands took on a great deal in this period. There was no money available to restrain the rivers, so initially the plans got no further than carrying out a number of studies. This was the first time the rivers had been surveyed in detail. Illegal constructions and other obstacles in the channel bed were located and removed. Numerous committees studied how the rivers could be improved.

The miserable state of the channel beds was pinpointed as the root of all the problems. The rivers had silted up in places. Islands had formed or the dikes had converged too much, making the river courses too narrow. The researchers also concluded that there were not enough estuaries. The water did not have enough opportunity to flow into the sea, with the result that it accumulated in one place and flowed away uncontrollably in another. This caused rivers like the Merwede to silt up, as the sediment was able to settle. Irregular features along the riverbanks, such as the creeks and channels in the Biesbosch, also posed a danger. Rough and irregular banks are the ideal place for the formation of ice dams – the river dweller's biggest nightmare. The ice gets caught up and the floes slide over one another, sometimes totally blocking the river. The blockage causes the water to flow over or through the dikes and into the polders.

After a great deal of thought, new channels were dug for the river, and old river courses were dammed up. The Nieuwe Merwede river was channelled across the Biesbosch, using old creeks. A new river, made by human hand, would drain the water from the Waal and Maas into the sea. This improved safety in the river basin, but the situation was not perfect. The Boven Merwede took in water from both the Maas and the Waal. The river was high as a result of sedimentation. It was also wide and did not cause enough erosion, so it was not deep enough for shipping. Something more had to be done. By that time technology had advanced sufficiently to allow steam dredging machines to be used to dredge away sandbars. In the late nineteenth century many kilometres of river were 'normalised' in this way. Bends were straightened and some sections were artificially narrowed with groynes in the channel bed. The water could flow faster and the river silted up less quickly. After this success hydraulic engineers turned their attention to separating the Maas and Waal in order to be able to manage these two major bodies of water better. The dikes dividing the two rivers at Heerwaarden and St. Andries were reinforced and in 1904 the Maas was given its own estuary at the Hollands Diep. The Bergse Maas was dug and the Maas was dammed off between Heusden and Loevestein. At the turn of the twentieth century the worst of the danger had subsided.

But that did not stop the polders flooding on several occasions over the past hundred years. The people living behind the dikes regularly watched with fear as the water crept up to the top of the dike. Great was their joy if the dike gave way on the other side, allowing the water to drop several feet on their side. This meant they were safe for the time being. As for their neighbours on the other side: bad luck. Or perhaps it was the will of God …

The Koekoek dike house is now a boring modern pumping station. In the early twentieth century it was decided that, in the event of flooding, the Alblasserwaard should be saved at the expense of the Krimpener-waard and the Lopikerwaard. At least, that's how it goes in Herman de Man's book *Het Wassende Water*. He based his work on the blackest version of events. First there were ice dams in the Lek river that proved

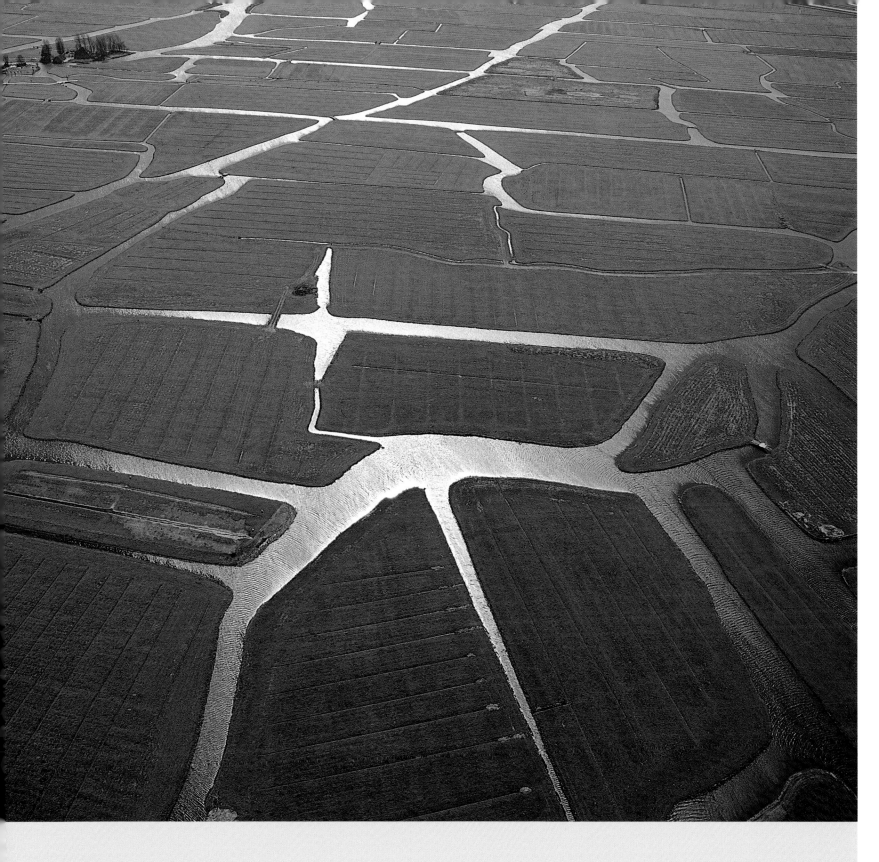

SUDDENLY, THE ROBUST LANDSCAPE TURNS INTO A DELICATE PIECE OF LACEWORK FORMED BY DITCHES AND SMALL DIKES. THE PARCELS OF LAND BECOME LONG AND NARROW, SEPARATED BY INNUMERABLE LITTLE DITCHES DUG LONG AGO, OFTEN WITH WOODEN SPADES. A FRAGILE LANDSCAPE, WHICH FROM THE AIR LOOKS LIKE A PRINTED CIRCUIT BOARD. IT IS A GREEN PLAIN TRAVERSED BY SILVER LINES IN AN UNFATHOMABLE PATTERN. THIS LANDSCAPE MUST BE EXCEEDINGLY VULNERABLE. ONE FATAL ERROR AND THE ENTIRE SYSTEM HAS TO BE REBOOTED.

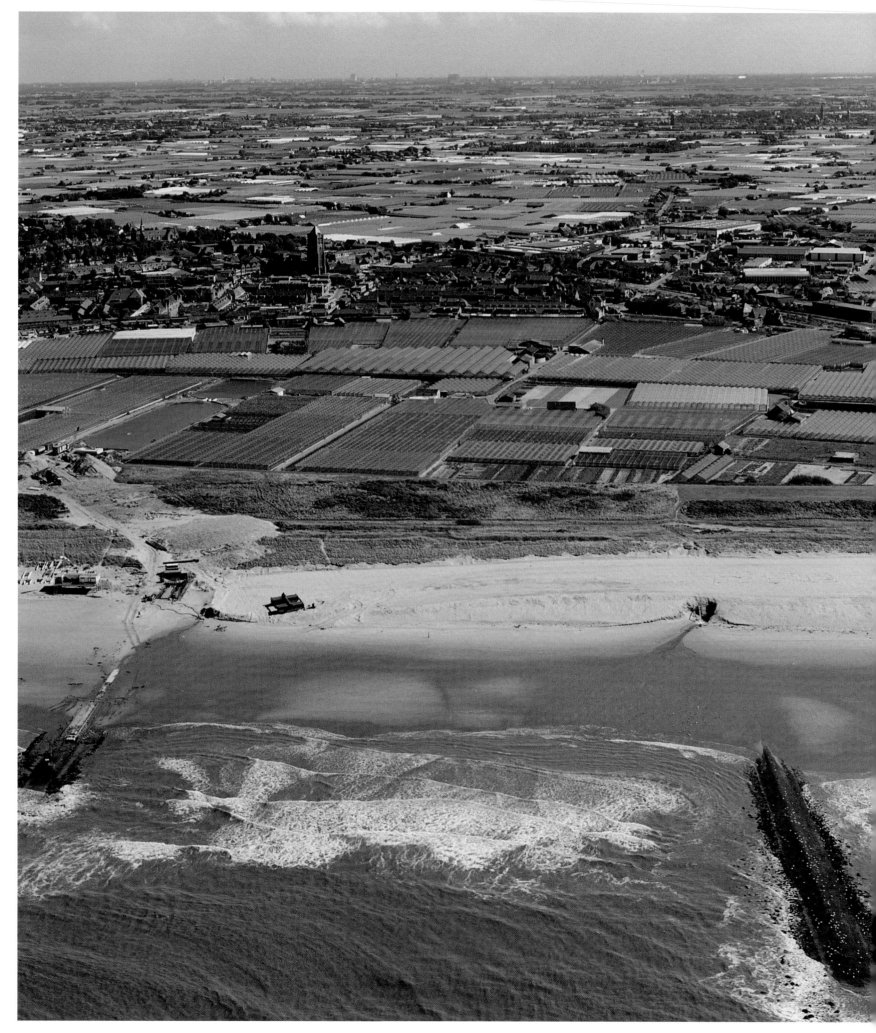

North Sea coast

impossible to remove even with explosives. After several hours the ice floes had mounted up to form a jagged mountain. Fallen trees knocked against the dam. The water backed up, and in Nieuwpoort it flowed over the dikes. The dam breached, and the danger subsided.

But then, as the thaw set in, melted snow and ice and rainwater came in from Germany. White paddle steamers sailed down the river displaying huge boards with the water level upriver chalked on them. The news worried the people on the dike.

The wind blew up. An onshore wind forced even more water into the rivers. A week after the ice dam near Nieuwpoort had broken, the water was once again worryingly high on the other side of the dike. It had been many decades since this had happened and people were afraid for their country. The government ordered that Rotterdam must be saved from flooding at all cost. But at the same time Captain Portheine of the Engineering Corps, and a top public servant at the *Rijkswaterstaat*, would not allow the Alblasserwaard to be flooded. It would be impossible to drain the water to the Waal or Merwede from there, as they were already full. What is more, there were rail lines running through the Alblasserwaard and Portheine was afraid that the military defences on the Diefdijk line would be damaged.

Gieljan Beijen, *dijkgraaf* (dike warden) and farmer, was concerned. The people were afraid. Some land would have to be inundated so the water could be drained into the Hollandsche IJssel, which was not yet full, and to the sea. Beijen decided to breach the dike near Jaarsveld and allow God's water to flow away over the polders ...

> *Damn! They couldn't believe it. This had surely never happened before? And wasn't he a farmer himself, this man who announced it so coolly? And what did a farmer know about that great body of water? Must they lose everything they owned just because a farmer had misunderstood a book? But the engineers supported the dijkgraaf. They explained that this was a grave emergency and that the dijkgraaf had not taken the decision himself, that the Government in The Hague had taken it on the advice of the Provincial Authorities. 'But,' asked a rugged, broad-shouldered farmer from Eiteren, 'did our dijkgraaf advise them to do this?'*
>
> *'My advice was given in confidence,' answered Beijens, 'but I'll be happy to tell you. Men, I am convinced of the need for this! There is no other way!'*
>
> *'We've heard enough,' answered the farmers' spokesman coldly. They went outside and disappeared into the crowd. They could not immediately relay their message amid the pushing and shouting. But they eventually reached the village square below the dike and announced the grim news.*

The Harley is silent. The village square in Jaarsveld is perfectly still. The sound of a speedboat rises from the river. Eighty years ago it was just as still, dreadfully still. Herman de Man leaves his farmers with the thought that the water is to be let in by human hand. Suddenly, incomprehension turns to anger. The people call for the *dijkgraaf. He was a farmer, and should come when the farmers called for him.* They wanted to send their own telegrams to The Hague, to the Queen even. They had been betrayed!

Jaarsveld is still steeped in the same atmosphere evoked in the 1920s novel. But it is difficult to imagine a furious, murderous crowd here. The wind rustles in the chestnut trees along a narrow avenue that links the village with the hinterland of the Lopikerwaard. Farms huddle against the dike. The church is on higher ground. On the village square where De Man had his farmers gather stands an abandoned truck. Not a soul can be seen in the houses. Here *dijkgraaf* Beijen was mobbed by an angry, desperate crowd. The fact that he showed no fear saved his life. He convinced the farmers of the need to flood the land. The water would come anyway. So it was better to let it in in a controlled way through the culverts and sluices than to wait for a dike breach that could happen at any time.

> *'And breaching the dike on the other side would be a crime! Why? Because an area twice the size would be inundated and there would be no chance of turning it back. Because they would not be able to get rid of the water anywhere near as well out of the Alblas and the Herenlanden, and because the rail lines out of the country would be put out of action. Understand?'*

Eventually the farmers meekly allowed God's water to flow over God's land.

The noise of the Harley tears into the silence. I turn into the avenue to follow the route of the water out of Jaarsveld, into the polders, along the banks. In the book this was where the roofs of the farmhouses could just be seen above the water. A cruel grey sea, as far the eye could see. Everything dead, rotten. I drive to Oudewater, where soldiers drove the people out. They had to wait for orders, were not allowed simply to flee to avoid queues of carriages. Hornblowers passed the signal from one farm to the next. The people left, an exodus. And Holland? Holland is a pathetic empty bowl, the defenceless prey of the water when the mighty dikes fail.

‾7 metres

WHEN THE MIGHTY DIKES FAIL THE WATER FLOWS TO THE LOWEST SPOT IN THE NETHER LANDS, NEAR NIEUWERKERK AAN DEN IJSSEL, NOT FAR FROM THE A20 MOTORWAY. EVEN AT THIS MOMENTOUS SPOT, THE DUTCH DISPLAY THE CHARACTERISTIC THAT BEST TYPIFIES THEM: COMMERCIAL ENTERPRISE. AT THE LOWEST SPOT IN THE COUNTRY THERE IS A CAR DEALERSHIP. AND NOT JUST ANY ONLY OLD DEALERSHIP. THIS SHOWROOM IS FULL OF THE MOST EXPENSIVE FERRARIS, LAMBORGHINIS AND ROLLS ROYCES. THEY BEAR WITNESS TO THE FACT THAT THE WATER HAS BROUGHT US MORE MONEY THAN MISERY. THE RIVERS CONNECTED US TO THE HINTERLAND, CARRIED US TO THE SEA AND THENCE ALL OVER THE WORLD. THERE WE AMASSED OUR UNIMAGINABLE WEALTH. THANKS TO THAT WEALTH PEOPLE CAN BUY EXPENSIVE CARS AT THE LOWEST POINT IN THE NETHERLANDS. BUT IF THE DIKE BREAKS, THAT WEALTH WILL BE WIPED AWAY IN ONE FELL SWOOP. THE SHOWROOM WILL BE UNDER SEVEN METRES OF WATER.

Historian Han van der Horst accompanies me on my visit to the lowest point in the country. He has written several books about the Netherlands and its people. Many pages were devoted to what he calls the 'fiction of equality'.

The showroom full of shiny new metal provides more evidence in support of his theory. 'Anyone who drives a Ferrari in the Netherlands is likely to provoke aggressive responses,' he explains. 'A Ferrari driver breaks the consensus that we are all equal. Just look at the showroom itself. It's a very democratic building, very ordinary. And look: among the expensive cars there are Volkswagens. You can also buy ordinary cars here. So that the stinking rich can say that they actually came to buy a VW Beetle but ended up with a Bentley!' The fiction of equality.

The prize specimens are not set apart. They stand among the ordinary offerings. You would never find this in Italy or France, says Van der Horst. They would put the expensive cars on a pedestal. And they would also mark the spot, the lowest point in the country, differently. 'The French government would build a Lowest Point Museum there and hold an annual procession. Ceremonies where dike wardens are awarded honours. Things like that aren't likely to happen here.'

Outside is the Monument of the Lowest Point, just in front of the crash barrier alongside the busy road. The Dutch speed past in their small cars. Is it because of the water, this hankering after equality? Van der Horst thinks not. 'I think it has more to do with the early decline of aristocratic power in this country. Early urbanisation meant the arrival of a non-aristocratic wealthy commercial class. They had to do deals, they couldn't present themselves as too superior. Otherwise the majority of people would turn against them, and that would ruin their plans.'

Van der Horst says the Dutch have other characteristics that are closely related to the water. He mentions our deep-seated belief that we can shape our society as one example. 'I think this conviction came from water management. You don't take land here, you make it. You build dikes, dig watercourses and ditches. You have to construct all kinds of things to acquire and keep land. This idea that we can shape the things around us persists to this day. We make our own wealth. As Nobel prize-winning economist Jan Tinbergen put it: "Economics is engineering". He was right. We even make nature in this country!'

This has turned the Dutch into a nation of arrangers and regulators. But we never go too far, because then – and we firmly believe this – the water will turn against us. 'We Dutch see it like this,' says Van der Horst. 'You can come to some kind of symbiosis, but you can never win. You can even explain our attitude to drugs like this. You can't win the battle against them, so you give them a place in society. To foreigners this is an unfathomable mix of tight regulation and total anarchy.'

Van der Horst says the Dutch are masters of calculation. As he sees it, contrary to what we would have people believe, our environment is in fact quite kindly disposed to us. Our rivers are mere ditches compared to rivers in some other countries. We know how much water to expect and how quickly it will rise. We can even keep pace with the subsiding land, which is happening at only a few centimetres per century.

'We have had two thousand years to develop the technology to preserve our way of life here. Bangladesh has something like twenty raging Eastern Scheldts together. The Ganges and Brahmaputra flow through regions where metres and metres of water fall every monsoon season. The sixteen thousand cubic metres that flow into the Netherlands at Lobith are nothing compared to that.'

In the double-glazed showroom it is quiet and warm, while outside the weather does not seem to know what to do, sunny one moment and raining the next. The leaves of the poplar trees twist in the wind, then

rain falls from clouds scudding across the sky. 'That reminds me of something else to do with water,' Van der Horst says philosophically. He suggests that the constant threat of the water might be the reason behind our strong tendency towards moderation. 'This climate is certainly no bed of roses. It doesn't encourage the worship of some fertility goddess with rituals that would be more likely to make me believe than continually doing penance. Here, you put your country and your life in order. You make sacrifices and reject all worldly things in order to please God. Otherwise you might lose everything. Unimaginable excesses like driving around in a Ferrari with a beautiful woman at your side don't fit into this way of life. We do things in moderation. Everything, otherwise the water will turn against us.'

Everywhere in the world that you come across fundamentalism and a belief in a 'punishing God', people are constantly under threat from something in their environment. In the Middle East the threat comes from the desert, in the Netherlands from the water. 'Our Bible Belt runs basically from Zeeland across the forelands of South Holland to the Betuwe and on to the Veluwe. Inhospitable areas. Behind the dikes live traumatised communities who see floods as God's punishment. People who live in old fishing villages are often strictly religious. When the polder is slowly filling with water, or you're in a small wooden boat on Dogger Bank, your eyes turn to heaven. You realise that God has the power to punish you. In towns in Flanders and Holland ascetic ideas like this have never taken root, but they fell in fertile ground in Moerkapelle, Urk and Alblasserdam. The windmills at Kinderdijk are beautiful. But you also have to remember that they only just managed to save the Alblasserwaard from drowning.'

The sun breaks through. We immediately abandon all asceticism and ask if we can start up a Ferrari. It is not actually the monument outside that is the Deepest Point. The Real Deepest Point is in fact beneath the most democratic showroom in our country: the cellar where the Ferraris are kept. No mausoleum for venerated dike wardens this. No, this is the stall that houses the Sacred Cow. Van der Horst lightly touches a metallic blue racing car. When the engine sparks up it's like fifty vacuum cleaners starting together. Great forces are unleashed. The car moves towards the light, up the ramp, through a narrow opening and out into the sun. Like in a painting by Hieronymus Bosch the Deepest Point of the Netherlands spews forth a growling beast amongst a herd of brown and white cows.

After we hand the keys back Han van der Horst modestly takes the bus back to Schiedam. I mount my motorcycle to continue my journey along the dikes, braving the blustery weather. There are holes in the asphalt here and there. The 'makable' land stretches out from the foot of the dike. Ditches and watercourses crossed by hiking paths and nature invented by man.

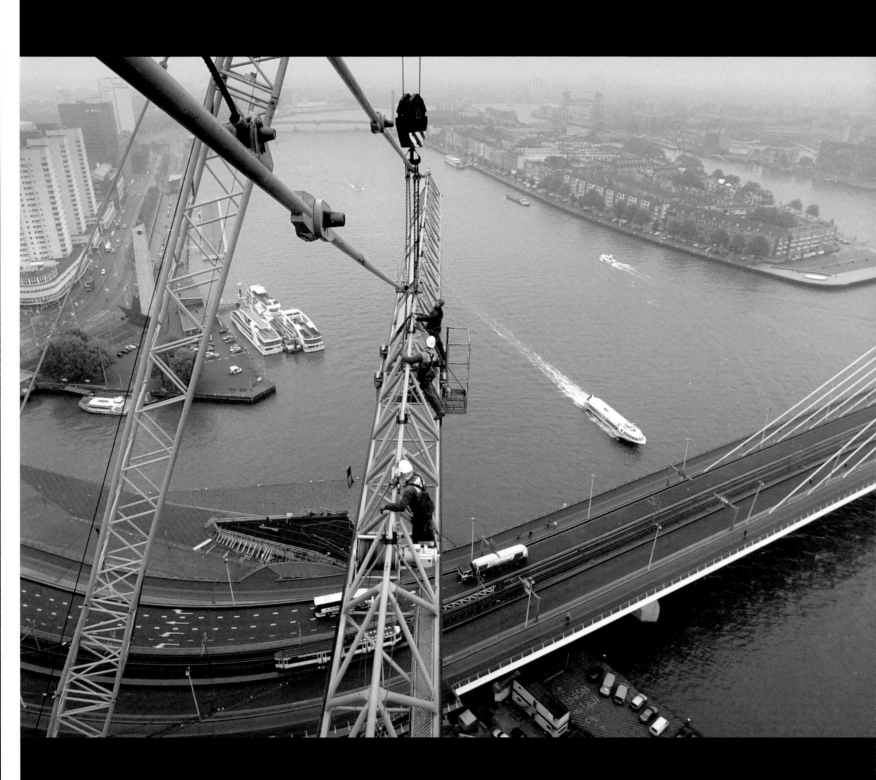

WE HAVE A DEEP-SEATED FEELING THAT WE

CAN SHAPE OUR SOCIETY. AND THAT FEELING

IS JUST AS STRONG TODAY. WE MAKE OUR

OWN PROSPERITY.

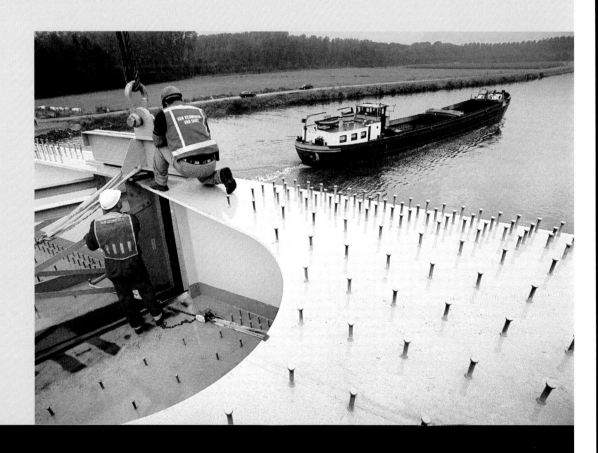

Economics in engineering

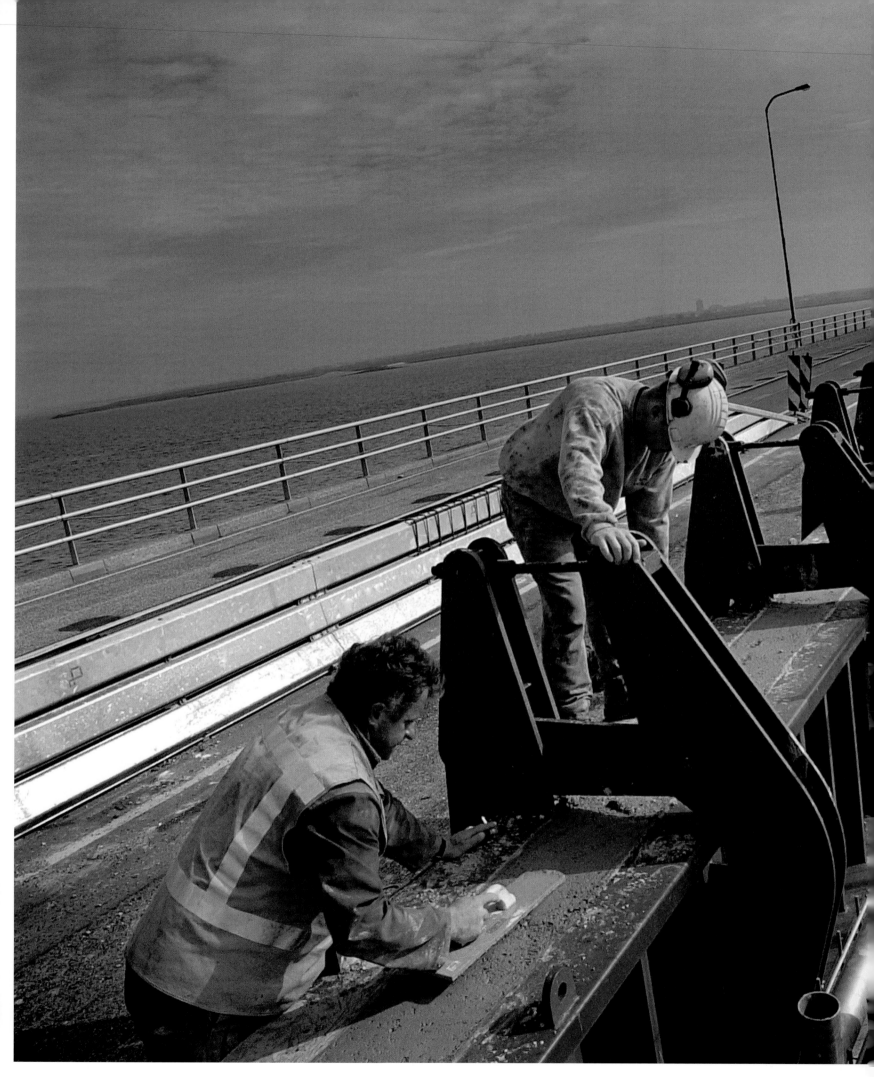

The Dutch have turned into a nation of arrangers and regulators. But they never go too far

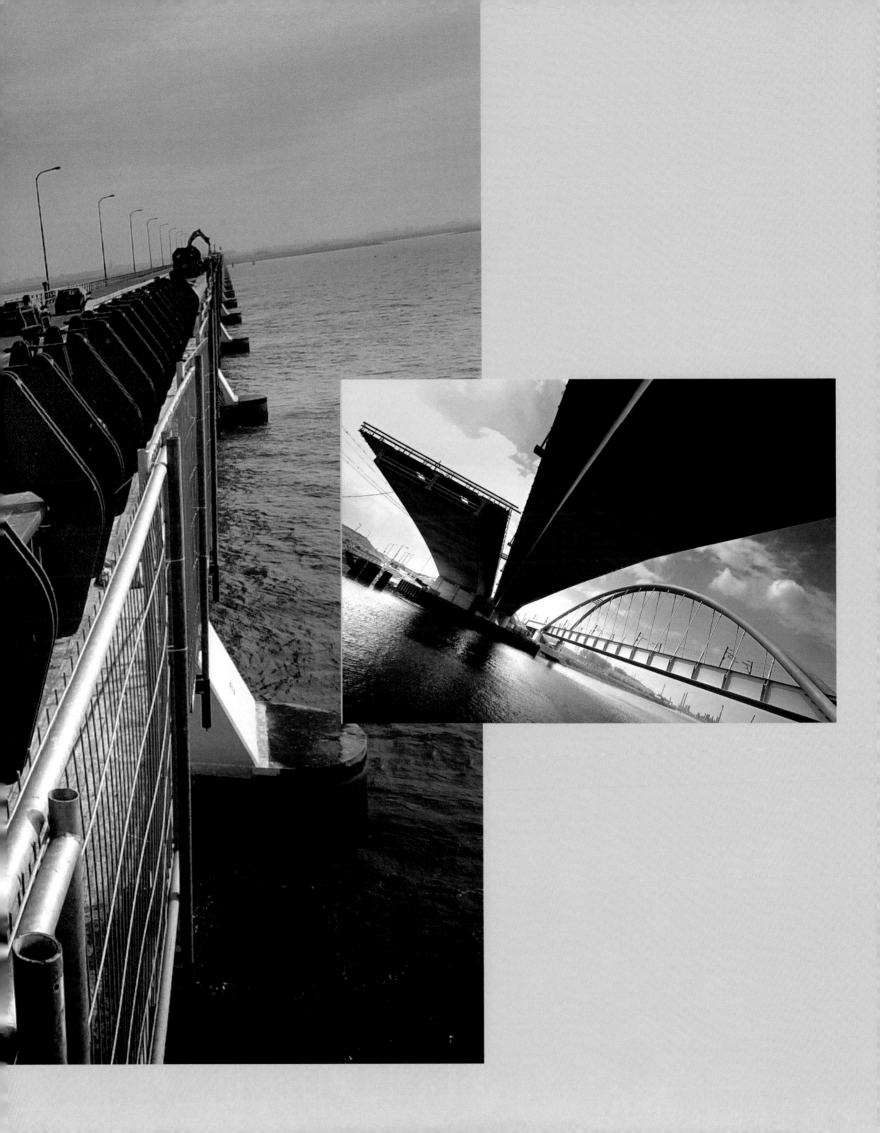

+ **58** metres

WE FIND A BEACON IN THE POLDER, HIGH ABOVE GROUND LEVEL. A QUIET PLACE WHERE WE CAN TALK ABOUT THE PROBLEMS OUR CHILDREN WILL FACE WITH THE WATER. ON THE EDGE OF THE GREEN HEART OF THE RANDSTAD CONURBATION, FIFTY EIGHT METRES ABOVE NAP: THE WATER TOWER AT KRIMPEN AAN DE LEK. THERE I MEET LOES DE JONG OF THE RIJKSWATERSTAAT. SHE APPEARS AT THE HEAD OF THE STAIRS AFTER A DANGEROUS CLIMB UP LONG, STEEP LADDERS. THE WIND BLOWS THROUGH HER HAIR. IT IS COLD DESPITE THE SUNSHINE.

We stand at the crenellated edge of the roof and absorb the view. The windmills at Kinderdijk have stood silently in the wind for centuries. Keeping your feet dry below sea level is a complicated process, involving a great deal of hard work. It is only thanks to a complex system of watercourses, culverts, sluices and pumps that our land remains habitable. For centuries a windmill was an essential tool for keeping the forelands of South Holland above water. The series of mills at Kinderdijk is the best preserved example of a windmill-driven drainage system. A few centuries ago the Netherlands was full of rows of windmills like this. Now this unique example at Kinderdijk draws thousands of visitors a year from all over the world. UNESCO has placed it on its list of world heritage sites.
Below us, the Lek flows along the edge of this panorama. Diagonally opposite the river Noord flows into the Lek, and the Hollandsche IJssel joins it a little further along. The scene is imbued with a majestic peace.

But appearances can be deceptive. The Lek is a problem river. It was created when man altered the course of the Rhine somewhere around AD 800. A dam was built near Wijk bij Duurstede, the Kromme Rijn was closed off and the Rhine ceased to flow into the sea at Katwijk. After that, all the water that had flowed down the Rhine tried to find its way through the much narrower Lek, which had originally been little more than a brook behind dikes. 'Now, over a thousand years later, it's causing us problems,' says De Jong.
The area below the great rivers – what we are looking at from the water tower – has seen a great deal of development over the last hundred years. The dikes have been built closer and closer together, making the river narrower and narrower. On the land side of the dikes the banks have come to be used more and more intensively for housing, farming, leisure and industry.
Climate change means that more and more rain now falls in Germany, Belgium and France. 'Add to that the meltwater from the mountains and you can see that a growing volume of water has to be carried to the North Sea,' says De Jong.
The other side of the circular water tower looks out over the Krimpenerwaard foreland. We see villages, warehouses, factories, roads, a huge electricity supply complex and a children's playground near one of the substantial farms along the dike. On the horizon is the economic and administrative 'coronary artery' of the Netherlands: the Randstad conurbation. 'That region represents an economic investment of at least two hundred billion guilders, and is home to millions of people,' says De Jong. 'And everything as far as the eye can see is below sea and river level.'

She outlines the problem in just a few sentences. 'More and more water has to pass along rivers that we have made narrower and narrower. That means higher water levels. The potential damage to the hinterland when a dike breaches will grow. The subsidence in the land, which in some places is falling by several centimetres a year, increases the difference between the land and river levels year by year. The North Sea is also a factor. We Dutch, living here on this delta, will be affected by the rising sea level. We have to assume that in fifty years' time the water will be sixty to eighty centimetres higher than it is now.'
Sea level also affects the water level in the rivers here, because this is a tidal zone. Twice a day seawater pushes deep inland, swelling the rivers. If we don't do something about it, we will already be facing major problems by 2015. If we continue simply to watch and wait, the *Rijkswaterstaat* estimates that the water will wash over the dikes sometime shortly after 2050.
Raising the dikes is not enough. The difference in the level of the land and water would still continue to grow, gradually increasing the impact of any dike breach that occurred, until we reached a point where the consequences would be incalculable. Furthermore, the weak soil in this boggy part of the country cannot take even heavier dikes. The structures would collapse under their own weight, or sink into the marshy ground.

Nevertheless, De Jong is optimistic about the future. 'As long as we start treating the water differently,' she says. 'We have to stop seeing water as our enemy. If we allow it into areas we live in, we can guarantee our future security. We shouldn't be raising the dikes, we should be widening the rivers.

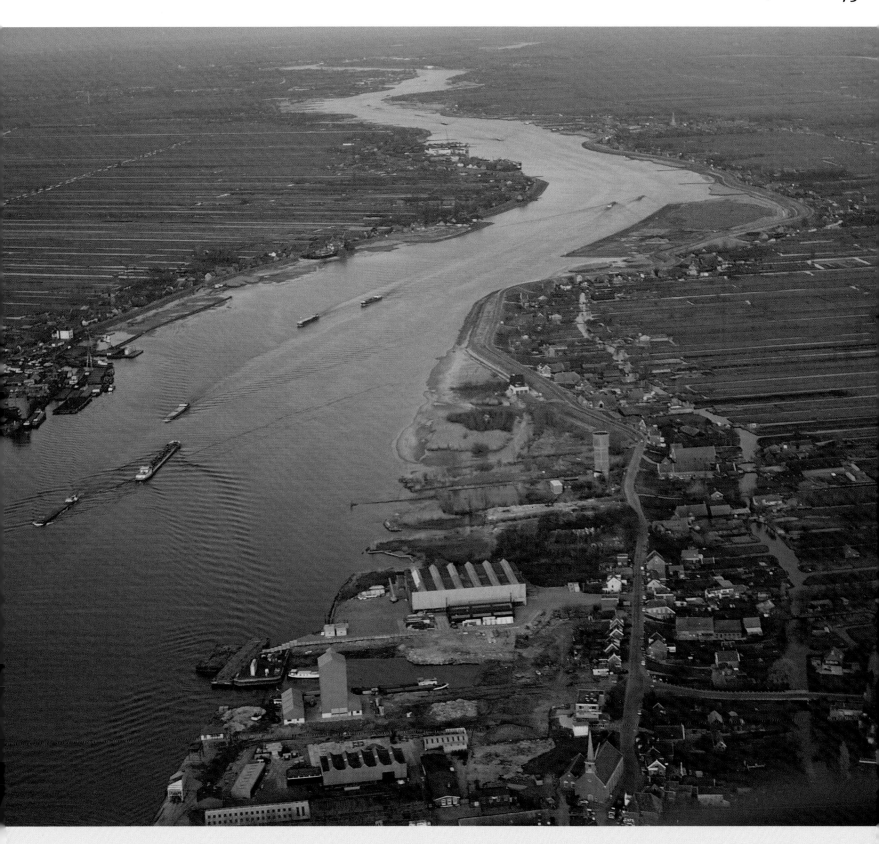

NOW, OVER A THOUSAND YEARS LATER, IT'S CAUSING US PROBLEMS. THE AREA BELOW THE GREAT RIVERS HAS SEEN A GREAT DEAL OF DEVELOPMENT OVER THE LAST HUNDRED YEARS. THE DIKES HAVE BEEN BUILT CLOSER AND CLOSER TOGETHER, MAKING THE RIVER NARROWER AND NARROWER. ON THE LAND SIDE OF THE DIKES THE BANKS HAVE COME TO BE USED MORE AND MORE INTENSIVELY FOR HOUSING, FARMING, LEISURE AND INDUSTRY.

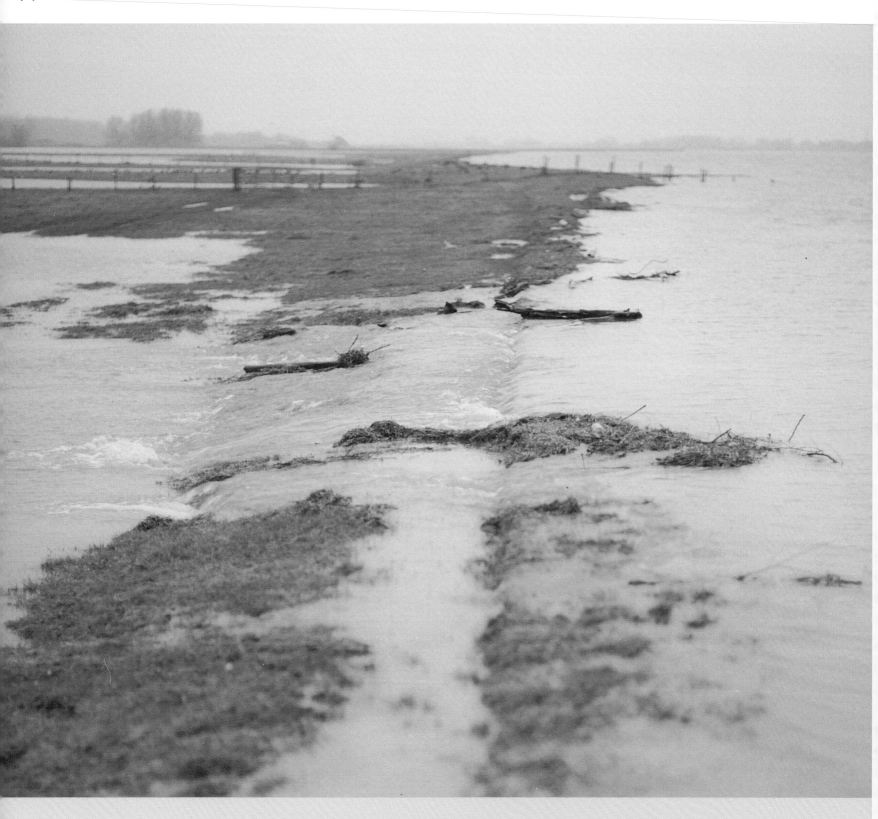

WE HAVE TO STOP SEEING WATER AS OUR ENEMY. IF WE ALLOW IT INTO AREAS WE LIVE IN, WE CAN GUARANTEE OUR FUTURE SECURITY. WE SHOULDN'T BE RAISING THE DIKES, WE SHOULD BE WIDENING THE RIVERS.

We have to give the water more space so it can spread out rather than rising up.' This is the rationale behind the idea of designating certain pieces of land for flooding in emergencies. In some places, the landscape is to be allowed to return to its former natural state. Old creeks that have been dammed off are to be filled again. Empty polders can be made ready to accommodate excess water when necessary. And we have to reserve space for new river arms to be created in the future.

Water managers have surveyed the options. It is all possible. 'We saw from the air that there is space between Nijmegen and Schoonhoven over in the east,' says De Jong. 'We can widen the rivers into the river meadows. There aren't that many areas outside the dikes between Schoonhoven and the North Sea. This means there's less room for discussion about allowing the rivers to run freely. We'll have to look for solutions in the areas within the dikes there. But even there I could mention several promising spots.'

Near Dordrecht, too, there are places were the rivers can be given more breathing space. The water that can no longer be accommodated in the Lek could be channelled off to the Biesbosch, the Eiland van Dordrecht and the Land van Heusden en Altena. 'The Biesbosch has always been an important link between the rivers and the sea,' explains De Jong. 'By sending more water along the Waal and the Nieuwe Merwede to the Biesbosch, rather than along the Lek, we could get rid of an awful lot of it. But we've made it impossible by diking up the creeks.'

The policy of allowing the water more space has been presented as something new and unique. Indeed, the 1996 document setting out the new policy *(Beleidslijn Ruimte voor de Rivieren)* is regarded as groundbreaking. But in the library of Loevestein Castle stands a small book, centuries old, which sets out exactly the same ideas. If today's managers were to read this little book, they might well conclude that there is nothing new under the sun.

In 1757 Jacob Pierlinck, an army captain and engineer in the service of the *Vereenigde Nederlanden*, a military predecessor of the *Rijkswaterstaat*, wrote a personal statement in response to the major river floods that had occurred a short time before. His conclusion was that the rivers were too constricted in some places. They had to be given more space, and side channels had to be dug so excess water could flow off to places like the Biesbosch when necessary.

Pierlinck's ideas fell on deaf ears. Against the backdrop of the bickering between the powerful cities of the day, his plea did not stand a chance. Not everyone was convinced of the need for what he proposed. And there was a great deal of unwillingness to spend the large sums of money needed to control the water.

The problem of water is an eternal one, and so are the debates about how to solve it and the associated costs. Except that now engineers have financial resources and technology that poor Pierlinck could only dream of. It was not until a century after his death that there was at last enough money and technical know-how to actually do something, for the first time, about the threat of the water. And that was only the start. For over a hundred years we thought technology would be enough to tame the water. Now we are coming to realise that we cannot win the war and that we have to use our money and technology differently. Work with the water, not against it. If you can't beat it, join it, as the saying now goes.

After a perilous descent we stand once more on the Lekdijk. The brick tower rises up darkly against the low sky. It's a strange thing: on the one hand we go to great lengths to pump the water out of the ground so we can have it on tap in our homes, while on the other hand we have to take measures, at almost exactly the same spot, to deal with the high water level in the river. At the base of the water tower a major dike reinforcement operation is under way, despite the government's plans to change tack.

Before Loes de Jong boards the yellow bus, she turns to me and says reassuringly: 'We'll always care for the dikes. The Netherlands would be unthinkable without dikes. Only we have to abandon the idea that dikes and water defences are the only way of controlling the water. We have to return to some kind of organic coexistence with the water. We have to give the rivers back their old resilience. We'll really need it in the future, when even more water comes into our country.'

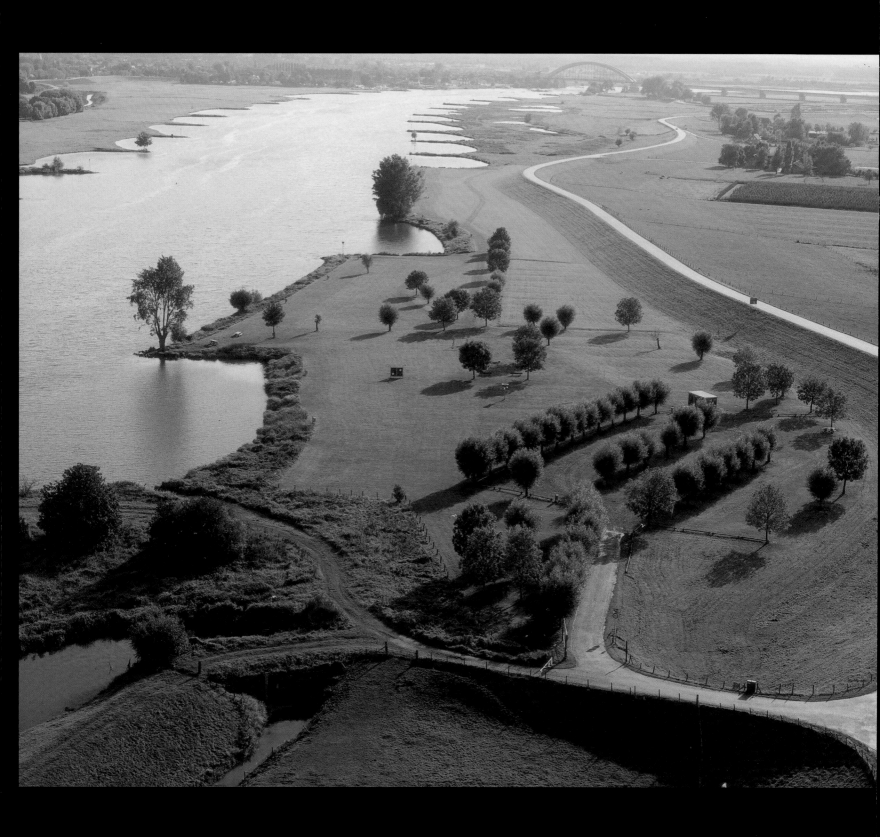

Sometimes a river still has room to expand....

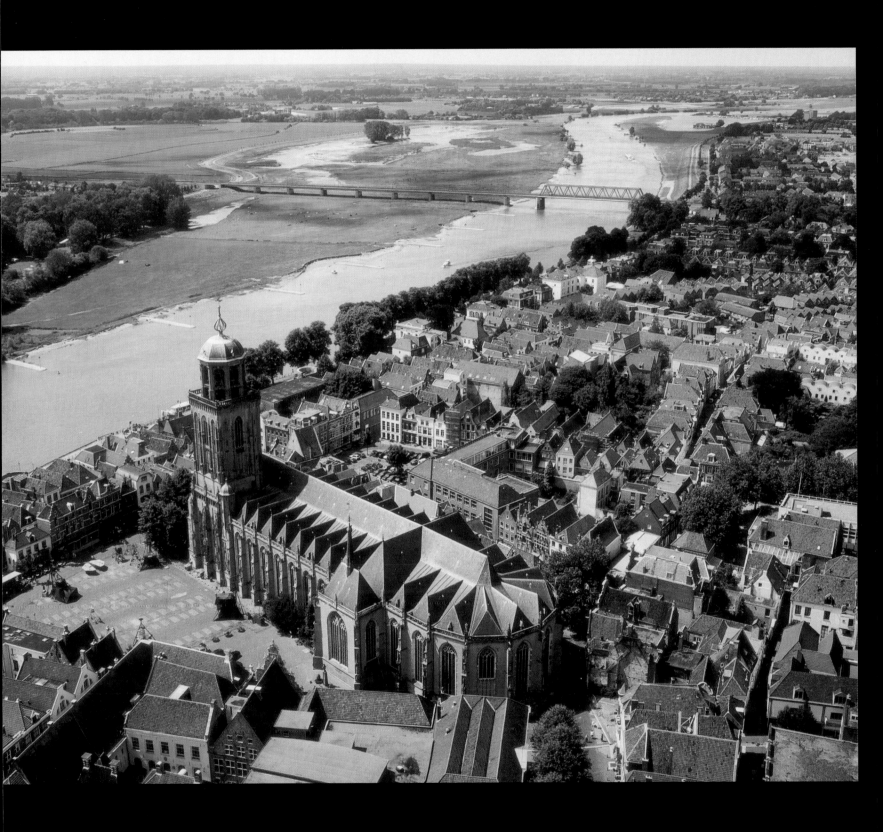

.... and sometimes it doesn't

below the MARK

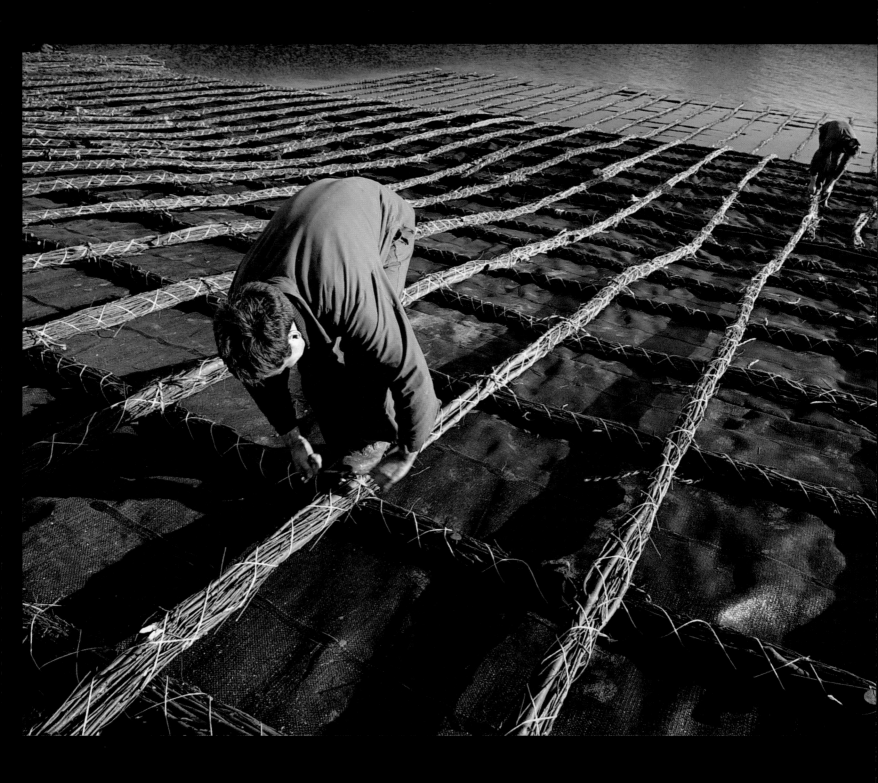

Fascine for use by hydraulic engineers

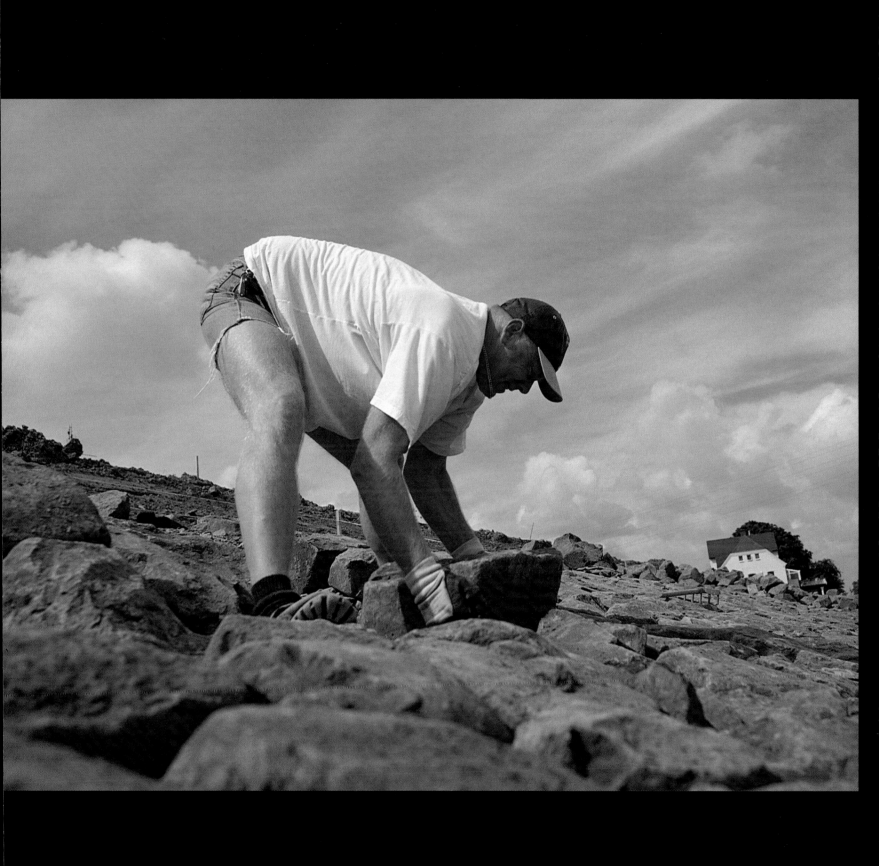

A stoneworker shoring up a river bank

I AM ALONE ON THE LEKDIJK, FOLLOWING ONCE MORE IN THE FOOTSTEPS OF HERMAN DE MAN. THE PLEASANT SMELL OF GREASE AND OIL RISES UP FROM THE ENGINE AS THE BIKE WARMS UP. THE OLD HARLEY CARRIES ME EAST WITH A MUFFLED GROWL. AFTER LEKKERKERK I CAN CHOOSE BETWEEN TWO DIKES. TO THE RIGHT IS THE ANCIENT, NOW UNSTABLE LEKDIJK, BUILT IN 1100. TO THE RIGHT IS A BRAND NEW DIKE, WAITING UNTIL IT IS DECLARED STRONG ENOUGH TO HOLD BACK THE WATER. BETWEEN THE TWO IS A KIND OF NO MAN'S LAND THAT BELONGS TO NEITHER RIVER NOR POLDER. THE OLD DIKE WILL BE REMOVED ONCE THE NEW ONE HAS SETTLED ENOUGH, AND WITH IT A BOTTLE-NECK IN THE RIVER LEK, WHICH IS ALREADY TOO NARROW. IT SHOULD LOWER THE WATER LEVEL BY SEVERAL CENTIMETRES.

The old dike is being tested to see how strong it is. Even after a thousand years of dike building we are still unable to predict when one is about to give way. Once the test is complete the dike will be dug away centimetre by centimetre to establish what is in there. 'It's been raised over and over again so it will be like a sandwich of clay with several fillings of asphalt from the twentieth century, cobbles from the eighteenth and nineteenth and cinder paths prior to that,' predicts one engineer. 'And when we get down to about a metre we'll find wormholes, excrement and wood from the Early Middle Ages.' The landscape around the new dike has been carefully restored. The new houses have been constructed in an old style and even the old wooden telegraph poles have been replaced. Young fruit trees line the verges. But according to the Krimpenerwaard water authority, this is more down to luck than design. 'We just put back what we found, as per specifications. There were wooden poles, so we replaced them.'

On the way to Varik in Gelderland I cross several rivers. At Schoonhoven I take the ferry to Gelkenes. Waiting for the boat, I consider the fact that the effect of the tides is noticeable up to precisely this point. I don't mind waiting for the ferry. The only worry is whether the Harley and I will fit on board. And if we don't, we'll just wait for the next one.

It seems like no one minds waiting. It's because of the river. The Dutch have been waiting for the ferryman for centuries. The river doesn't arouse anger, it brings calm. You actually get something out of waiting. It's like sitting in a wide-screen cinema showing a succession of different panoramas. Rain and wind chase across the grey and green water. Then the cloud breaks, the water turns beige and the crests of the waves are whiter than white. The river is the Netherlands, and the wait is worth it.

In Varik, I knock at the door of a nameless farm that nestles against the Waalbandijk. This is the home of someone who would not be out of place in one of De Man's books: landscape painter Willem den Ouden. Like De Man's character Gieljan Beijen, Den Ouden was almost mobbed over his views on water and dikes. He became famous for his paintings of the dike landscapes of Gelderland. A landscape which, as he sees it, was lost for ever after the high water levels in 1993 and 1995 and the dike reinforcement operations that followed. 'They bulldozed the soul out of it,' he says. 'That landscape was our collective memory. The government's engineers wiped it out.'

But in fact the process that destroyed the landscape had been under way for a long time. Land consolidation and pesticides had taken their toll. 'Where are the flocks of thousands of birds that used to flutter around me squawking as I sat out in the river meadow painting the landscape? Driven away by tractors with rotary mowers. They'll never come back.'

Den Ouden finds the fact that he received so little support from local conservation groups galling. He thought he had found an ally in the *Gelderse Milieufederatie,* a local environmental group. 'But it turned out they'd done a deal with the *Rijkswaterstaat,*' he says. 'In exchange for their approval of the dike reinforcements, they got to manage the river meadow. That wasn't progress. You used to see beautiful black-and-white cows standing by the water. Now there's just these long-haired oxen, which we have no affinity with here.'

Disappointment followed upon disappointment. But the u-turn by the *Rijkswaterstaat* and the water authorities came as a real shock. 'I couldn't believe my eyes when I read that the state secretary wanted to return to the system of flooding certain polders. That they wanted to give the river more space and that the *Rijkswaterstaat* wanted to allow water between and behind the dikes, rather than raising them. They should have thought of that 20 years ago. Then there would have been something left to save ...' It was 20 years ago that Den Ouden and several other like-minded individuals came up with the idea of storing excess water behind the dikes. But the water managers weren't interested at that time.

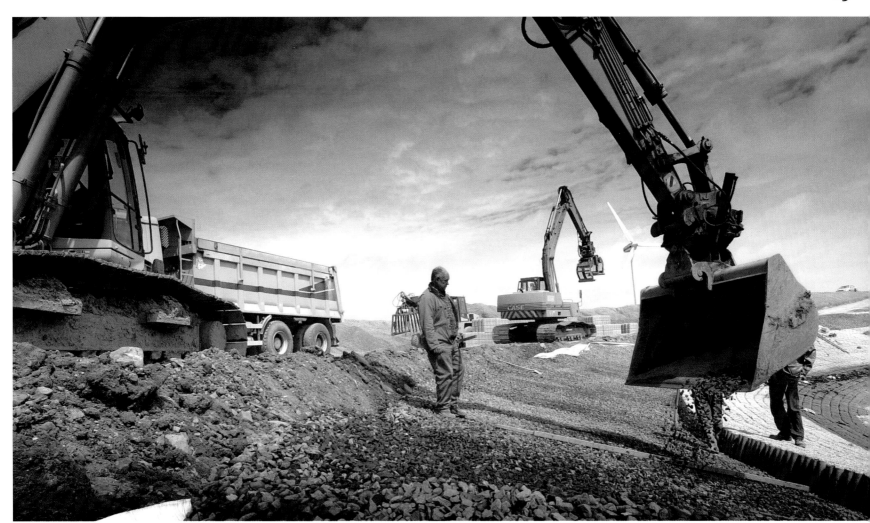

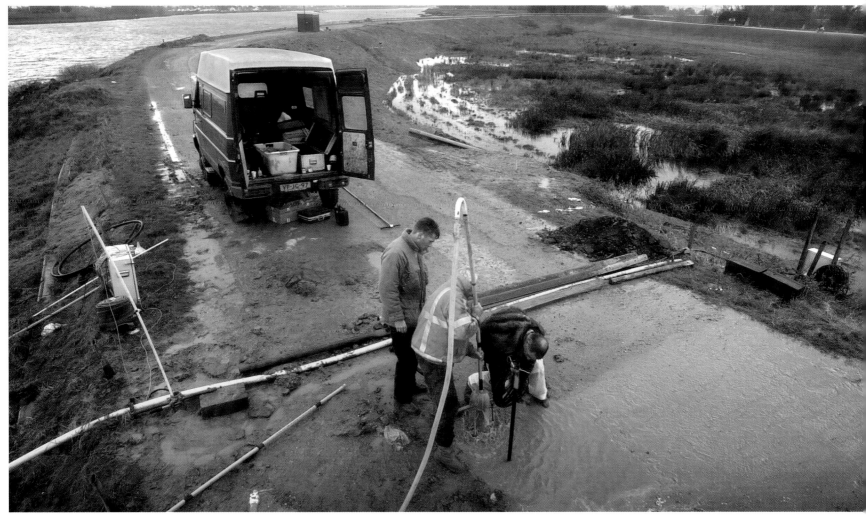

After thousands of years of building dikes we still cannot work out just how strong this sandwich of clay, clinkers, ash and asphalt really is. This is now being investigated between Bergambacht and Lekkerkerk

Den Ouden had only just moved to Varik when, in 1970, the water rose almost to the top of the dike. He panicked. The local populace laughed at him and said 'Willem, we get high water like this quite often.' But the water spilled over the dike in Brakel. The dike was only just saved. From that moment on, everyone felt something must be done. Allowing the water to run off elsewhere was not even considered. The dikes had to be raised.

'You could see the dikes had been neglected,' says Den Ouden. 'You could point to spots where seepage had brought sand to the surface, a sure sign that a dike is being undermined. The engineers came and looked, but as soon as their car doors slammed and they drove off, we saw no more of them. I sometimes think they deliberately ignored the situation so they could come back with the bulldozers later.' Take measures, sure. But he was angry about the way it happened. Why did so much of the landscape, so many memories, so many people's lives have to be destroyed?

The compulsory purchase of dike homes began as early as 1960. Residents were put under pressure to leave. 'Because the engineers said the dikes couldn't be wiggly worms, they had to be slithering snakes,' says Den Ouden. The meandering dike was straightened. 'Large-scale' became the watchword in this small-scale landscape. 'The dancing lines disappeared. It all became lifeless.'

The people of Brakel saw the perfectly straight dike approaching from Woudrichem, saw the houses in which they were born, half their village, disappear. When, in 1975, 160 houses were demolished, the characteristic look of the village was destroyed, and things reached a low ebb. But this was the turning point. Opposition grew. A tough conflict between arrogant water authorities and emotional dike residents tore through the heart of the river country in the 1970s and 1980s.

'On paper, homes were declared non-residential property, which made them completely worthless,' says Den Ouden. 'They were then bought up at scandalously low prices and demolished.' You can still hear the indignation in Den Ouden's voice. Those who tried to go to court to stop the process were later bought off with large amounts of money, sometimes up to three times the estimated value of the property. The authorities did everything in their power to bring the protesters to their knees. But the opposition continued to grow.

The campaign was coordinated by the family doctor from Brakel, Dr. A. van den Beek. He set up an organisation, *Stichting Dorp en Landschap*, and appealed against the decision to demolish properties. When that failed he set up a political party and got elected to the local council, from where he continued his opposition. The doctor had a hard time, Den Ouden recalls. Nevertheless, people followed his example. Other organisations were set up further along the dike, right into the Ooijpolder. Willem den Ouden was one of the founder members of *Stichting het Waallandschap*. The press and public showed a lot of interest in this group of photographers, poets and painters, but the authorities held firm. Although surveys showed that a large proportion of the population supported the idea of protecting the landscape, the provincial and polder authorities swept aside all opposition. And so Brakel was lost.

The result is there for all to see on the dike between Zuilichem and Brakel. Here, the hulking, solid 'slithering snake' rises up out of the ground, with the river some distance away beyond the river meadows. The entire dike is covered with the same type of grass. Not a tree or flower in sight. Anyone who doesn't know this area couldn't possibly imagine what the landscape was like before the dike was reinforced. Brakel became the prime example of how not to do things. Gradually, the landscape, nature and the cultural heritage came to be regarded as important, too. The next villages that lay in the path of the bulldozers were not hit so hard. But Den Ouden felt the government had not learnt enough by any means. He carried on with the fight and planted black flags along the dike to mourn the destruction of the landscape and way of life. His campaign gained national notoriety.

His first sweet taste of victory came in 1992 at Groeneveld Castle in Baarn, when the *Rijkswaterstaat* lost a public debate with Den Ouden's organisation. After that, it seemed to change its thinking. But the high water levels of 1993 and 1995 threw another spanner in the works. The rivers swelled to an enormous volume. 'The second time it happened the government forced residents to evacuate,' says Den Ouden. He and his supporters were accused of holding up the necessary dike improvements, thereby putting other people's property at risk. The painter was threatened, and someone even shot at him. It became impossible for him to work. He still feels the anger was unjustified. 'I am not against dike improvements,' he explains. 'But you can restore a dike and still preserve its original character. We have the technology.

I AM NOT AGAINST DIKE IMPROVEMENTS. BUT YOU CAN RESTORE A DIKE AND STILL PRESERVE ITS ORIGINAL CHARACTER. WE HAVE THE TECHNOLOGY. THE ARGUMENT THAT IT COSTS MILLIONS CARRIES NO WEIGHT WHEN YOU'RE TALKING ABOUT ANCIENT LANDSCAPES. WE DID THINGS BETTER IN THE 1930S, INCLUDED HOUSES IN THE PLANS RATHER THAN DEMOLISHING THEM. AND IF THERE WAS NO ALTERNATIVE, THEY WERE DISMANTLED AND REBUILT LATER.

The argument that it costs millions carries no weight when you're talking about ancient landscapes. We did things better in the 1930s, included houses in the plans rather than demolishing them. And if there was no alternative, they were dismantled and rebuilt later. We could do that now, what they've done in Zaltbommel proves that. The dike looks more beautiful than ever there.'

The extremely high water levels of 1993 and 1995 created support for new, rigorous measures. The Delta Project for the Major Rivers allowed the dike reinforcement operations to be accelerated. Den Ouden disappeared from the public eye, his landscape disappeared, the debate died down. The engineers had won. Only a few people visited Den Ouden to show their support. One of them was an engineer from the *Rijkswaterstaat*. 'He thought I was right, but couldn't stop the work that was already under way,' says Den Ouden. 'The last time I saw him he came to say goodbye. He was leaving the *Rijkswaterstaat*.'

Over the past few years Den Ouden has visited the dikes only reluctantly. 'I've tried, but I can't paint with a mirror on my easel so I can see what is happening behind. I'm constantly on my guard. And anyway, I just can't do it anymore. I've lost heart. I also don't like visiting the places I painted in the past. I'm afraid of what I might find ...'

In his studio, he shows me some of his work. 'I only paint skies now. The government can't spoil them. They're just as beautiful as they were hundreds of years ago.' The landscape has been reduced to a strip at the bottom. But those skies! They are full of joy. A tremendous outburst of sparkling light, clouds breaking open to reveal the waking sun. The feeling is still there, you just have to look more closely.

Before we say goodbye Den Ouden walks with me to the dike. We look out over the water. The river is alive. Boats bob at anchor before the old church spire. A minibus brings in a new crew to one of the boats. 'Look,' says Den Ouden with venom. 'An empty gesture by a hard and rigid water authority: "Here you are, painter, here's something for you".'

Right in front of his house the concrete dike structure makes way for the original basalt. Den Ouden wearily raises his hand. Why is he so disappointed?

Even today, anyone who drives along the Waalbandijk south of Geldermalsen is overwhelmed by the beauty of the landscape. Squat church towers, sun breaking through the clouds, glittering on the water, ships that suddenly appear behind the dike. Wind, birds, rustling leaves. And, if you listen carefully, you can hear the fanfare. The sounds roll in on the wind across the river meadows of the Land van Maas en Waal.

The Land van Maas en Waal

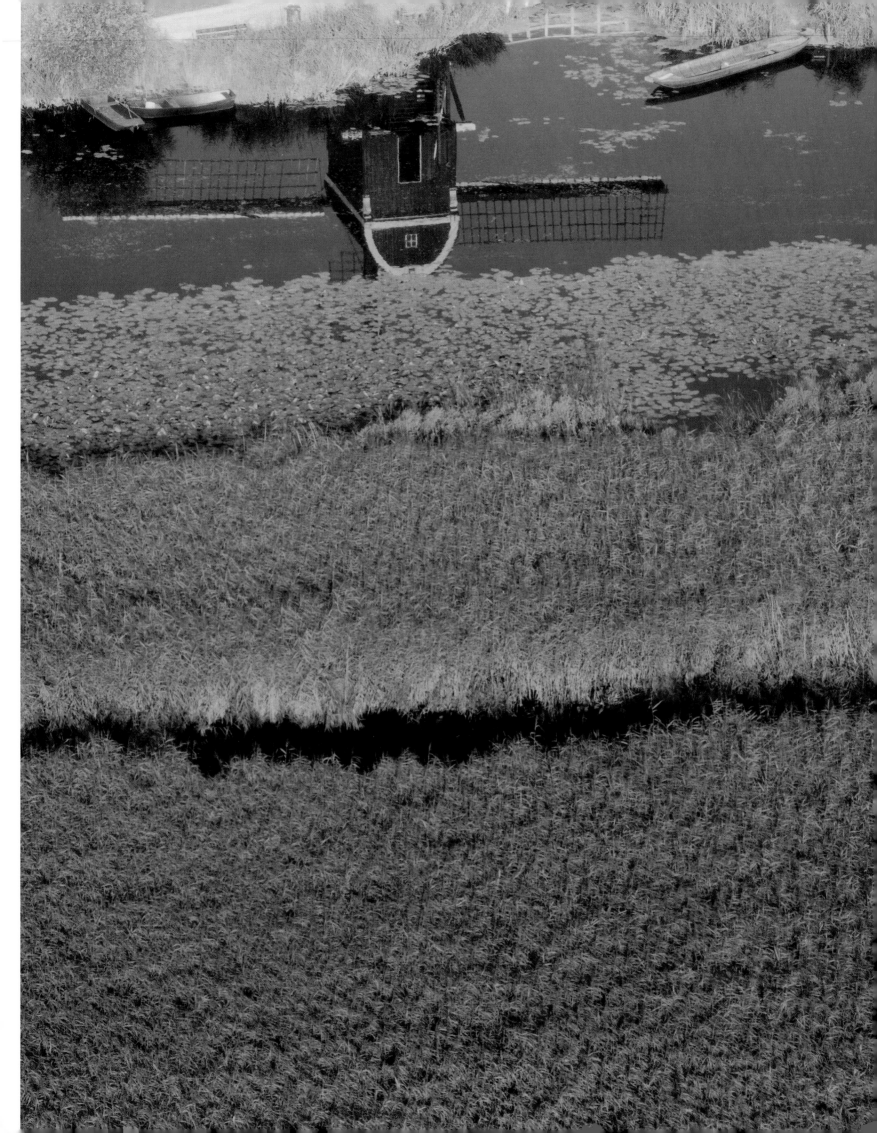

does below NAP mean under water?

THE SAINT ELIZABETH FLOODS OF 1421 AND 1424 CAME FROM THE SEA AND REACHED AS FAR AS LOEVESTEIN. THEY ENGULFED THE GROTE WAARD, A HUGE MEDIEVAL POLDER PROJECT NEAR DORDRECHT, ALONGSIDE WHICH EVEN THE DELTA PROJECT PALES INTO INSIGNIFICANCE. ONLY SMALL PARTS OF IT WERE LATER RECLAIMED FROM THE WATER. AT THE POINT WHERE THE SEA AND RIVER MET AND OVERPOWERED THE LAND, AN INHOSPITABLE MARSHLAND WAS CREATED: THE BIESBOSCH. FOR CENTURIES ITS NATURAL WATERCOURSES, CREEKS AND LOW-LYING POLDERS MEANT THE BIESBOSCH FUNCTIONED AS THE 'KIDNEYS' OF THE NETHERLANDS. IF THERE WAS AN EXCESS OF WATER, THE BIESBOSCH WOULD ABSORB IT. THE WATER FLOWED OVER THE TOP OF ITS LOW EMBANKMENTS AND POLDERS ACTED AS LARGE BASINS THAT RETAINED WATER. AS SOON AS THE RIVER WATER RECEDED, THE BIESBOSCH EMPTIED AGAIN. THIS CAME TO AN END IN THE TWENTIETH CENTURY BUT NOW, UNDER THE RIJKSWATERSTAAT'S PLANS, THE BIESBOSCH IS ONCE AGAIN TO ABSORB WATER TO SPARE THE SURROUNDING AREAS.

In the past shipping used to be hampered by low water levels when the rivers emptied into the Biesbosch along the many channels that branched off the river. In the spring, however, high water levels were a problem, as ice dams caught fast in the many openings into the Biesbosch. The water accumulated behind them and threatened to inundate the Alblasserwaard and the Land van Heusden en Altena. The seventeenth century engineer Jacob Pierlinck called for what we would now term a 'green river': a bypass that would drain water away if the main river became blocked by ice. Eventually, another solution was chosen, with the digging of the Nieuwe Merwede in 1869. This could take more water than all the Biesbosch channels together. High dikes kept the water in the channel, and the fast flow stopped it silting up. But it meant that the Biesbosch was cut off from the river system. Water levels became manageable, the risk from ice dams was reduced and agriculture and drinking water abstraction were allowed to develop.

The Dutch government is now seeking a compromise between all the different functions and facets of the Biesbosch so it can be used to accommodate excess water again. Two-and-a-half centuries later, the bypass through the Land van Heusden en Altena is in line with the latest thinking: a dry area normally used for farming, which can act as an 'emergency exit' when flooding threatens.

The Biesbosch as we know it today has been shaped by man over the centuries from what was just an expanse of water. This wildlife habitat has been created by hard work, by the cultivation of rushes, reeds and timber. Rushes were planted in the lake for basket-weaving, and this accelerated the sedimentation process. The mudflats thus created were planted with reeds, which speeded up the process even further. Eventually, the mudflats were so high that osier beds were formed: areas that were dry at low tide, where reeds and willows grew. Rushes, reeds and willow were exported to the many craftsmen working in surrounding villages like Hardinxveld, Giessendam, Sliedrecht and, above all, Werkendam. There they were used as raw materials for thatching roofs, and for weaving baskets and fascines, mats used in the construction of embankments, roads etc.

The Vissersdijk is perpendicular to the Merwede and winds out of the polder into the heart of Werkendam. In one of the tiny houses on the old dike lives a man who has seen it all. He saw the water flooding the Biesbosch during the spring tides, and the channels pulsing to the rhythm of the tides. He has lived a hard life that paid little. He was witness to the loss of the Biesbosch when, in 1971, the gates of the Haringvliet locks were fixed permanently in the low tide position so that the area was no longer tidal. This man has recorded his life in a few photo albums. One day he closed them, vowing never to look at them or talk about them again. He is Tinus Klop, the last living *Biesboschschipper*, Biesbosch bargeman.

'It was heavy, badly paid work. I removed vegetation from the Biesbosch at dead of night. Things were good for a short while after the floods of 1953. It sounds awful, but there was a huge demand for fascines to repair the dikes that had been washed away. But the market collapsed when they started to use fascines made of artificial material.' It became more and more difficult for people like Klop to keep their heads above water. But osier bed cultivation somehow managed to survive against all the odds. It was not until the 1980s that the last *Biesboschschipper* moored up his barge for the last time in Werkendam.
Tinus Klop is a man of few words and he thinks others can recount the tale better than he. Will he go back

to the Biesbosch? No chance. But the others are all dead. Reluctantly, he agrees to take a trip down memory lane. We borrow a flatboat and a few days later we sail out of the dock. A friend who emigrated to Canada, Jan van Drunen, is also on board. He wants to revisit the place where he was born.

Once we have left the mooring, Klop haltingly begins to tell his story. But once he gets going, there's virtually no stopping him. His father's boat, which he used when he took over the business in the 1950s, was open and offered absolutely no protection. 'In the front there was a low shelter, where there was a little round stove, and a pull-out bed. If you didn't shut it up properly, you had to sleep with wet blankets for a week. That's how I lived. First with my father, and later with my wife.'

When you were at the helm, you were outside, day and night, summer and winter. 'In the winter I used to peep through my buttonhole into the driving sleet, and in the summer I wound a cloth around my head to protect me from the heat. It took no skill to be a bargeman, just insanity!' Like they say in the Biesbosch: 'Toil away until you die and sail into the afterlife'.

The rhythm of life was determined by both the seasons and the tides. 'The Haringvliet was still open, there was a tide of one-and-a-half to two metres. At high tide we entered the channels, from hopper to hopper. As soon as we could, we rode the tide back out again.'

We sail into a dark passageway between two green walls of vegetation and immediately come across a canoe. The Biesbosch used to be anything but a recreation area, a whole district lived off what nature had to offer there. There was a lot of farming in the polders that often flooded. Klop recalls how the farmers didn't mind the floods. The silt they left behind made the land fertile. But the floods were unpredictable. 'I remember setting out one night,' he recounts. 'When I cast off I noticed I was being slowly carried along by the flow. A hole had appeared in the dike and the polder was filling up. What a current! I had to do all I could to stop the vessel ending up in the hole, otherwise I'd have lost everything.'

Floods were a fact of life in the Biesbosch. Pierlinck's book from the library in Loevestein Castle tells of twelve disasters between 1653 and 1757. They were all caused by ice dams and large quantities of melt-water that proved too much for the low, weak dikes. 'He who fears not more sorrowful consequences, who looks to this short summary, which shows at one glance that this perishing evil does increase all the while, in particular since 1740.' Pierlinck already saw that a serious situation would arise in the future. What he did not know was that the floods at that time were the result of a fluctuation in the climate. At that time the Earth was not growing warmer, but in fact colder. This period was later to become known at the 'Little Ice Age'.

Jan Buisman is a historical geographer and has written several books on weather and climate. In his series *Duizend jaar weer, wind en water in de Lage Landen* ('A Thousand Years of Weather, Wind and Water in the Low Countries') he describes the Little Ice Age as we experienced it in these parts. I call him from the barge. 'It was not always cold then,' explains Buisman. 'There were major fluctuations in temperature. But on average the winters between 1430 and the nineteenth century were colder and the summers cooler than they are now. I once counted the number of times the rivers flooded in the eighteenth century, just for the fun of it. There were about 22 floods in as many years, lots more than I expected. What you find in the past, like in the time of Pierlinck, is that the number of floods increased after harsh winters with heavy snowfall.' People have been worried about the weather for centuries. Snow, followed by a thaw and heavy rainfall and combined with ice dams, caused people in the river country many sleepless nights. You could compare this with our concerns about today's changing weather as a result of climate change. 'But in Pierlinck's day their nightmares often soon became reality. For instance, in the very cold spring and cool summer of 1740 there was still snow on the ground in the German Mittelgebirge mountains. Another cold spell in October was followed by a thaw later in the winter which produced double the normal amount of meltwater. The floods in the winter of 1740/41 were notorious. This terrible incident was on Pierlinck's mind when he wrote his report of the 1757 floods.

Just how bad these floods were for the inhabited polders outside the Biesbosch we can barely imagine. Pierlinck's reports give some idea of the desperate circumstances. The huge mass of water and ice that washed over and through the dikes in 1757 caused untold damage. Many houses, still built of clay and timber, simply collapsed. The food supply was lost completely. Stocks were destroyed, fires extinguished, bakers could no longer bake bread. Food was brought in by ship, but they could barely make it through the ice. Some people sat for two weeks on what was left of their dike waiting for help, their children sheltering under their clothes, living on what happened to float by.

'Oh if only we could relieve the great rivers,' sighed Pierlinck, 'by letting the water flow over land to the Biesbosch.' If only he could persuade them of it.

The twentieth century also saw flooding. When Tinus Klop was eighteen the water rose much higher than normal during a spring tide when a north-northwesterly storm was blowing. That had not happened for generations. 'Bargemen who sailed the rivers could already taste the salt in the air at Zaltbommel. They knew something was wrong. The mayor came to our house in waders. There was half a metre of water in-side.' Klop and his father had to go out in their boat. 'It was requisitioned, we had to take soldiers and policemen. The first thing we did was fetch a pregnant women from the Stenen Muur. Then we went back to rescue a farmer on the Donderzand. When his house floated away he climbed onto the straw in the barn and listened in the dark night as his pigs squealed and drowned. In their terror they tried to climb onto anything. When we arrived there was a drowned pig hanging out of every window. The farmer had been driven mad by desperation.'

During that fateful night in 1953 the seawater pushed into the rivers. As the Biesbosch filled, it prevented a dike in the east of the Alblasserwaard from rupturing. But the dikes in Zeeland were too low. The water simply flowed over them. And the dikes in large areas of South Holland also broke.
The disaster had an upside for the people of Werkendam, as it brought them a great deal of work. 175,000 hectares of land had flooded and the tidal movements were making the holes in the dikes bigger and bigger. The repairs, a speciality of the people in this area, took all the materials and manpower available. It was a period of hitherto unknown prosperity for the bargemen of the Biesbosch. 'Builders got rich on it,' says Jan van Drunen. 'Before they ate they prayed "Lord give us today our daily bread and every year a flood".' Tinus jumps up and reprimands him: 'Jan, no bible quotes!' Jan acquiesces with a smile. He had forgotten how well-versed in the Bible his friend is.

Tinus Klop's family shared in the newfound prosperity. They bought a house and a bigger boat, with a cabin to offer protection from the elements. While he has been recounting the story, beads of sweat have begun to appear on his forehead. His hands are shaking. 'Nerves,' he explains, apologetically. His hard life has not only damaged his back, it has also frayed his nerves. He takes medication to suppress the effects of a life of heavy physical work. 'Looking back on it, it all seems like madness,' he says, because his story also has a bitter side to it. 'Actually I did myself out of a job,' he says. 'By taking brushwood to the Delta Project I helped them shut off the Haringvliet. The tides disappeared from the Biesbosch, which meant the reeds also went and there was no work for me anymore.'
There is only thirty centimetres of tide left, as opposed to two metres in the past, too little to venture far into the creeks in a boat. Osier bed cultivation gradually withered away after 1971, when the gates at the Haringvliet were closed.

Our fellow passenger, Jan van Drunen, thinks the Biesbosch has deteriorated. 'This place gets all the dregs of progress. Pollution has increased along with prosperity. All the filth has settled out here in the still waters. There is more toxic sediment here than we will ever be able to clean up,' says the returned émigré, who deals in machinery back in Canada. When he moved there, it was like moving back to a lost past. 'I live in the Land of a Thousand Lakes. It looks like the Biesbosch used to, just a thousand times bigger. I can look three metres down into the water, and see trout and salmon swimming. They are the biggest fresh-water lakes in the world. You can't really compare them with the Biesbosch. But it is wonderful to be here. It keeps drawing you back.'

From the Steurgat we turn back into the Nieuwe Merwede. We talk about the Dutch government's plans to restore the Biesbosch to its former glory. Not only is more river water to be let in, the gates at the Haring-vliet are also to be opened. This will increase the tide in the Biesbosch to one metre. 'If you think about it, it's the only solution,' says Van Drunen. 'If you shut everything off you're working against nature. Letting the water and the tides back will mean working alongside nature. Water will be able to flow into the Bies-bosch at high tide, and the silt will also be carried out of the sea inlet, rather than settling here.' And when there's a storm at sea, the gates in the dam will be closed and the Haringvliet and hinterland will be safe. As we enter the little port, our trip down memory lane draws to a close.

Not long afterwards I was travelling by coach through the same area. Seen from the land the Biesbosch has an entirely different character. It is a framed landscape, full of peepholes that afford distant views, old

houses surrounded by trees. The roads are narrow, and the driver sometimes has difficulty getting his coach through.

When the coach stops at a farmyard and the doors open, warm air floods in. This is the hottest day of the year 2000. State Secretary for Transport, Public Works & Water Management Monique de Vries is visiting the Biesbosch, with a large number of senior civil servants from the *Rijkswaterstaat,* the water board, mayors, aldermen and journalists in her wake. Once inside, we see the 'polder model' at work in perhaps its most literal sense. The State Secretary takes a seat at the kitchen table, while five farmers take it in turns to tell their story.

It appears they are worried about the plans to allow water back into the Biesbosch polders. Some families have been farming here for generations, while others have been farming in the Biesbosch for less than a decade after being forced off their land elsewhere. There are also likely to be problems with the buildings if the polders are used to accommodate excess river water to prevent flooding. The old houses are high up, but the new ones are at ground level and many barns have been built in old watercourses.

The farmers explain to the State Secretary that they are afraid they will be pushed out by other people's interests. They are looking to the *Rijkswaterstaat* to play its traditional role of bringing people together to work out a solution. The government looks after victims, compensates those who suffer.

The small kitchen is getting hotter and hotter. The State Secretary's dress sticks to her back, the farmers wipe their brows. Maps appear on the table. The plans drawn up by the water board and the *Rijkswater-staat* are laid beside an alternative plan that the farmers have drawn up in coloured pencil. Various possibilities and problems are discussed. Trust grows between the two sides, and the farmers' alternative will be considered in further studies. The parties say that they understand each others' point of view. No specific undertakings are made, but it looks like the water managers and farmers will reach a compromise.

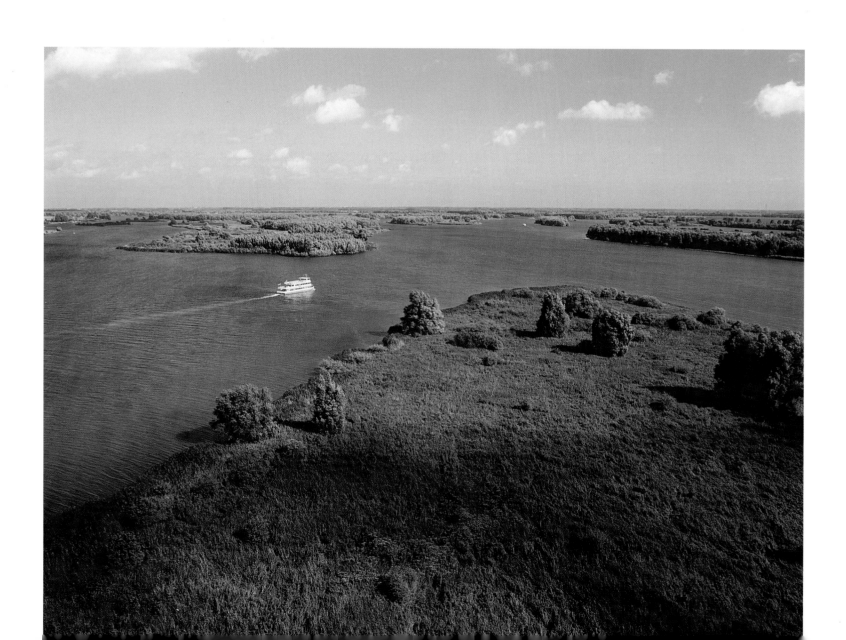

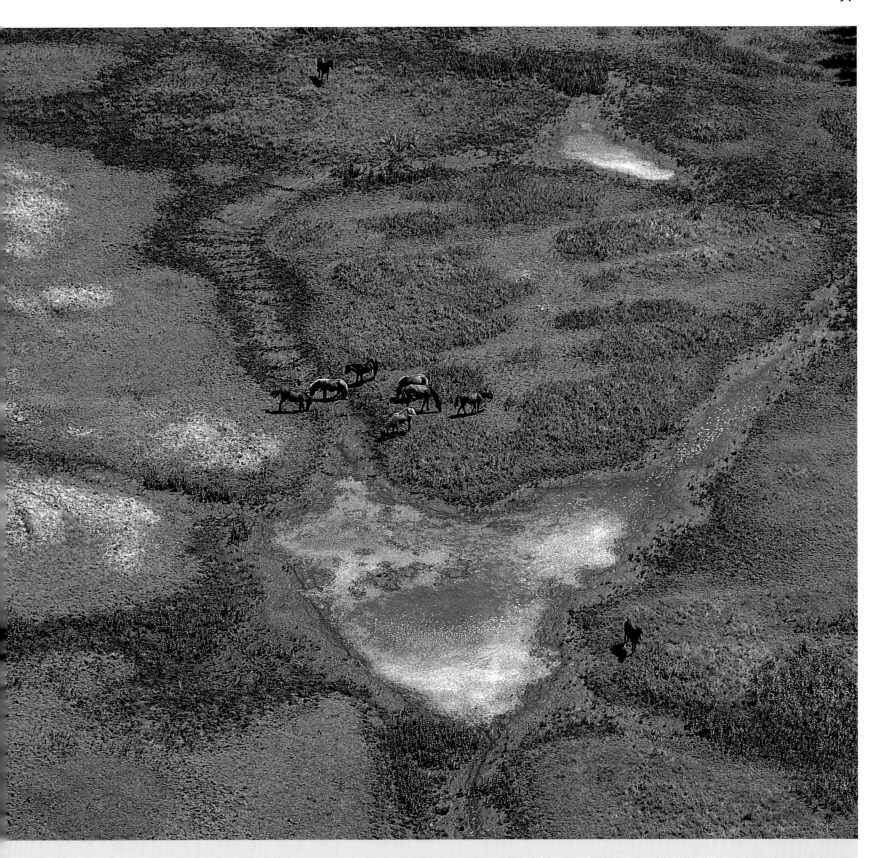

FOR CENTURIES ITS NATURAL WATERCOURSES, CREEKS AND LOW-LYING POLDERS MEANT THE BIES-BOSCH FUNCTIONED AS THE 'KIDNEYS' OF THE NETHERLANDS. IF THERE WAS AN EXCESS OF WATER, THE BIESBOSCH WOULD ABSORB IT. THE WATER FLOWED OVER THE TOP OF ITS LOW EMBANKMENTS AND POLDERS ACTED AS LARGE BASINS THAT RETAINED WATER. AS SOON AS THE RIVER WATER RECE-DED, THE BIESBOSCH EMPTIED AGAIN. THIS CAME TO AN END IN THE TWENTIETH CENTURY BUT NOW, UNDER THE RIJKSWATERSTAAT'S PLANS, THE BIESBOSCH IS ONCE AGAIN TO ABSORB WATER TO SPARE THE SURROUNDING AREAS.

Recreation in the Biesbosch

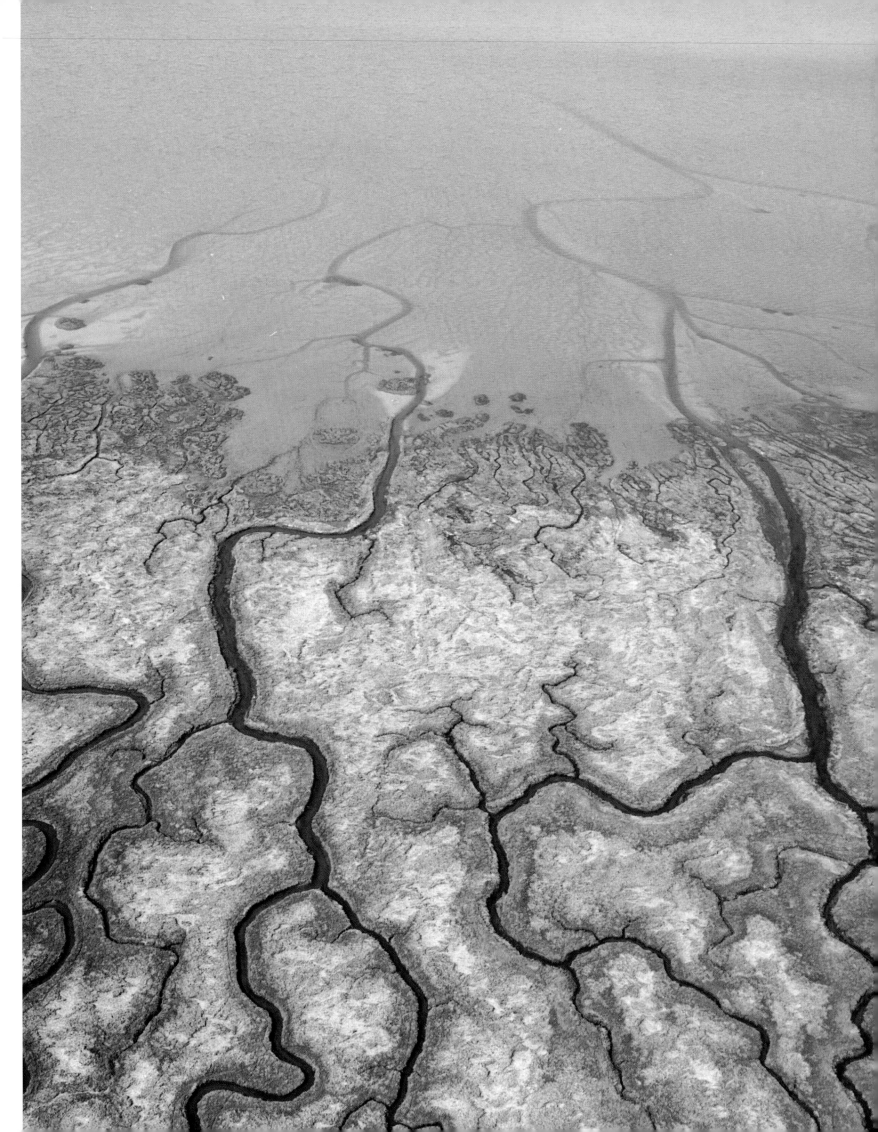

below **NAP** it's never dry

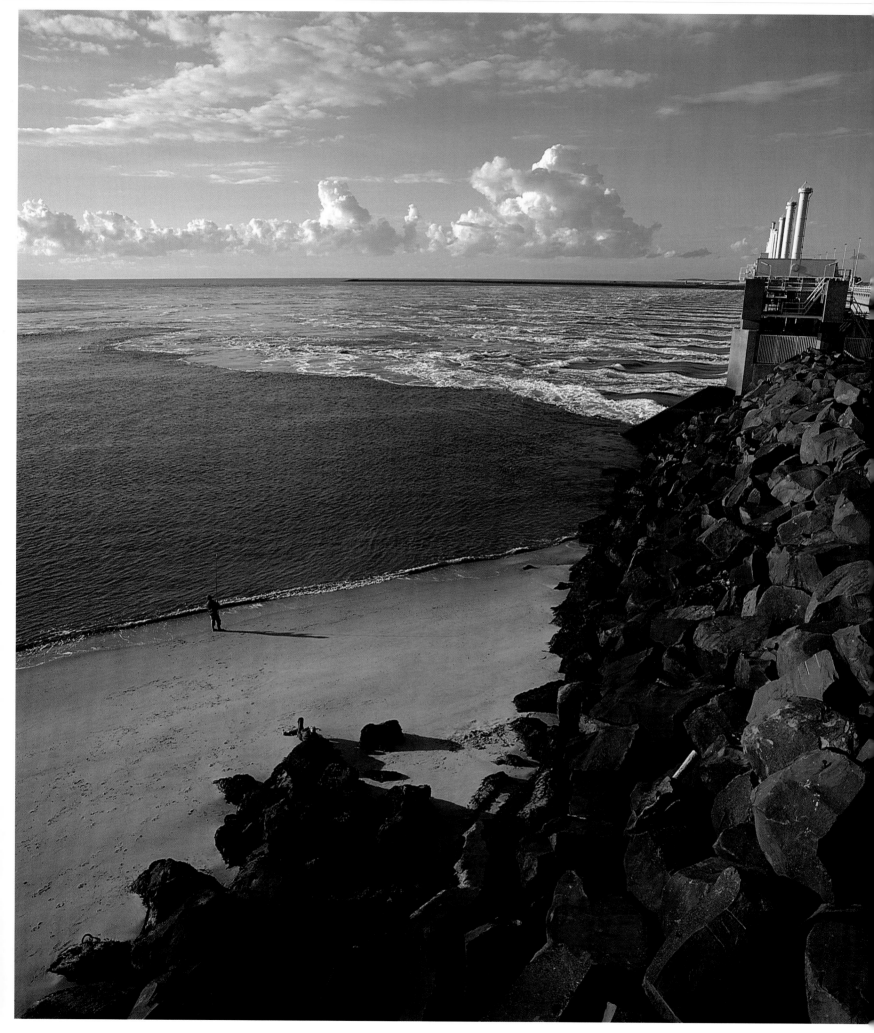

All rivers lead to the sea. The storm barrage in the Eastern Scheldt is usually open but is closed during spring tides

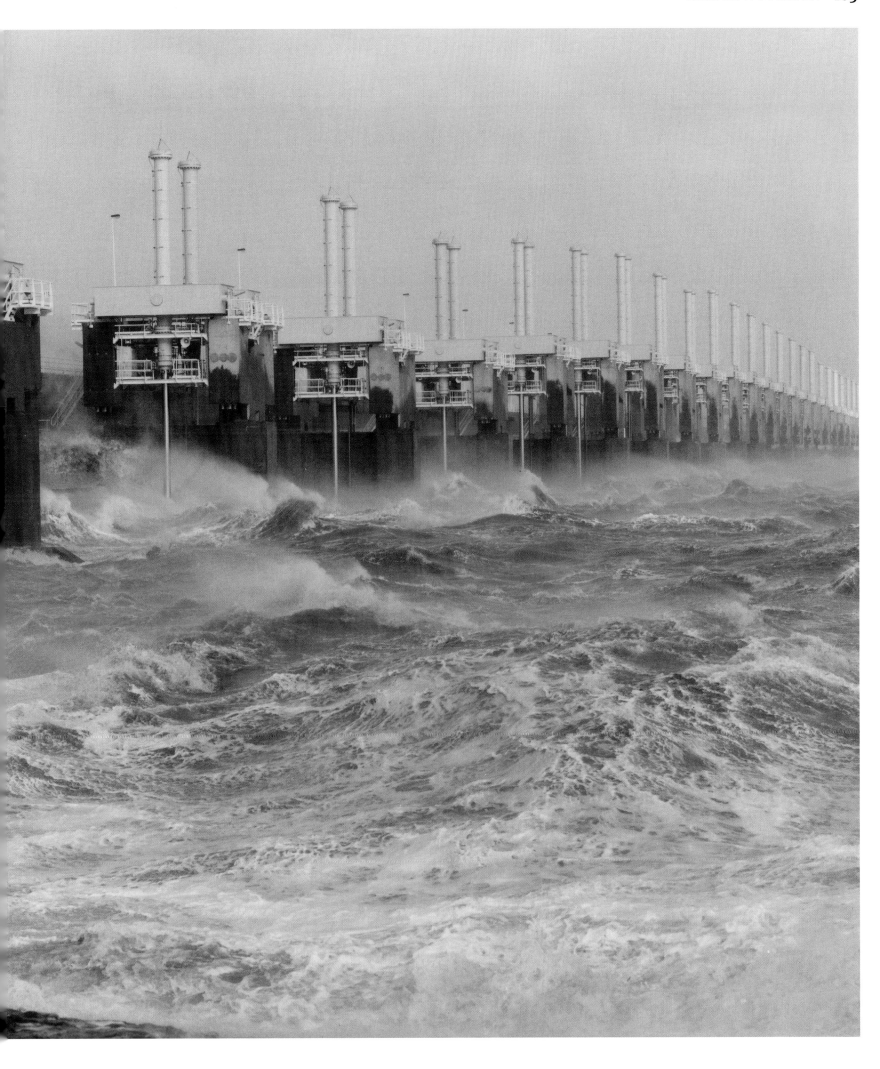

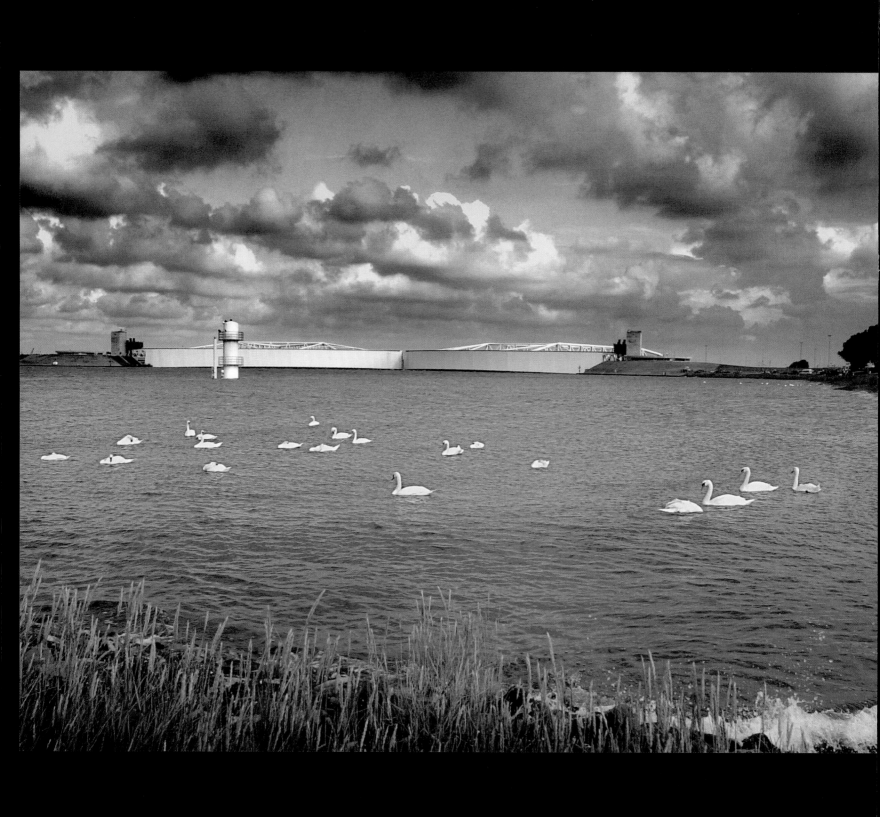

The Maeslantkering [barrage] closed for a test

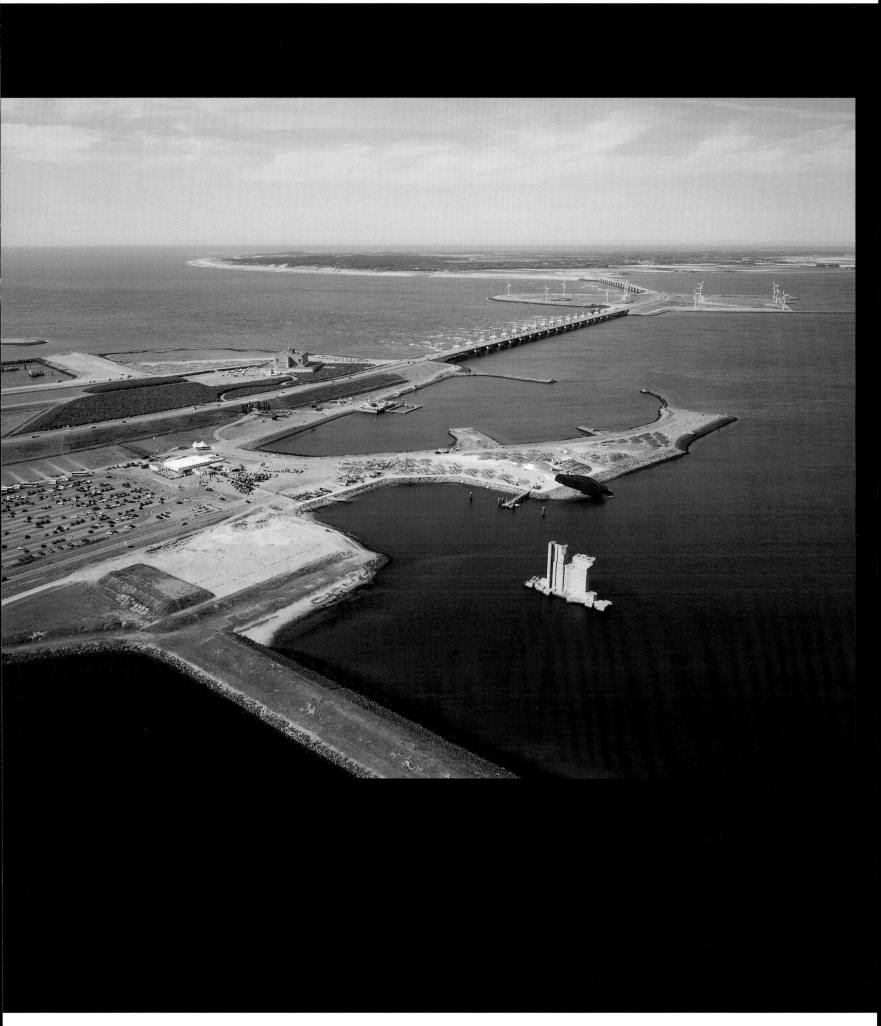

The Delta Works in Zeeland

EVERY RIVER FLOWS TO THE SEA. IN THE NETHERLANDS, A BEAUTIFUL LITTLE DELTA FORMED WHERE THE RHINE AND MAAS RIVERS MEET THE SEA: THE PROVINCE OF ZEELAND AND THE ISLANDS OF SOUTH HOLLAND. THIS IS WHERE FRESHWATER MEETS SEAWATER. FRESHWATER PRESENTS LITTLE DANGER HERE, BUT SEA- WATER IS AN ENTIRELY DIFFERENT STORY. EXPERTS SAY THAT FLOODING SEAWATER IS WORSE THAN A FLOODING RIVER. ALTHOUGH IT MAKES LITTLE DIFFERENCE TO A DROWNING MAN WHETHER HE'S IN SALTWATER OR FRESHWATER. IT DOES, HOW-EVER, MAKE A MAJOR DIFFERENCE TO THOSE WHO SURVIVE. SEAWATER RETURNS EVERY HIGH TIDE AND KEEPS ON ERODING THE DIKE BREACHES. EVERY SIX HOURS THE DAMAGE GETS WORSE. THE SALT PERMEATES THE SOIL AND PEOPLE'S HOMES. RECLAIMED LAND IS RUINED FOR MANY YEARS. JUST THINK ABOUT 1953.

Practically everyone in the Netherlands has seen the newsreels that shows the disaster in all its enormity: the top branches of trees barely visible above the water, abandoned farms, dikes rising above a lake that stretches as far as the eye can see, the water pouring through where the dikes have been breached. People desperately and apparently pointlessly passing sandbags, while the last man in the chain throws them into a huge seething hole. Would the land ever dry out again? Later the newsreels showed pictures of big machines, tugs, caissons, cranes, black clouds of smoke belching out of rumbling engines. Help had arrived. And later the first colour pictures appeared: blocks of concrete falling from a cableway into calm water, as the sea inlets were closed off. Journalist and programme maker Kees Slager knows these images off by heart. He experienced the disaster twice: as a fourteen-year-old boy on the island of Tholen, and again at the age of fifty, when he published his book *De Ramp* ('*The Disaster*'). In the intervening years he was a member of a group campaigning to keep the Eastern Scheldt open.

We climb to the top of a bank where the Vierbannenpolder meets Schouwen-Duiveland. In the village of Ouwerkerk alone, 91 people drowned. This meant the village, which lies behind us, lost a fifth of its inhabitants. In the café at the highest point in the village the water was up to the green baize on the billiard table. Terrified people sat either silently or hysterically in the attic, waiting for what would come next. Many felt that God was punishing them and some were convinced that this was the Great Flood.
As we appear over the top of the dike we startle a group of coots. With a sound like breaking ice they flee over the water. We look out over the Eastern Scheldt. To the left the caissons at Ouwerkerk rise above the closure gap. People have written declarations of love on the concrete: 'I love Petra'. We can hear children's voices coming from the woods that have grown up around the inlets.

'Peaceful, isn't it? 1953 seems a long way away.'

'1953 was the last real disaster to hit the Netherlands' says Slager. 'The generation that will soon be in power will never have experienced a disaster. My toes curled up when I watched the flooding on TV in 1995. That wasn't a disaster. Not in Limburg, and not in the Betuwe either. It was all media hype. A bit of water damage, some frightened people on the dike, and ruined parquet floors. You can't call that a disaster.' A plane crash killing dozens of people and a whole neighbourhood blown away when a fireworks store explodes also aren't real disasters as far as Kees Slager is concerned. They are just terrible accidents. So what is a real disaster then? If you want to know, read Slager's book. It includes gripping eye-witness accounts of the terrible storm that swept all before it on that fateful night in 1953.
You will learn that a disaster is when a father finds his young daughter after three weeks, her little body three hundred metres from the place where the house in which she was born once stood. Her dirty wet hair all matted and half covered in silt. A disaster is when you say that this father was lucky. He found his daughter and was able to bury her. Some were left with absolutely nothing, nothing except that last look of desperation in their loved one's eyes, a final scream in the dark as they were swept away by the water. They were left with only emptiness. Waiting, searching, unable to find any trace. Tragedies that occurred on every farm, in every street, in every village. 1,835 times.

Weather map in 1953, 12 hours before the floods

Zeeland and South Holland after the floods

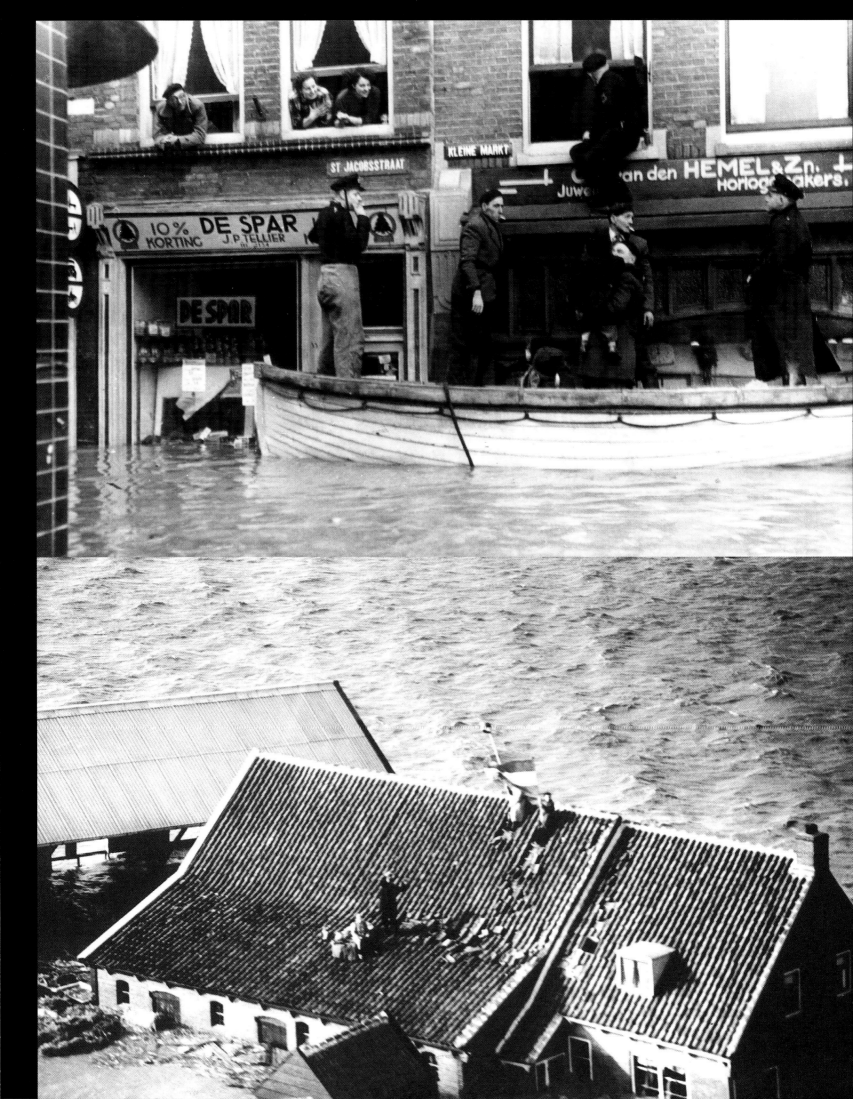

Slager writes:

> So many people from around Nieuwerkerk had washed up on the Rampaartdijk that Jozeas Verton's house was getting too small. Any unnecessary furniture had been taken outside. Almost a hundred people were crammed into the tiny house. Some had seen relatives drown before their eyes, others could only hope that they were not the only ones to have survived. And still no help arrived.
> "Someone began to say a prayer in the attic," Velders recalls. "The others joined in. From Monday afternoon the entire attic was full of people praying out loud. It sent shivers down your spine. It went on for hours, well into the night."
> 'In the afternoon they spotted fisherman Hubrecht Koster's ship sailing through the hole in the dike towards Ouwerkerk. Towards evening it went back through the hole into the Eastern Scheldt. The group waiting on the Rampaartdijk felt even more alone.

It has been calculated that some 75,000 years of life were lost. And why? Because of a backlog of maintenance, failing administration, bad luck and stupidity. There were heroes and there were cowards, but above all there was the total failure of Dutch government and administration. Carelessness allowed the disaster to happen, indecisiveness made it worse than it needed to be. It was not until 1992, with the publication of *De Ramp*, that these accusations were openly expressed. Slager thinks that these days it wouldn't take forty years for people to start asking questions.

'Now modern communications immediately place any wrongdoing in the glare of unrelenting publicity. Just think about 1995. There was a camera at every crack in the dike. Journalists no longer go to the authorities cap in hand. They start apportioning blame before the bodies have even been recovered.' Slager was the first to ask the residents, rather than the authorities, what happened. What happened prior to the disaster? What happened afterwards? He established that people had had absolutely no warning. The national meteorological office KNMI knew there was a storm brewing, but wasn't allowed to broadcast on the radio after midnight on Sunday. Although there weren't many telephone lines, every village in Zeeland had a few. But they weren't used to warn people. The exchanges weren't manned in the evening. And even when it was too late, the authorities didn't do anything. The first person to make a reconnaissance flight over the area was a journalist from the daily newspaper *De Volkskrant*. The navy was indecisive, and any help was organised by the people themselves. And sometimes there just wasn't any help. Like on the island of Schouwen-Duiveland, which was under water for 24 hours before that brave fisherman from Yerseke dared to go through the hole at Ouwerkerk.

Appalling as it may seem, many believe that the disaster was caused by systematic underinvestment in sea defences. The authorities were nonchalant to such an extent that they even neglected to replace the flashboards that people had burned during the War.

Kees Slager knew nothing of this at the time of the disaster. He was fourteen. It was all just one big adventure. 'The anger hadn't hit us yet on that Sunday. I can remember the whole village packed together listening to the cattle dealer's car radio.' That was when he first heard what had happened to his region. 'We walked backwards into the wind to Sint Maartensdijk. That was where we first got an impression of what had happened. They were just carrying the first body that had washed up from Stavenisse into a house.' Slager's own village, Tholen, was cut off on only three sides by the water and no one was killed. He helped farmers to save their animals. 'I couldn't hold them and ended up on the dung heap, cow and all. They were up to their udders in dung. I remember planes dropping food and sacks. Later American soldiers took me to school in their amphibious vehicle. Our village was mentioned on the radio. It was all very exciting!'

Kees Slager smiles at the memory, his small brown eyes squinting over the glassy Eastern Scheldt into the distance. He had already had an adventure with water. During the floods in the Second World War, in January 1944, the people were unceremoniously turned out of the polders by the occupying forces. The sluices opened at high tide and closed at low tide. But the polders also flooded because there was no fuel to power the pumping stations. In 1953 the land had just begun to recover. The little saplings that had been planted to replace the trees lost were washed away in the February storm as the water came over the dike. The months following that disastrous night in February were taken up entirely with repairing the damage. There was no time for grief or anger. Homes had to be rebuilt, the land dried out.

The disaster brought radical change. Many horses had drowned, so mechanical devices were essential. Tractors and draglines appeared in the polder. Kees Slager and his friends dreamed of becoming dragline

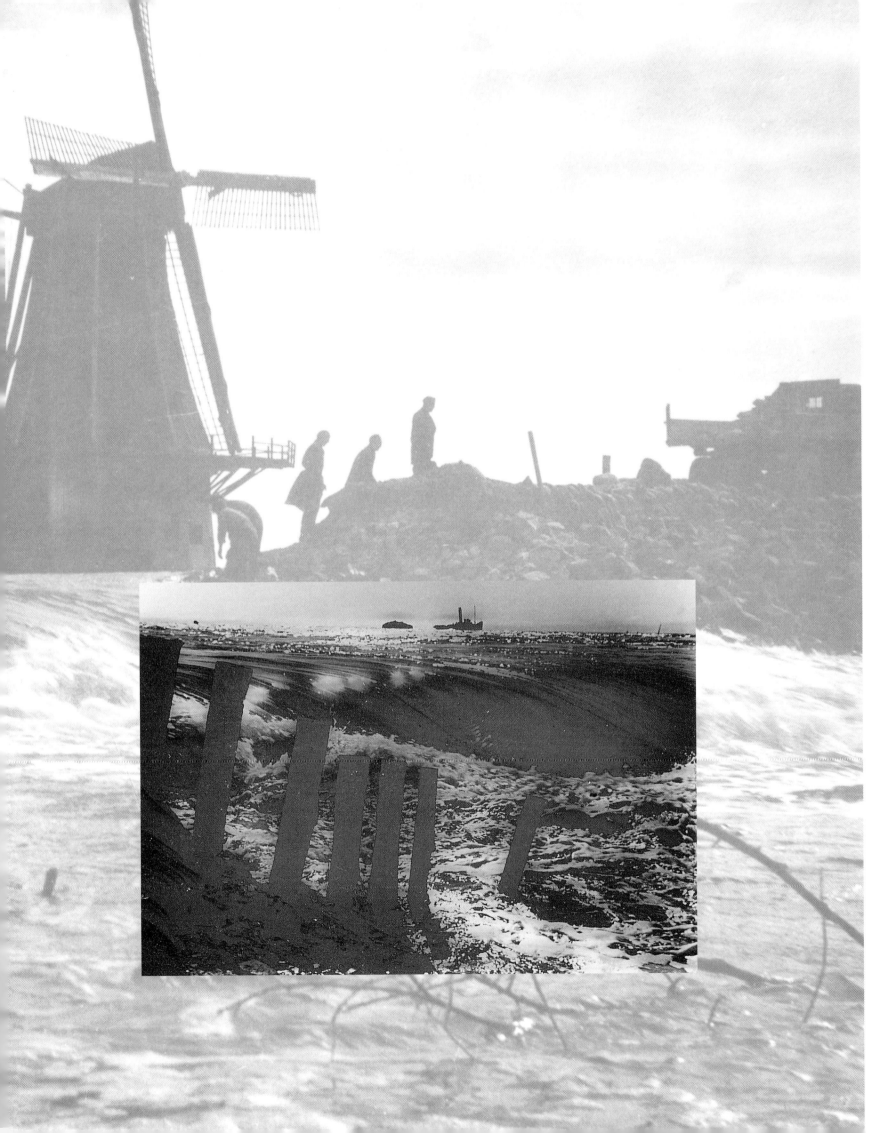

operators. But looking back, a lot of beautiful things were lost. Little roads that had wound through the countryside for centuries were straightened out and paved, old paths disappeared, hawthorn hedges were pruned right back. 'No one saw it at the time …'

Only years later did people realise what they had lost when the land was redeveloped and the Delta Project was built. A growing feeling of unease among local residents, fishermen, businessmen and ideological youngsters led to the setting up of the campaign group 'Eastern Scheldt Open' in the 1970s. Kees Slager also joined. 'The Eastern Scheldt is part of my youth and my roots. That was my motive. But everyone had their own reason for joining. There was a printer who offered his services for free because his business was under threat. He printed labels for jars of mussels.'

Eventually, a survey found that two-thirds of Zeeland residents were in favour of keeping the river open, as long as the dikes were raised. Slager is convinced that the Delta Project had more to do with farming interests than fear of the water, even in the worst affected areas, Zeeland and South Holland. 'The people weren't traumatised. Of course there was individual suffering, people lost their children, their loved ones. But overall, money has always been more important.' He points out that many farmers wanted dams because they were cheaper than raising and maintaining the many dikes in the area.

In the battle over whether to close off the Eastern Scheldt or leave it open, economic interests also played a leading role. For instance, farmers need freshwater for their crops. But to win the argument, they played on people's emotions, and emphasised their fear of the water. 'They wanted to make an impression,' says Slager. 'Even if it was just all hypocrisy. But of course the media lapped it up. And we were guilty of the same. In our campaign we used fishing boats with banners that read "Eastern Scheldt closed = death".'

The argument was eventually settled via the media. The result was a 'compromise of affluence'. A bit closed, a bit open, and a bit expensive. The money – billions of guilders – was there, and so was the political will, because otherwise the government would have fallen. So a three-kilometre stretch of the nine-kilometre dam was fitted gates that can be closed at very high tides.

We have now descended to the bottom of the dike, and are scrambling over the slippery basalt. Slager says he has been asked to collaborate on a play about the disaster. It is due to be performed in 2003, the fiftieth anniversary. Yes, he admits, whether he likes it or not, that one night in February has come to dominate his entire life. 'For a long time it was all anyone was interested in. At parties it would only take five minutes for people to start talking about it. That's all over now, fortunately. Ouch! Dammit!'
He has cut himself on an oyster he just picked. The past comes back again. He tells me how he and his brother and friends used to gather sea lavender and marsh samphire from the Eastern Scheldt. 'The sea would reveal its bounty at low tide. We would go out with a sharp knife and a sack. With freezing fingers we would pick the delicacies and sell them later for a few cents. You're not allowed to go out there now. You get fined if you get caught. You have to have a permit.' He regards this as an offshoot of our highly organised society. It has made us so safe that luckily no one knows what a disaster is these days. It's just a shame that it's been at the expense of the landscape.

Recreation on the Veerse Meer in Zeeland Het Zwin, Cadzand Bad in Zeeland

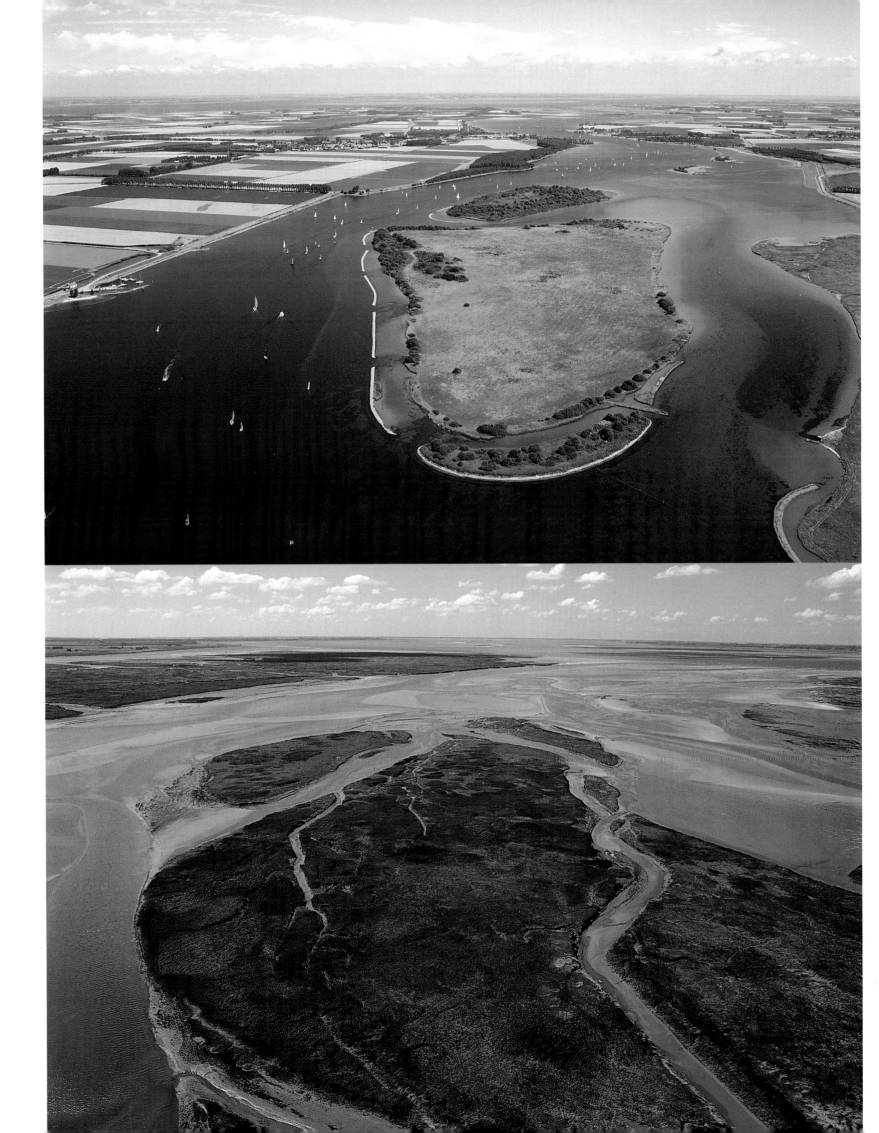

16.75
metres

CNN TOLD THE WORLD: 'THE DUTCH ARE NO LONGER SAFE BEHIND THEIR DIKES. THE LOW COUNTRIES ARE THREATENED BY FLOODS. THE MANMADE WATER BARRIERS ARE ABOUT TO GIVE WAY'. THE WHOLE WORLD SAW STREAMS OF CARS, LOADED WITH HOUSEHOLD GOODS. THE LOCAL GELDERLAND BROADCASTING COMPANY HAD NEVER BEEN SO BUSY, BROADCASTING PICTURES OF THE DISASTER. AND THE PEOPLE OF THE BETUWE DISTINGUISHED THEMSELVES WITH THEIR IMPROVISATION SKILLS AND DISCIPLINE. HUNDREDS OF THOUSANDS OF PEOPLE FLED THEIR HOMES IN JUST A SHORT SPACE OF TIME. 'THE RIVER IS GRUMBLING,' AS ONE SENIOR CIVIL SERVANT AT THE RIJKSWATERSTAAT PUT IT. THIS MARKED THE TURNING POINT IN TWENTIETH-CENTURY THINKING ON WATER MANAGEMENT.

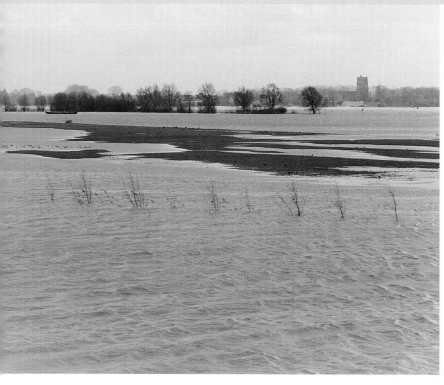
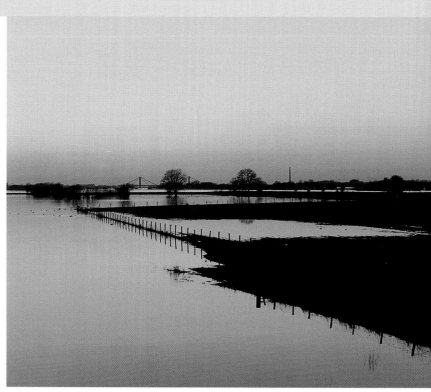

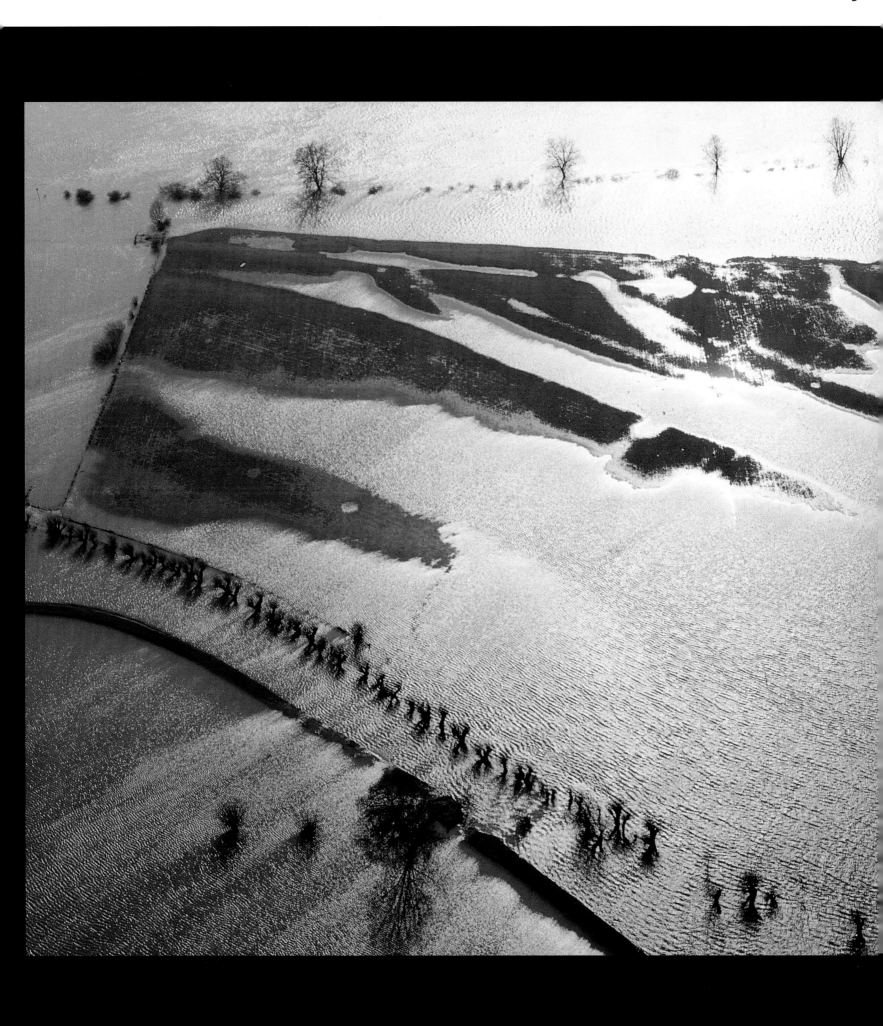

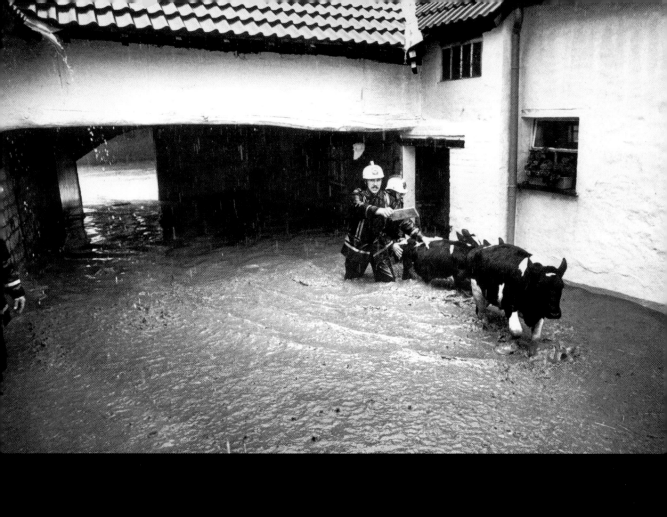

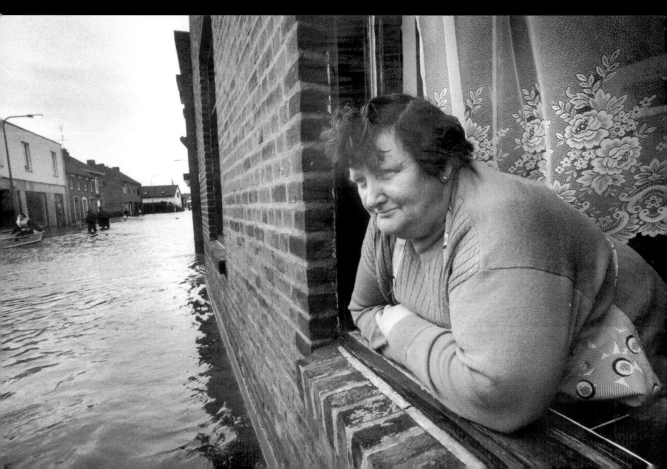

LOCAL AUTHORITY OFFICIAL JOOP VERMUNT EXPERIENCED IT AT FIRST HAND. 'SOME PEOPLE SPENT HOURS IN QUEUES OF TRAFFIC,' HE SAYS. 'HUNDREDS OF THOUSANDS WERE FORCED TO LEAVE THEIR HOMES WITHIN TWELVE HOURS. IT'S UNBELIEVABLE HOW QUICK AND ORDERLY THE EVACUATION WAS, HOW MUCH SOLIDARITY THERE WAS. IT MIGHT SOUND CRAZY, BUT I WOULDN'T HAVE MISSED IT FOR THE WORLD. I'LL NEVER FORGET THE ATMOSPHERE THAT DAY.' VERMUNT AND HIS COLLEAGUES WORKED ON THE HIGHLY SUCCESSFUL EVACUATION OF ZALT- BOMMEL IN 1995, WHEN THE WATER ALMOST CAME OVER THE DIKES. IF IT CAME TO THE WORST, HE WOULD HAVE BEEN THE LAST TO LEAVE ALONG WITH THE MAYOR.

The A15 motorway played a key role in the evacuation. It cuts through the river landscape from east to west. In the east it stretches out lazily like a sleeping cat, in the middle section filled ditches cause slight dips every fifteen metres and car traffic bumps along to the rhythm of a train. In the west the cat arches its back, and the viaducts seem dangerously low. Sometimes the road runs along the dam, right against the river, and sometimes it cuts right through the polder. In the cold and pitch darkness of the night following the evacuation there was no traffic on the A15. Agricultural machinery huddled together on the viaducts like irregular silhouettes in the dusk. You could also just make out the outline of a luxury caravan, a string of cars on the bank, a steamroller, a mobile snack bar. But not a single human being in sight. At the beginning of every slip road on and off the motorway, a spotlight illuminated a police flag snapping taut against a flagpole in the strong wind. The same wind that had whipped up the water even higher than had been forecast.

A riot police van, parked at an angle on the verge, with the dark figure of a police officer nearby: black boots, dark blue trousers, jacket, woolly hat. And a pathetic self-inflating life jacket around his neck, hurriedly handed out by the Royal Dutch Navy. This police officer was guarding the village. His instructions were simple. Let no one in or out without a permit from the mayor. And if it floods, climb onto the nearest high object or up a tree.

The new bridge over the river Waal was the highest spot in the area in 1995. The fire service had set up its command post there. Zaltbommel, on the other side of the water, was like a ghost town in that first week of February. The only official sign of life was in the town hall. The mayor and his emergency staff had their operations room in the attic. 'We were given a boat on a trailer,' recalls Vermunt. 'If the dike broke we could use it to sail to the bridge.' Beneath them – unbeknown to those left behind in the town hall – the water would then have risen to eight metres. It was only later that Vermunt realised just how close they had come. The Dutch government had designated the small and relatively sparsely populated Bommelerwaard as an area that could be inundated to save others. A hole would be made in the dike, thus sparing other parts of the country. Fortunately, it didn't come to that.

Like everyone else, Joop Vermunt's family had left and gone to a safer place when the threat became too real. Joop had been home to tell them that people were being evacuated. He then quickly returned to his post. Family and friends helped his wife and children take the furniture upstairs. Then they went to stay with relatives elsewhere in the country. Those who did not manage to get away quickly enough slept on camp beds in an emergency reception centre. Elderly people and those who lived alone were evacuated by the emergency services. Overall, the evacuation was rapid, but there were a number of incidents. The press – present in huge numbers – seized upon these cases immediately. The entire country saw an elderly man crying as he sat in a chair waiting for the water to come, his only companion a parrot in a cage. 'They forgot me,' he sobbed.

In the meantime, the emergency team kept its spirits up. Although the rivers had been rising for days, the crisis came unexpectedly. A few days earlier, after an evening out, Vermunt had gone to look at the water. 'It was high, but not worryingly so,' he says. 'We came out of the pub and took a leak in the Waal. If we'd known the trouble it would cause, we wouldn't have done it.'

The emergency team saw nothing of the evacuation. They were too busy organising things. 'I didn't go outside until 24 hours later,' says Vermunt. 'I'll never forget it. Just imagine walking into a shopping street that is usually teeming with people and finding not a soul in sight. No bikes in front of the bike shop, no bread or cakes in the bakery window, no cars in the showroom. It's like suddenly finding your own sitting

room completely empty.' Vermunt tried to take a nap in his own bed in the attic, but he didn't get a wink of sleep. In the distance he could hear the evacuation traffic thundering by. He even thought he could hear the river. 'So I just went back to the town hall.' He had no sleep for three or four days.

The Bommelerwaard was empty. The people had left, businesses had closed down. All possessions stored safely as far as possible. Ten kilometres to the west things were completely different. The people living behind the Meidijk had not been evacuated, but were following the situation keenly. 'We had the TV on all the time,' says Jelle Grim, a businessman from Brakel. 'We saw the neighbouring village moving out and heard that you got twelve hours once the evacuation order came. That sets you thinking. Twelve hours is not much time to relocate your entire business. And the critical places were so close.'
Grim's company Holland House, with a silhouette of Loevestein Castle on its logo, provides automation services for clients all over the world. He could not simply close down indefinitely. 'We decided not to just sit and wait for the water. We quickly converted our employees' garages into workspaces, and installed telephone lines. Then we started packing.' He discovered what thousands of his neighbours also discovered: within a few hours there wasn't a single box to be had in the whole area. He had to toss files and other loose objects into his car. The company was rebuilt in locations all over Brabant. Later Grim received some basic compensation from the government. 'But it still ended up costing us a lot of money. And I do still have a secret supply of sixty removal boxes. I won't make the same mistake a second time!'

The emergency team in Zaltbommel were not frightened, but the people on the dike were. Their throats audibly tightened as they described over their radio phones how the water was gushing over the dike. Or when they reported a leak in a particular section. Trucks carrying sand were dispatched to the weak sections. On Wednesday 1 February a journalist from Brabant described how upstream, in Ochten, an 800-metre stretch of dike was now unsafe.
'"Form a line! Form a line! Pass the sandbags! Don't carry them all that way along the dike!" Sailors, soldiers and police follow the orders of a farmer's son. Another 15,000 sandbags have to be laid on the bank. Here in Ochten on the river Waal speed is of the essence. At least forty metres of dike have started to give way. Just a few centimetres, but enough to worry the dike experts. Telltale cracks have appeared in the asphalt on the dike road. In the distance a new platoon of soldiers is marching in. "I've no time to explain the situation in detail," shouts the local dike warden. But the assembled soldiers from Soesterberg need no prompting. In no time, sandbags are passing from one to another at a rapid pace.
'Hand to hand is the only way in Ochten, as the dike can no longer take heavy machinery. On the river side of the failing dam the sailors have disembarked. Their divers immediately try to secure plastic mats two metres under the water. Caissons will be sunk to strengthen the dike and pontoon bridges will be needed so the sand can be brought in.
'"I can't see a thing, I'm just going on touch," shouts a frogman. He gets no response and decides to give it another go. "We need more divers, this is taking far too long," says a sergeant, and gets on the phone right away. Down in the village the next column of sand trucks thunders through the deserted streets.'

But Vermunt says that not everyone realised how serious the situation was. Market gardeners were particularly stubborn, and some of them refused to leave. 'They wanted to stay with their greenhouses. Leaving would have cost them too much.' Their refusal to leave led to confrontations with the police. Some were arrested. 'A rumour started that market gardeners in the Westland were getting together to help their colleagues in the Bommelerwaard resist the authorities. We got threatening telephone calls at the town hall. An extra unit of riot police was called in, but they didn't need to be deployed.'
There were others who refused to leave their homes. Some hid. Even with hindsight, Vermunt has little sympathy with them. He thinks it was right to evacuate, even though the dike eventually held. He knew about the seriousness of the situation from first hand. He knew how critical it was. He thinks local authorities should work together better. They all apply the evacuation rules differently, so one local authority allowed a manufacturer back to switch off his machines, while another didn't. 'But that's what you get in a situation like that. The emergency response plan only exists on paper. When something major happens like several hundred thousand people having to be evacuated, you have to start improvising. You wouldn't believe what you have to organise in such a short time, but you manage. Cattle trucks from all over the country came to pick up the animals. Emergency vehicles, removal vans, local health authority officials came in. Our town, with 110,000 inhabitants, was empty within 24 hours!'

Five years after the evacuation Zaltbommel is preparing for a party. The town had hoped the heir to the throne would attend, but the Queen's Commissioner is to open the expensive new dam on his behalf. Thanks to the inspiring efforts of people like artist Willem den Ouden in campaigning against the loss of the traditional landscape, the water board and central government have put up a huge amount of money to provide Zaltbommel with a water defence that is in keeping with the look of this historic town.

The structure forms part of the harbour. It is made of austere basalt, crowned with masonry. A stainless steel groove runs along the top, in which a barrier can be slotted if the water rises too high. So the people of Zaltbommel will never again have to flee their homes. When the river is quiet, they can enjoy an unrestricted view over a low wall to the green banks on the other side of the river. There they see the bridges disappearing between the willows. The murmur of the traffic sounds like the wind.

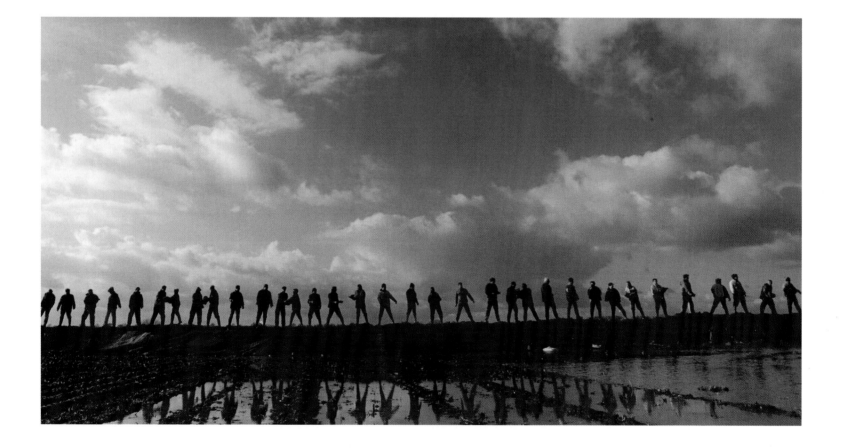

'Form a line! Form a line! Pass the sandbags!'

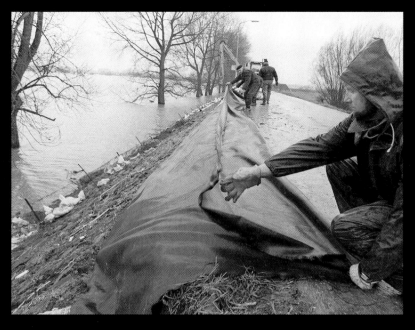
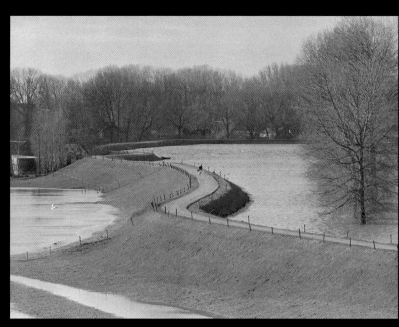
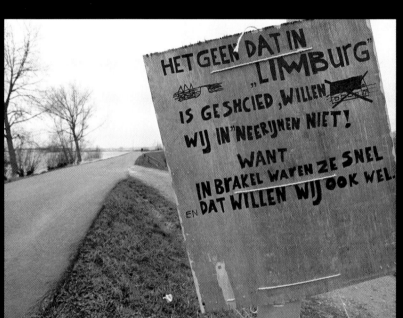
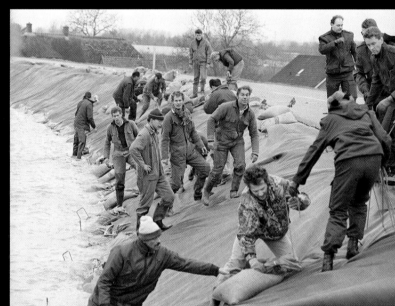
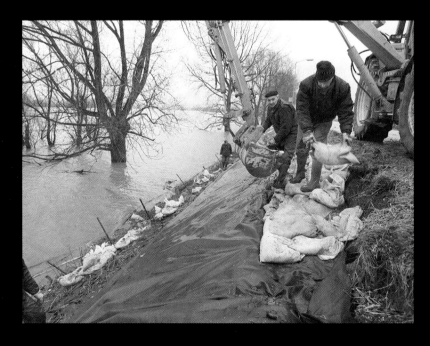
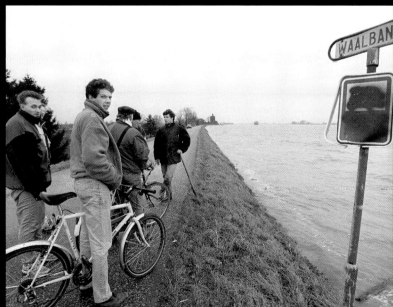

+ **6** metres

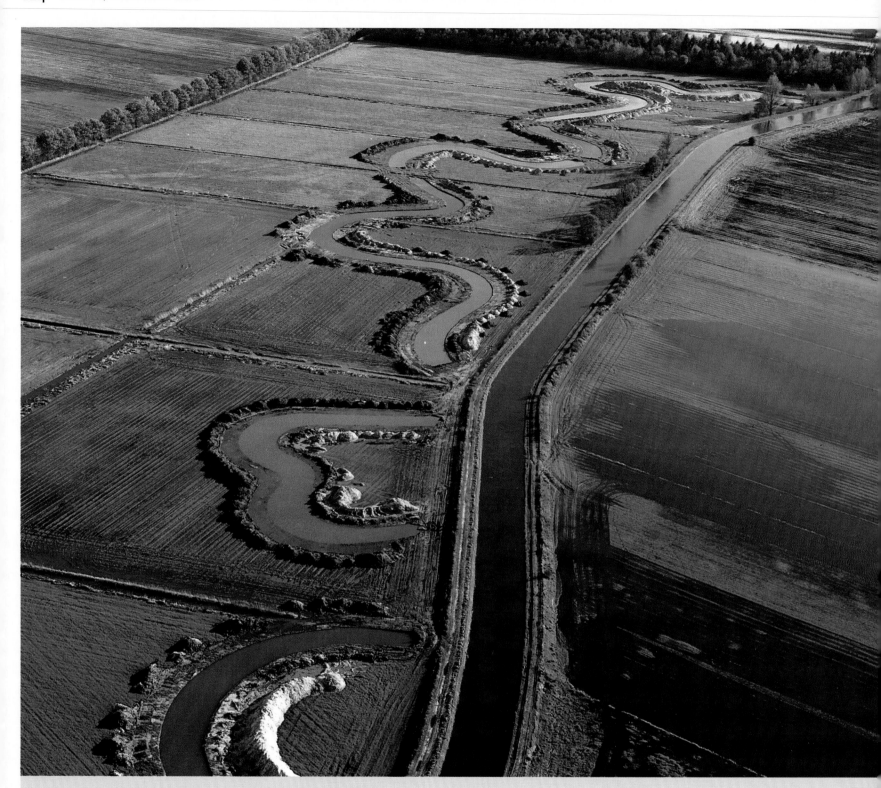

OF COURSE WE HAVE TO KEEP WORKING TO IMPROVE, BUT THERE'S NO NEED FOR THIS HASTE. AS WE PREPARE OURSELVES FOR A LARGE INFLUX OF WATER IN THE FUTURE, WE MUSTN'T FORGET THAT THE DIKES IN GERMANY WILL BE THE FIRST TO GIVE WAY. THE WATER WILL NOT ALL ENTER THE NETHERLANDS AT ONCE. BY RUSHING LIKE THIS WE'RE SPENDING AN UNNECESSARILY LARGE AMOUNT OF MONEY ON WHAT MIGHT BE STUPID IRRELEVANCES. WE HAVE TO WORK ON THE RIVERS, BUT WE HAVE TO HAVE A PROPER POLICY.

A QUIET DUSK FALLS BENEATH THE ANCIENT TOP BEAMS OF LOEVESTEIN CASTLE. A THIN BRIGHT SHAFT OF LIGHT PENETRATES THE DARKNESS. IN THE MIDDLE AGES PEOPLE LIVED IN THIS DIM LIGHT ALL THE TIME. A CASTLE WAS SAFE, BUT IT WAS ALSO COLD AND DARK. ONCE MY EYES GROW ACCUSTOMED TO THE DIMNESS, I ENTER AN ALCOVE. I SLIDE BACK THE BOLT FROM THE SHUTTER AND LOOK OUT OVER THE RIVER LANDSCAPE THAT UNFURLS BEFORE ME. MUFFLED SOUNDS GROW CLEAR, CHILDREN'S VOICES RISE UP. CHESTNUT TREES DEEPEN THE PERSPECTIVE IN THE DISTANCE AND IN THE WINGS FLOWS THE RIVER WAAL. A SHIP PASSES BY, ITS DIESEL ENGINE SNORTING LIKE A HORSE. GEESE FLY LOW OVER THE BANKS, THEIR CALL ECHOING OFF THE OUTBUILDINGS.

Dirk Loef van Horne built this place in 1361 using clay from the river. He constructed an impregnable fortress at the highly strategic point where the Maas and Waal meet. The lord of the castle paid for his home by charging tolls to all the ships that passed. In late February 2000 the castle was the setting for the presentation of the unexpected, and expensive, plan for the future of this area. It is based on the idea that the way to deal with high water levels in the rivers is to allow certain pieces of land to flood. In the chamber where Hugo Grotius was once held captive, State Secretary for Transport, Public Works and Water Management Monique de Vries addressed a group of officials and journalists. The bold plan – and De Vries' warning that the Netherlands' very existence was under threat from the excess of water in the rivers – caused quite a stir. The plan was subjected to the full glare of publicity, and elicited emotional responses even at its launch.

The areas intended for flooding were shaded on a map, copies of which were passed around. Feelings were running high. The *Rijkswaterstaat's* plans drew a thick black line through some local authority plans. Work on a residential development under construction outside Nijmegen would have to stop, and some new houses might even have to be demolished.

Local officials did not hide their feelings. 'Madam State Secretary, you surely can't mean it.' But she did. She deduced from the sometimes embittered reactions that her plan might also prove too sensitive for politicians. The Dutch want to get rid of the water, not let it in. That meeting at Loevestein Castle marked the start of a national debate on our future safety. The flood plan reminded everyone of the danger we all face. Farmers, businessmen and polder residents felt their very existence was under threat. Just how safe would they and their possessions be behind the dikes? Another not unimportant matter was who was going to pay for the new plan. It would cost billions. But ultimately such questions proved unimportant compared with the main issue: what will the Netherlands be like in, say, 250 years?

That is no easy question. The experts I phoned from Loevestein outlined a wide range of visions of the future. To start with, I contacted Gerard van de Ven, who specialises in the history of water management. He lives in Nijmegen, safely above NAP Van de Ven is a social geographer by profession, but over the years he has become the historical archive of the *Rijkswaterstaat*. He has written several books chronicling the many ways the Dutch have attempted to keep their feet dry throughout the centuries, and how the water still managed to lap over the top of their boots on occasion.

Van de Ven is sceptical about the latest plan for the river country. 'Why is the government panicking like this?' he wonders. 'Why this sudden haste to give the water breathing space before 2015? The preliminary studies were conducted with such haste that their quality leaves much to be desired, he fears. 'There is no historical justification for the plan. They didn't look to the past and the way people responded to water problems then. I'm afraid we're going to make some big mistakes, that we'll be simply tossing money into the water.'

He thinks the government's sudden haste might be due to the public's panic after the extremely high water levels in 1993 and 1995. 'People were probably so shocked that they got the idea there's something wrong with the way we manage water. When in 1998 we had such heavy rain that the pumping stations couldn't get the water out of the polders, it was time for action. Furthermore, history shows that we have short memories. We soon put disasters out of our minds. People are only prepared to spend a lot of money for a short time afterwards. The longer ago it was, the more likely we are to opt for an easy solution. I think that the *Rijkswaterstaat* realised that if it wants to do something, it mustn't leave it too long. A kind of "strike while the iron's hot" idea.'

At the same time, Van de Ven detects a typically Dutch half-heartedness even on such a serious matter. 'Even now we're still building on the major bed of the river Maas, although the local authorities and

property developers know it's not right. It has been decided that any building plans agreed before 1995 should go ahead. Knowing that it's wrong. It's so stupid! If we took the idea of river-bed widening more seriously, we wouldn't be doing this.'

In technical terms, there's not so much urgency, according to Van de Ven. 'Everything's fine as far as I can see. Of course we have to keep working to improve, but there's no need for this haste. As we prepare ourselves for a large influx of water in the future, we mustn't forget that the dikes in Germany will be the first to give way. The water will not all enter the Netherlands at once. By rushing like this we're spending an unnecessarily large amount of money on what might be stupid irrelevances. We have to work on the rivers, but we have to have a proper policy. I'd say start by taking measures at the mouth and work upstream, taking small steps as you go. Accommodating water behind the dikes, which is what they plan to do in a future emergency, is a lot less effective than we think. Spillways and retention areas have never really worked properly, simply because the water wants to follow its own course, and flowing away over land presents too much resistance. And to force it into a storage area will take huge structures, loads of concrete, to deal with the force of the water. Otherwise it will tear huge holes and devastate large areas of land.'

After a short silence Van de Ven continues: 'It's strange, but the public regards each disaster differently. The Dutch accept disasters caused by people more easily than natural disasters. Take the floods in Limburg in 1993. They only caused economic damage. No one died. The damage amounted to around 250 million guilders. There was a national campaign complete with bells ringing on the radio and TV. The firework disaster in Enschede in 2000, caused by human negligence, killed more than twenty people and caused a billion guilders' worth of damage, but there was much less of an outcry.'

Van de Ven has also tried to find the reason behind this remarkable ambivalence with which people regard disasters. He has come to the conclusion that we cannot accept that Nature is unstable, that flooding is possible. 'We have to control the water. It mustn't be allowed to cause any damage. But I think that if you were to compare the damage caused by manmade disasters with that caused by water, you would find the latter caused much less. We Dutch live in a prosperous country in a convenient location. All over the world people live in coastal areas. It's an a-historical idea that we might give up this country one day.

'I think that we will try to preserve our country with all the technology and money we have, even though it might be a less appealing or environmentally-friendly prospect. We will probably build a dike in the sea. An "advance dike", along the current coastline from the Hook of Holland via Den Helder and around the Frisian Islands. We can also preserve the coastline by replenishing the sand even in the face of a rise in sea level of over 80 centimetres. And we will continue to keep our rivers in check. Our country is too precious to let go. If we were to leave, other people would settle here immediately.'

Van de Ven believes that all in all we have little to complain about. 'In fact we've got a lot to thank the water for. Our urban development, and our prosperity, are all down to the population moving out of the countryside as the land settled and became marshy. After 1450 it was only possible to keep cattle. This required less manpower than arable farming, creating a potential labour force that gathered in the first towns.'

But the water did more, it initiated the development of negotiation and cooperation in society. 'People could only live in this country if they took each other into account. I don't know if you would call this a "polder model", but through the centuries different parties have always had to find a compromise. The principle of compensation is as old as the Netherlands. If a village built a canal to drain its water away, the farmers got a bridge paid for from community funds so they could still reach their fields. This principle lives on to this day. And undoubtedly it will continue to do so.'

A group of young knights brings the conversation to an abrupt end. The children are visiting the castle dressed in plastic helmets and tunics made of aluminium foil, carrying plastic shields and swords. They are not surprised to see a man with a telephone and notepad sitting at one of the windows. For them the castle is full of dragons and villains they are here to slay. They are invincible. The big bad 'water wolf'? They just laugh. These six- and seven-year-olds are the first batch of future water knights.

Once the kids are out of earshot I call Han van der Horst. As a historian, he will probably have something to say about the future. He has exactly the opposite response to Van de Ven. 'I think there are two possibilities,' he says. 'Our civilisation can collapse, and in 250 years' time water will be lapping at the foot of the hills outside Utrecht, where a handful of farmers and fishermen will be living. That's more or less what happened in these parts after the fall of the Roman Empire. The second possibility is that our technology-

BUT NO, THE WHOLE LOT WILL NOT BE UNDER WATER. ONE MAJOR CHANGE WILL BE THE DISAPPEAR-ANCE OF FARMERS. THEY ARE THE ONES WHO CREATED OUR LANDSCAPE BUT THEY WILL BE FORCED TO LEAVE. THE BETUWE RAIL LINK WILL BRING MORE INDUSTRY AND PEOPLE TO THE RIVER COUNTRY. THOSE PEOPLE WILL WANT LUXURIOUS SURROUNDINGS, SO THE RIVERBANKS AND WATER MEADOWS WILL CHANGE INTO NATURE PARKS WITH HIKING PATHS AND OTHER RECREATIONAL FACILITIES. AND, THANK GOD, THE RIVERS WILL JUST KEEP ON FLOWING... BUT TODAY'S LANDSCAPE? THAT WILL BE HISTORY. IT ALREADY IS.

based society will continue for a few centuries. Then, in due course, we will look for a technological solution to preserve some of the most notable examples of the "Old Civilisation". Amsterdam will be surrounded by dikes and covered with a glass dome to preserve it as a monument for all time. The rest of the country will be abandoned and returned to the sea.' But of one thing he is certain: 'We will leave. Living here will be too expensive. The borders within Europe are already fading. Many will leave this little country, where people get so worked up about how many square metres a pavement café may take, and settle in places where life is better. The Dutch tendency to regulate everything will grow stronger as the pressure on the living space increases. That space will become more and more expensive, if only because of the increasingly complex measures we will have to take to protect ourselves against rising water levels. How much higher will it be by then? Two metres?'

When I ask landscape painter Willem den Ouden the same question, he bursts out laughing. 'Never thought about it,' he says. When he has had time to order his thoughts, he continues. 'Little changed in the river country after 1750. It's only been in the last fifty years that things have changed so much. A trend was initiated in 1950 that is set to continue. I think the river country will change radically over the next 250 years. That's not enough time to allow the land to disappear, people will still live there, but it will look completely different. The *Rijkswaterstaat* will continue to do its work, it will dig channels and create more breathing space for the water. But no, the whole lot will not be under water. One major change will be the disappearance of farmers. They are the ones who created our landscape but they will be forced to leave. The Betuwe rail link will bring more industry and people to the river country. Those people will want luxurious surroundings, so the riverbanks and water meadows will change into nature parks with hiking paths and other recreational facilities. And, thank God, the rivers will just keep on flowing... But today's landscape? That will be history. It already is.'

Project manager Loes de Jong of the *Rijkswaterstaat* is at her desk when I call. Her vision of the future: 'Climate change will continue, as will the forecast sea level rise. This will change conditions in this country, but we will adapt, like we have in the past. The coastline will move inland and a beautiful and fascinating marshland will develop. The higher-lying parts of the country will rise above this. The water will be up to the Utrecht Ridge, where people will tell each other exciting stories about how the residents of Utrecht did all they could to save the treasures of the city. They will have been taken to Groningen. The coastline will run from Groningen to the new metropolis of Arnhem which, with a natural sea port, will have taken over

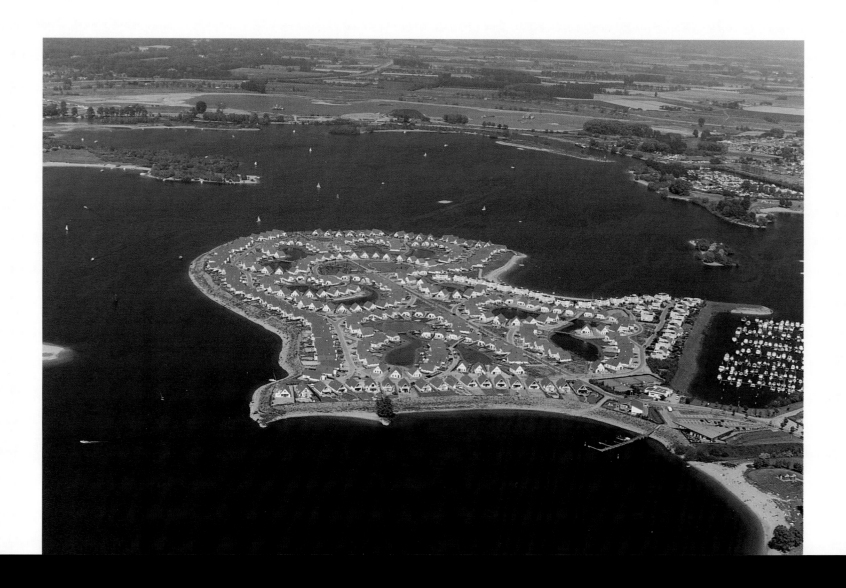

WE LIVE ON THE WATER. THAT — AND HAVING A LOT OF FREE TIME — HAS
HAD AN ENORMOUS INFLUENCE ON THE LAYOUT OF OUR COUNTRY.

from Rotterdam. The pre-delta between Arnhem and the sea will offer recreation for an economy still based on services and the distribution of goods that come in from the Universal Sea. Archaeologists will excavate the drowned cities in the delta – which is nothing new of course. Now, in the year 2000, they are looking for the remains of the drowned landscape of Saeftinge in the mouth of the river Scheldt and the lost village of Houweningen in the Biesbosch. I think the west of the Netherlands will be relinquished once the costs of protecting it no longer outweigh the benefits. Then we'll have to make the best of a bad job and go and live on higher ground. A new chapter in the history of the Low Countries is being written; the book isn't finished yet.'

Zeeland-based journalist Kees Slager: 'If the world still exists in 250 years then the low-lying part of the Netherlands will still be here too,' he thinks. But it will look different. 'A lot will depend on the next fifty years. All the Nouveau Riche want to live by the water. This, and the huge amounts of free time everyone has will change the appearance of this country. But exactly how I can't say.'

What does bargeman Tinus Klop think? What is his future vision of a soggy Netherlands? 'I couldn't say,' he says modestly. 'I am a religious man, but not a prophet. I base my views on the Bible and try to live by them, to live from the hand of the Lord you might say. He'll decide the future of the Netherlands.'

Conclusion: apart from Klop, everyone thinks they have some idea of what our country will be like. And so in fact we know nothing, because their visions are so different they cannot be reconciled. In the castle kitchen at Loevestein I run into the bunch of knights who are silently watching an interactive cook. The digital age has reached even this ancient castle. Things continue to exist down the centuries, it's just that we keep changing the way we use them. Just like the country itself. The electronic cook's presentation is over, the electronic pass is withdrawn from the slot. I join the colourful band heading towards the exit. Behind those huge doors lies the Land van Maas en Waal, the Merwedes, the Rhine, the Lek, the delta and the sea. The kids are happy to be outside again. They run towards the riverbank, as their mothers warn them to be careful of the water.

Riding my motorcycle along the castle wall I spot one grey stone among the bricks. An old stone with a faded inscription. I stop the bike, get off and feel the letters. What was it that Jacob de Witt, once also a prisoner here, said to his children? 'REMEMBER LOEVESTEIN!' He was right. Dirk Loef was not just a skilful chap, he also had vision. Because if the water does come, we'll have to come here. To Loevestein. The inscription on the stone reads:

6 metres above NAP.

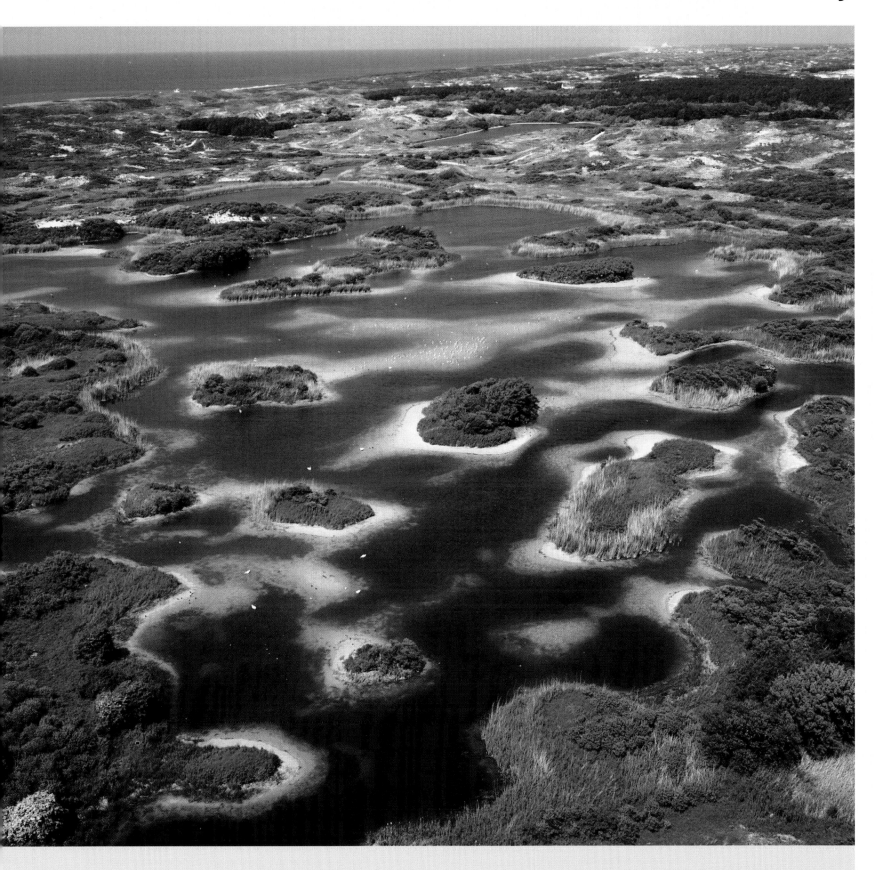

CLIMATE CHANGE WILL CONTINUE, AS WILL THE FORECAST SEA LEVEL RISE. THIS WILL CHANGE CONDITIONS IN THIS COUNTRY, BUT WE WILL ADAPT, LIKE WE HAVE IN THE PAST. THE COASTLINE WILL MOVE INLAND AND A BEAUTIFUL AND FASCINATING MARSHLAND WILL DEVELOP. THE HIGHER-LYING PARTS OF THE COUNTRY WILL RISE ABOVE THIS.

COPYRIGHT © SCRIPTUM PUBLISHERS

ALL RIGHTS RESERVED. NO PARTS OF THIS BOOK MAY BE REPRODUCED OR TRANSMITTED IN ANY FORM OR BY ANY MEANS WITHOUT PERMISSION FROM THE PUBLISHER, SCRIPTUM, DAM 2, 3111 BD, SCHIEDAM, THE NETHERLANDS.

ISBN 90 5594 220 0

PHOTOGRAPHY ANP[107, 120] FREEK VAN ARKEL [14, 15, 18, 19] FRITS BAARDA [98, 99] TON BORSBOOM [8, 9, 11, 43, 60, 64, 65, 66, 67, 68, 69, 80, 82, 83, 85, 100, 104] GEORGE BURGGRAAFF [2, 3, 6, 7, 12, 13, 20, 21, 26L, 30, 31, 39, 52, 54B, 81, 87, 112, 117, 132, 133] WILLIAM HOOGTEYLING [121] MARCO DE NOOD [16, 17] EPPO NOTENBOOM [P. 22, 26R, 27, 28, 29, 34, 35, 38, 40, 43, 46, 47, 53, 54, 58, 70, 73, 74, 76, 85B, 86, 93, 102, 114, 128, 129, 135] RIJKSWATERSTAAT [103, 106, 108, 109] KAREL TOMEÏ [10, 24, 32, 33, 37, 41, 42, 45, 50, 51, 57, 76, 77, 78, 88, 90, 91, 96, 97, 105, 111, 115, 122, 124, 127, 131] ARNAUD WILNIK [116]

TEXT ART DE VOS

TRANSLATION ANDY BROWN

DESIGN AND LAYOUT PAUL WEIJS

LITHOGRAPHY AND PRINTING SNOECK-DUCAJU & ZOON

SOURCES

R. Cobben & T. Van Esch, *Nederland vecht tegen het Water*
M. Dendermonde, *De Dijken*, 1956
H. van der Horst, *De lage hemel*, 1999
H. van der Horst, *Nederland, de vaderlandse geschiedenis van de prehistorie tot nu*, 2000
IRMA, *Ruimte voor Rijn en Maas*, 1999,
H.W. Lintsen, *Twee Eeuwen Rijkswaterstaat*, 1994
H. de Man, *Het wassende water*
L. Mulder, *Lexicon geschiedenis van Nederland & Belgie*
J. Pierlinck, *De Verschrikkelyke Watersnood*, 1757
C.S. Tielrooij, *Waterbeleid voor de 21ste eeuw*, 2000
Rijkswaterstaat, *Integrale Verkenning Benedenrivieren*, 2000,
Rijkswaterstaat, *Ruimte voor Rijntakken*, 2000
W. Silva & G. Blom, *Van Lobith naar zee*, 2000
K. Slager, *De Ramp, een reconstructie*, 1992
T. Stol, *Wassend water, dalend land*, 1996
J.P Thysse, *Onze Groote Rivieren*, 1954
J.M. de Vries (kabinetsstandpunt Paars 2), *Hetzelfde Water*, 2000
G.P van de Ven, *Aan de wieg van Rijkswaterstaat*, 1925
G.P van de Ven, *Leefbaar Laagland*, 1976
T. Westerhout, *Werkendam, met kist en bult de biesbos in*, 1993
De grote bosatlas, 1998
De Wereld volgens de bosatlas, 1938
Grote Wereld Atlas, 1993
Een Dubbeltje op zijn Kant, 1983

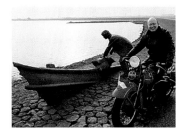

A. DE VOS

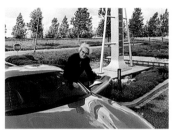

H. VAN DER HORST

L. DE JONG

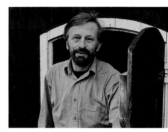

K. SLAGER

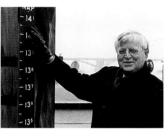

DR. G.P. VAN DEN VEN

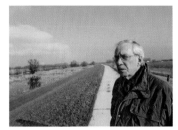

J. GRIM

W. DEN OUDEN

T. DE NIJS

J. VERMUNT

DRS. J. BUISMAN

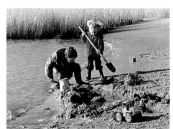

JOS AND JANNEKE